THE HOCKNEYS

Never Worry What the Neighbours Think

JOHN
HOCKNEY

Legend Press Ltd., 51 Gower Street, London WC1E 6HJ
info@legend-paperbooks.co.uk | www.legendpress.co.uk

Print ISBN: 978-1-7895507-3-3
Typesetting by Richard Carr | www.carrdesignstudio.com
Cover design by Gudrun Jobst | www.yotedesign.com
Printing managed by Jellyfish Solutions Ltd

Content and photographs © John Hockney 2019
Artwork © David Hockney 2019

THE
HOCKNEYS

CONTENTS

A short mention of family trees................................vii

Foreword..ix

1 Mum's Parents – The Thompsons................................1
2 Dad's Parents – The Hockney Grandparents..................9
3 Laura Thompson – Early Life................................15
4 Kenneth Hockney – Early days................................25
5 Marriage and Settling Down................................31
6 War – Evacuation – Reunion................................37
7 Marriage and Beyond................................45
8 A Laugh a Day Helps the Lungs They Say!................61
9 Paul Hockney................................97
10 Philip Kenneth Hockney................................111
11 Margaret Hockney................................125
12 David Hockney: Art is Life................................143
13 David Hockney: Devotion Costs................................175
14 John Hockney: Stage by Stage Part 1................................219
15 John Hockney: Stage by Stage Part 2................................257

A Thank You to Bradford................................289
Acknowledgements................................291

A short mention of family trees

THE HOCKNEYS

My great-grandfather Robert Hockney was born in Croxby, North Lincolnshire in 1841. A farm labourer, he married Harriet Sutton in 1865 who bore him two boys:

John Robert Hockney b: Ottringham, East Yorkshire in 1865, and my grandfather William James Hockney b: Thorngumbald, East Yorkshire 10 March 1868.

William James Hockney married Kate Louise Jesney on 3 March 1903 at Hunslet, near Leeds. They had seven children, two dying at childbirth. The five remaining were Harriet b: 1892, Lillian b: 1897, William b: 1899, **Kenneth, my father b: 19 May 1904** and Audrey b:1907.

I had some difficulty tracing the Hockney grandparents, being assisted by a Mr. Hackney from Hornsea. It was he who eventually realised William James Hockney and Kate Louise Jesney had three children before marrying in 1903.

THE THOMPSONS

Robert Thompson was born on 21 May 1827, marrying Jane Whinter on 25 December 1851. They had eight children with **Charles my grandfather** being born in Scaming, Norfolk, in 1861.

Charles married Mary Hannah Sugden in 1882 in Bradford, Yorkshire. They had five children:

Rebecca, Jane, Annie, **Laura my mother (b: 10 December 1900)** and Robert.

Interestingly both the Thompson and Hockney families were registered as agricultural labourers living in rural areas. Most Hockneys listed today (not necessarily related) live around North Lincolnshire and Humberside in Yorkshire. The movements of each of the families are well documented within the stories I share.

Foreword

'Never worry what the neighbours think'

was a quote my father frequently shared with his children. He never wanted us to be anything else except true to ourselves, to be confident and pursue life and opportunities as we faced them. Each Hockney sibling followed his advice, making a place in their world. As David Hockney commented: *"My father's statement is aristocratic, not working class. I have followed it all my life."*

I use Dad's quote for the title of this book because each sibling achieved in their lives *'never worrying what the neighbours thought.'*

From character-forming but opposing moralistic grandparents, to financially deprived parents who believed in knowledge and education as a future for their children, *Never Worry What the Neighbours Think* becomes the story of the Hockneys of Bradford and their children. David Hockney, the most famous sibling, as one of the world's foremost living artists, often overshadows the individual successes of Paul, Philip, Margaret and myself, John.

This is their story.

'You must keep your room tidy, David.'

My mother verbally chastised David for his slovenly behaviour. Paint tubes scattered on the floor; clothes dropped where he stepped out of them. He needed discipline to think tidy. Scrounging from her precious budget, mum paid Mr Whitehead two shillings a week to teach David calligraphy. Her idea succeeded when a few weeks later David's room appeared neater, and he presented her with an illustrated scroll of Muslihuddin Sadi's delightful poem, *Hyacinths to Feed Thy Soul*.

> *If of thy mortal goods thou art bereft*
> *And from thy slender store two loaves*
> *Alone are left,*
> *Sell one, and with the dole*
> *Buy hyacinths to feed the soul*

David may have had the last word when later he was introduced to a poem by Robert Herrick, *Delight in Disorder*:

A sweet disorder in the dress
Kindles in clothes a wantonness;
A lawn about the shoulders thrown
Into a fine distraction;
An erring lace, which here and there
Enthrals the crimson stomacher;
A cuff neglectful, and thereby
Ribands to flow confusedly;
A winning wave, deserving note,
In the tempestuous petticoat;
A careless shoe-string, in whose tie
I see a wild civility:
Do more than bewitch me, than when art
Is too precise in every part.

Sharing an attic bedroom with David Hockney from 1943 to 1957, from childhood through mid-teen years, I had no perception he was to become one of the greatest artists of the twenty-first century. He quietly kept his own counsel about his life plan, until he became devious to ensure his future followed the artistic path he so passionately sought.

Whenever I met people telling me 'I know my station in life', I was sad. Not because my family were any better, but because we were aware, informed; we knew we had a *choice*. And we used it.

The Hockneys: Never Worry What the Neighbours Think is written to share my stories of the Hockneys of Bradford.

John Hockney
Leura – Australia 2018

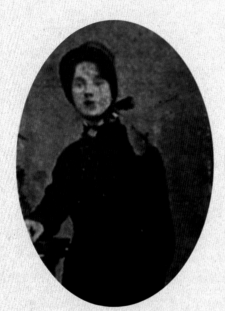

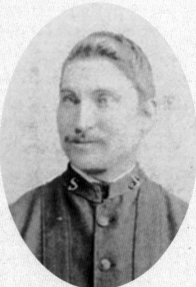

Hannah Sugden Charles Thompson

I

MUM'S PARENTS

Charles and Hannah Thompson

My interest in storytelling grew whenever my mother spoke about her childhood and her mother and father. As Grandad Thompson died before I was born, I became inquisitive about who he was, and where he came from. From an interview with my mother in 1989 I was able to compile this story.

Charles Thompson lay in a meadow, relishing summer's setting sun. He lay on his back, hands cupped behind his neck to support his head, as he chewed leisurely on a straw. The smell of newly mown hay filled the air. His eyes absorbed the gently undulating countryside where he lived and worked, creating a visual memory stored to renew at will.

Charles was leaving this countryside of Dereham in Norfolk to start his appointment as Captain of the Salvation Army Citadel in Bradford, the heart of the industrial north and a far different place to his native homeland. When the dark satanic blackness of smoke-filled air became too much to bear, he often recalled the sweetness and joy of that evening.

A Christian and founding member of General William Booth's Salvation Army, Charles was a fervent follower; passionate, with empathy and a deep desire to help others; the reason he became Captain.

Whenever Charles felt doubt or despair, he recalled Booth's citation:

While women weep, as they do now,
I'll fight
While little children go hungry, as they do now,
I'll fight
While men go to prison, in and out, in and out, as they do
now,
I'll fight
While there is a drunkard left,
While there is a poor lost girl upon the streets,
While there remains one dark soul without the light of God,
I'll fight, I'll fight to the very end.

He was given a third-class train ticket in a carriage with wooden seats. Through the train window, Charles took pleasure gazing at the lush green pastures of Norfolk and Lincolnshire. Gradually the landscape changed from golden fields to the coal slagheaps and steel mills of Sheffield and beyond. Darkness cloaked the atmosphere as he disembarked at Bradford, his final destination. Standing momentarily outside the station, he looked up at the smoke-filled sky, pondering his years ahead before striding towards the citadel that was to become his home as he spread the word of the Lord.

Cluttered by mills and terraced back-to-back stone cottages, the Laisterdyke Salvation Army Citadel seemed removed from the human despair around it. This was the place where God, and General William Booth, sent Charles to save souls. Unlike his native Norfolk, Bradford was densely populated, houses crowded around mills and scouring houses. He faced his first major problem. Cheap licences for public beer houses were offered to anyone prepared to open one.

An ordinary house could open their front room or parlour, provide seats and glasses, and offer pints or half pints of the local brew of beer from a barrel propped up on a table. The fast-growing pub industry lured men living on the breadline into a temporary retreat on drunken Friday night binges. They tried to forget their abject deprivation. Children stood barefoot, peering into parlour doorways waiting for fathers whose wages were spent or precious little left. Wives struggled to feed and clothe their families, facing another week of hardship, and the accumulation of more debt. Men became embittered by their own weakness, followed by deep remorse and sorrow, but too late to stop the continuous cycle of poverty.

Charles tried to help the best way he could, offering a shilling to buy food or making food parcels, helping families survive

a couple of extra days. Every day he was back, never forsaking the lost souls he wanted for Jesus, determined and tenacious in his goal. Early Salvationists were often taunted, spat upon, had chamber pots emptied over their homemade uniforms. Charles' faith and inner strength meant he never took their scorn personally. He understood their despair was about the system. All Charles desired was to break their circumstances through Jesus and His love. Salvationists, admired by rich and poor alike, achieved their eventual goal through patience, love and tolerance, and is why the Salvation Army is so respected worldwide today.

A few months after Charles arrived in Bradford, he attended a Salvation Army conference in nearby Halifax. He met a young lieutenant, Mary Hannah Sugden, who began working alongside him, both having a passion for Jesus and helping others.

When Hannah was thirteen, the death of her mother and the disappearance of her father meant she was alone and forced to work, fending for herself. Fortunately, she had learned to read and write, though with limited ability. She lodged with a kindly neighbour, working at a local weaving shed. The thunderous noise and clatter of the looms from seven in the morning to five-thirty at night, caused deafness, forcing workers to initiate a system of lip-reading for them to communicate with each other. They would chatter all day, sometimes laughing and sharing local gossip. Hannah hummed hymns to herself. With just thirty minutes for lunch, it was a long and arduous day.

Being virtually alone, Hannah joined the Salvation Army, becoming a lieutenant and secretary.

Hannah and Charles fell in love. They wrote to General William Booth requesting his blessing for their marriage, but Booth disapproved unless Charles were to forego his captaincy. Charles, usually a patient and tolerant man, was incensed by Booth's refusal.

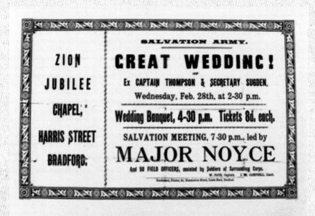

'Charles and Hannah married to a packed house of Salvationists and friends at Elim Four Square Gospel Church, on February 21st 1881 requesting eight pence to share their wedding banquet.'

He reminded Booth:

'What God hath joined together, let no man put asunder.'

Charles and Hannah married to a packed house of Salvationists and friends at Elim Four Square Gospel Church, on February 21st 1881 requesting eight pence to share their wedding banquet.

From that day the Thompsons left the Salvation Army and joined Eastbrook Methodist Mission, happy to continue their work with the poor and needy, dispensing the need for rank. Grandma Thompson survived many years after Charles, moving from their shop to live at Undercliffe with two of her spinster daughters, Rebecca and Jane. Every Saturday morning, I pulled my billycart to her house at the top of the hill. Her shopping list was ready on the table with the money wrapped in a piece of paper to make sure I didn't lose it. The greengrocer, butcher and grocer were patronised in order. A half stone of potatoes was too much for an old lady to carry herself. My billycart made it all so easy and I could ride downhill all the way home. Sometimes Grandma was ironing. She called it a sad iron. No wonder it was called sad; it was made of cast iron and had to be heated sat on a swing plate over red embers in the fire. There was no such thing as an ironing board, the corner of the table was used, with a blanket doubled over and a sheet as a cover. Her laundry always looked brilliantly white and crisp.

When my errands were complete, Grandma made a hot cup of cocoa with whole milk. At home it was mostly water with a dash of milk. We sat in front of a glowing fire, gazing into its deep red embers, she in her rocking chair and I snuggled at her feet. She would see great cities and faces in the embers. I saw them, she showed me. It was quality time, sipping our cocoa and eating her homemade fruitcake with a slice of crumbly Wensleydale cheese.

Her chair rocked slowly as she often dropped off to sleep. A gas lamp burned bright, casting shadows in the corner of the room.

I would look at her, her silver-grey hair shining in the light, her shiny face virtually wrinkle-free. Small blue eyes sparkled with a lifetime of stories and she wore a contented smile on her face. Thin bony hands, large and prominent arteries extended to her long fingers. Her back and shoulders, slightly rounded, were covered with a thick grey woollen shawl that she lifted over her head when she walked out in the cold. It is my vision of how I remember her before she died.

Grandma Thompson was ninety-two when she went to meet her Lord. Neither she nor Grandad Thompson worried what the neighbours thought, otherwise they could never have given so much to those who sought a simple but comfortable life.

James William Hockney Louise Kate Hockney

2

DAD'S PARENTS

The Hockney
Grandparents

A lush patchwork of fields surrounded the
East Yorkshire Village of Thorngumbald, a
stone's throw from the River Humber and
the shipping lanes to the city of Hull. Farm
labouring was the prime employment in the
area at the time William James Hockney was
born. He chose not to follow his father and
grandfather as a poorly paid farm labourer. He
became educated, ambitious, seeking more in
life. He wasn't ashamed of his family circum-
stances, rather he felt he could better himself.

Moving to Hull, he became an insurance agent with some success. A tall, handsome, pipe-smoking man, James dressed suitably in the fashion of the day, a three-piece suit, a chain and watch hung from his waistcoat pocket, homburg hat and polished shoes. He took lodgings with a family called Jesney. Their daughter, Kate Louise, a young lady of note and fashion fell in love with James. They eloped to Hunslet near Leeds, where they opened a tripe shop.

Whilst researching family history, I discovered a probable reason for their elopement. Though James was successful in his career at the time of their elopement, he was not wealthy per se. In 1868, a Marriage Bill passed in parliament required a pending groom to deposit a sum of at least twenty-five pounds with the registrar, parish priest or minister. Dependent on the wealth of the city or parish, the deposit amount could be much more.

Providing the marriage took place, the full deposit was returned, however, if the groom jilted, the deposit was forfeited in favour of the rejected bride, and the groom was out of pocket.

The law I understand was repealed in 1901 and is assumed to be the reason many couples began to marry at that time. Working class men would never have had access to such a sum and, though it was permissible to borrow money from family or a friend, few would have had spare cash, hence the probability of James and Kate Louise's elopement. Their marriage on 3 November 1903, attended by their children Harriet, age nine, Lillian, age four and William, age three, was recorded at Hunslet Parish Church. On their wedding certificate James was then described as a pharmacist's assistant.

After marrying, they moved to a large terrace house in the nearby city of Bradford. The house, at 15 St Andrew's Villas, was where my father, Kenneth Hockney was born on 19 May 1904, the first child in wedlock, followed by Audrey some three years later.

I can visualise Grandma Hockney as clearly today as the first day I met her. Snow-white hair, slight, thin frame, her face shallow with deep sunken eyes piercing through thick-lensed gold-rimmed spectacles. A touch of rouge on her cheeks to add colour, her chin quite pointed. Their house was rather grubby, and 25-watt light bulbs used for economy seemed to exacerbate the dark corners making it impractical for her to see clearly. Only when she was eighty after cataract removal, did Grandma Hockney notice the condition inside her home. She had it redecorated immediately.

My eldest brother, Paul, on an errand from Dad, knocked loudly on their door. Grandma answered, peering through her glasses, hoping to recognise her small visitor. In her squeaky voice she asked:

'Who is it?'

'It's Paul, Grandma,' he answered.

Without hesitation Grandma shouted up the hallway:

'It's coal, Willie!'

When Willie, her son, appeared he calmly turned to Grandma and said:

'Nay mother! It's not coal, it's *Paul*, Kenneth's lad!'

The genetic deafness Grandma Hockney suffered passed on to Kenneth, perpetuating itself in all the Hockney children. Margaret always suffered the worst affliction, followed by David, with Philip, Paul and myself with a manageable loss wearing hearing aids.

Kenneth grew up in a family open to life as it came. No religion, no regular attendance at church and, unlike Mum's teetotal parents, they partook of alcohol regularly. Morally opposite to the Thompson grandparents, they were nevertheless kind, thoughtful, generous and lovably eccentric. I never judged them.

My father, Kenneth Hockney, inherited Grandma's eccentricity, much to our delight. When unannounced visitors called, Grandma

excused herself saying, 'I'll just change my dress'. But when she returned, she had pulled a new dress over the one she already wore. Wobbly furniture legs were propped up with two-shilling or half-crown pieces. Before her cataract operation, Grandma cooked jam tarts, inadvertently dropping one on the floor. We retrieved it, bits of hair and dirt sticking to the jam. We'd tell her, 'We'll eat it later thank you, Grandma,' putting it in our pocket to be later discarded over the closest fence.

Dad's sister, Audrey was over forty when she married Scotsman, Peter McCaul, and was blessed with a daughter, Pauline. From the day Pauline was brought home, Willie adored her. Something about this tiny baby moved him. He began to dress smartly, shaved every day and took a renewed interest in life – the first time since he had returned from the trenches of France in 1918. He became the perfect babysitter, enjoying a renewed life for himself and those around him. His joy didn't last long. Soon after, Willie passed away.

He was the first person I ever saw dead. Willie lay in state in the front room for family and friends to pay their respects. It was customary for the dressed body to lie in a coffin in a darkened room of the house, curtains drawn day and night. His coffin was placed next to the aspidistra in the front room. Grieving family members wore black armbands on their coat or jacket, a sign of respect and personal loss. I was keen to see Uncle Willie, having no idea what 'dead' was. At eight years old Mum didn't consider me old enough to cope, but Aunt Audrey and Dad felt I should. I stood staring at Willie, seemingly asleep. Being dead hadn't sunk in yet. I touched his face, startled how cold he was, thinking if he had a blanket maybe he would feel warmer. Seeing his body lying in state never frightened me. He looked at peace. I still didn't quite understand what 'dead' meant, only I would never see him again.

My mother repeatedly told me Grandma and Granddad Hockney were 'not very nice'. Whenever I asked why, she never qualified her response. She must have known their background of living out of wedlock, considering it a sinful act, but also perhaps the times. I felt as my parents were God-fearing people, they should love or accept any person for who they were. That's what they preached to us, and Jesus would – wouldn't he? It wasn't until years later when I discovered the truth when researching family, I was told not to tell anyone. But for me, I liked Granddad and Grandma Hockney, loved them, and their wonderful eccentricity.

My Hockney grandparents lived a genuine love story; a couple who beat the law and loved each other sufficiently to have three children before marrying, then have two more once married, living contented lives. 'Love conquers all.' It did in their case.

My father inherited and passed on their strength of character, never worrying what the neighbours thought.

Laura Thompson – (about 20)

3

Laura Thompson –
Early Life

BORN 10 DECEMBER 1900 – DIED 11 MAY 1999

Laura Thompson's favourite hymn, *Trust and Obey*, was part of her funeral service. She had lived every day of her life believing whole-heartedly in its words. Not that she always lived them, but who is as saintly as Jesus on this earth?

When we walk with the Lord in the light of His Word,
What a glory He sheds on our way!
While we do His good will, He abides with us still,
And with all who will trust and obey.

Not a shadow can rise, not a cloud in the skies,
But His smile quickly drives it away;
Not a doubt or a fear, not a sigh or a tear,
Can abide while we trust and obey.

Not a burden we bear, not a sorrow we share,
But our toil He doth richly repay;
Not a grief or a loss, not a frown or a cross,
But is blessed if we trust and obey.

But we never can prove the delights of His love
Until all on the altar we lay;
For the favour, He shows, for the joy He bestows,
Are for them who will trust and obey.

Then in fellowship sweet we will sit at His feet.
Or we'll walk by His side in the way.
What He says we will do, where He sends we will go;
Never fear, only trust and obey.

Trust and obey, for there's no other way, to be happy in Jesus,
but to trust and obey.

When I first talked to Mum about her early life she spoke of a distant era. The twentieth century was eleven months and ten days old when Laura Thompson joined the world, on 10 December 1900.

Her home birth was supervised by a local midwife and Laura became the fourth child of Charles and Hannah Thompson. A shy, quiet girl, Laura was encouraged to accept and believe that Christian doctrine was the only true way to live and be happy. She followed God's service until the day she was promoted on 11th May 1999.

Her free time was spent on simple things. A walk with the family dog, Prince, holidays in Norfolk with relatives, or walking with close friends on Shipley Glen, Ilkley Moor or at Bolton Abbey. Otherwise her time was occupied by shop work, helping at home, making clothes, or preparation for Eastbrook Sunday School and socialising at Eastbrook Methodist Mission.

She wrote in her diary:

Sister Doris says it is good to ask ourselves sometimes why we do things.

Why do I teach at Sunday School?

I tried to think it out, and I'm sure I teach because I'm happy, so I believe that happiness comes from teaching. Each little child is a treasure of God's. I look at the purity and sweetness of the young life and think of the time when that purity and sweetness might be marred from the temptations of the world. Can I help God to keep and safeguard his treasure? Yes! If only these little souls learn of his love, friendship, care and father-hood to their little selves as they grow, so will the knowledge and reality of his love grow, until it becomes a shield, and armour and sword, enough to battle the fiercest of all tempta-tions and strengths.

I shall, when the end comes, feel partly responsible for the life of each child who has come under my influence. So Lord, help me do this great work for thee with all my heart, with all my power, and with all my strength.

Young Laura had an inquisitive mind, achieving high grades in her leaving certificate at Hanson School for Girls, but apprehensive of which direction her future would take. She asked herself what work she could embark on that was interesting but also for the good of others. Her sister Rebecca was deaconess at the National Children's Home and Orphanage. Perhaps she would follow Rebecca? She thought about becoming a missionary in Africa, saving the children in Jesus' love – a romantic idea soon forgotten.

When a friend of her father's asked her to create pattern books at his draper's shop, Laura was enthusiastic, seeing the task as an artistic endeavour. Her handwriting was copperplate style, perfect for creating professional pattern books. She worked from nine to six five days a week, with Wednesday afternoons until one, for half-day closing. On Christmas Eve the shop remained open until midnight, reopening at nine on Boxing Day. She was paid twelve shillings and sixpence a week, less tax.

Laura committed herself to her work designing pattern books. Each page was created by hand, applying patterns, noting the cloth code and description beneath, all written in her exquisite copperplate handwriting. After many months she had virtually completed the mammoth task when the owner replaced her without offering any reason, other than the new employee was his relative. Perhaps his action shocked Laura's sense of fair play, especially after she had invested her whole self into the task. Her boss was a friend of her father.

She was hurt and troubled, doubting her capability. She felt melancholy, dejected and worthless. Recovery of her confidence took many weeks, after which she accepted a new position at a draper's shop in Manchester Road. Laura felt useful again. Wages were better, with shorter hours. With renewed confidence, Laura's life at home, at work and at chapel became devoted to Jesus. She

selected gospel texts to pin up on the noticeboard at work so her fellow workers would know how gracious and loving God was. She prayed they would learn of God's love and forgiveness. Her faith was everything to her, dominating her life. Every problem was prayed about, but she sometimes struggled with her own belief.

In her diary of January 1925 she wrote:

> *I found myself in trouble first thing. It's all my own fault. I'm ashamed of myself. Yes! It is self I must watch. I read 'Imitation of Christ On Self' and found that I'm not being like him or doing what Jesus would do. No! If it does go against the grain, I'll do better.*
>
> *Have conquered a little bit today but have such a long way to go to be at peace. I feel happier when I help more but have precious little time.*

Yet she wrote of friends, May and Dolly, *'who go to bed to dream about tomorrow. I go to bed to toss and turn about.'*

Laura had soft skin, long, flowing hair and wore fashionable clothes she made herself. Her diaries tell of two suitors: Archie, who proposed but then withdrew, and a mysterious man called Ronald, whom she mentions from time to time but who was unfaithful. Her lifelong friends were few, all loyal members of Eastbrook Methodist Mission. With none of the communication methods we have today, churches and chapels were full to overflowing, representing an important part of community and social opportunity.

I began to be curious about my parents prior to their marriage. My mother had written her diaries, so I was aware of her feelings during her early life, but it didn't actually tell me *who* my parents were. In 2005 I wrote to the *Telegraph and Argus* in Bradford,

asking if anyone knew my parents prior to 1929. I received just one reply about my mother, from an Edna McMahon living near Park Avenue. I met with Edna at her home. She told me her story.

> *When I was twelve years old, I attended Miss Thompson's Sunday school class. A couple of months before Christmas, children were asked to offer themselves for parts in a pantomime 'Peter Pan'. I was selected to be Wendy, rehearsing regularly until the day Miss Thompson asked me to bring a clean nightie for dress rehearsals the following week. I instantly told her I couldn't play the part anymore.*

It was not difficult to guess Edna might not have a suitable nightie. Miss Thompson was well aware of students who lived in adverse conditions. She felt it was her job to understand. Pleading with Edna to turn up the following week, she assured her all would be well. A nightie would be available for her. That weekend Miss Thompson made a beautiful blue nightie. Edna continues:

> *My face lit up when I saw what Miss Thompson had made for me. The pantomime was a great success. On the final night, I changed and was handing back the nightdress. 'Oh No! That's yours to keep, you were a super Wendy and you deserved it'. I was overwhelmed, with tears welling in my eyes. It's the first present I ever received in my life.*

The twelve-year-old girl mothered her ten younger siblings. When I met Edna in her home, she presented me with a ticket for the play, kept all these years since 1930. I was touched she recalled my mothers' kindness and how this thoughtfulness was fondly

EASTBROOK HALL, Bradford Mission

120th SUNDAY SCHOOL
ANNIVERSARY
The Teachers and Scholars will present—

PETER PAN
(by J. M. Barrie)

Saturday, May 18th & Wednesday, May 22nd
at 6-30 p.m.

ADMISSION 1/-. Children 6d.

Peter Pan Tea at 4-30 p.m. on Saturday.

'When I met Edna in her home, she presented me with a ticket for the play, kept all these years since 1930.'

remembered for over seventy years. The ticket became a small but important piece of family history.

The first mention of a Mr Hockney in Laura's diaries was in 1926, when Kenneth helped in her Sunday School class. There was nothing between them other than a platonic working relationship. Her friend Doris thought Kenneth a good catch, but Laura rejected her idea as 'proper daft.' And, she was seeing Ronald. Two years later her life had changed. There was no doubt Kenneth was a handsome, smart young man, a photographic artist wearing modern fashions of the day. He was a practising Christian, a Sunday School teacher and local preacher, his belief was fine. He too was rather shy, having only one real friend, Enoch.

At a teacher and young people's outing to Bolton Abbey, Laura met Kenneth again. He took a photograph of her with her friend Doris in front of the abbey. Kenneth left them talking, moving on to set up his camera on the bridge, capturing the abbey and beautiful grounds. On their return train journey they met again. Kenneth running late, struggled up the platform with his two and a quarter square camera and tripod and must have looked a bit comical, running alongside the train as it began to move. Laura noticed him clasping his camera with no free hands to open the door and leaned forward releasing the catch for Kenneth to fall inside, his camera intact. There were no romantic exchanges, just kind nods, embarrassed smiles and, presumably, some eyeing up and down. Little did Laura realise Kenneth's lateness was normal.

During one of my many interviews I asked Mum how she met my father.

'He helped with my Sunday School class,' she said.

Then Mum became quiet for a few moments, deep in thought. She added rather falteringly that she had asked her mother if it were permissible for a girl to tell a man how she felt, rather than

the formal custom of a man asking the girl. Her mother thought for a moment.

'I don't really know,' she said.

'Well, do you think it would be alright to write to them?' Laura asked.

'I suppose so, if that's how you feel,' her mother responded.

Laura wrote to Kenneth. She could not recollect her exact words, but he spoke to her soon after he received her letter, resulting in their courtship, holidaying in London and the north-west of England and their eventual wedding. Their courtship was relatively short, causing some malicious gossip at the speed with which they set their wedding date – all put to rest when two years later in 1931 their first child, Paul, was born. Nevertheless, Laura was deeply hurt at the gossipy assumptions.

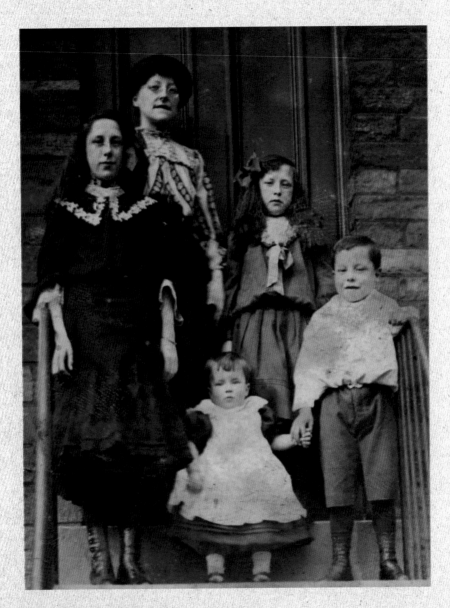

Kenneth wearing a dress with mother and siblings

4

Kenneth Hockney – Early Life

BORN 19 MAY 1904 - DIED 16 FEBRUARY 1977

I looked closer at the photograph and asked my father:

'You wore a dress?'

'Quite acceptable in those days,' Dad told me. 'Hand-me-down dresses were normal regardless of gender.'

Kenneth was three years old, standing on the steps with his mother, his sister Harriet, the eldest, Lillian and his brother Willie. I thought it rather odd wearing dresses, but then his mother was always eccentric.

Kenneth Hockney grew up in Princeville, an inner-city suburb of Bradford. Smoke hung in the sky, adding gloom to the atmosphere. Gas lamps worked hard to light pavements and roads when light rain or fog cast a sinister silver reflective sheen on wet cobblestones.

Kenneth attended Princeville Public School, a government free school close by. He had an astute mind, grasped meaning quickly and loved learning. Unfortunately for Kenneth, his education was soon to be curtailed. The 1914-1918 war conscripted brother Willie to the trenches of Northern France, creating a void in the weekly housekeeping budget. When Kenneth turned fourteen, his mother insisted he leave school to become a telegram boy. It seemed odd that his father left home to better himself but wouldn't allow Kenneth his golden opportunity for university.

The income from Kenneth's meagre wages seemingly was to make some difference. When Kenneth presented his application to leave school, the headmaster hurriedly paid a special visit to his parents, pleading with them to allow him to remain as he firmly believed their son was university material. His parents ignored the headmaster's request and Kenneth was made to leave.

From the first day, Kenneth knew his job of telegram delivery was brainless with little future. Six months later he sought a position as storeman at Stephenson Brothers Ltd Dry Salters and Grocery Wholesalers and began a new career, his handwriting skills and obvious schooling being quickly recognised. Kenneth was promoted to Stephenson's retail store in Godwin Street, employed as an accounts clerk – a position he held for twenty-five years. He sat on a high stool in a Dickensian one-man office, huddled over a sloping desk scribing daily accounts and learning accounting procedures. We always thought him so important having an office to himself. He had a quick mind for figures and balanced them perfectly at the end of each day.

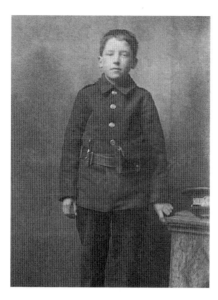

Kenneth as a telegram boy

Without a relevant accounting qualification, Dad's wages remained constant with little increase.

When World War 1 ended, Kenneth's brother Willie returned home, lucky to have survived. Or was he? Willie's personality had changed significantly. He suffered mental disability, recalling the face-to-face combat in the trenches, seeing mates die in front of him. A physical disability from gas poisoning caused him to retch and cough continually. Willie never shared the horror with anyone, becoming a shell of his former jovial self, saddening Kenneth deeply. I found a cartoon Kenneth had drawn of the Kaiser copping flak from British soldiers.

The government offered little support to returned men, leaving them to re-join society by fending for themselves. From that moment, Kenneth abhorred war, becoming a confirmed pacifist and anti-war propagandist. He reasoned it was easy for politicians to declare war, but it was 'ordinary' men who fought and died. In years to come he continued to question the basis of war, time and time again.

Willie continued smoking and drinking heavily as a means of forgetting. Eventually, urged by his mother, he became manager of a pawnshop, but he was soon dismissed for frequently sleeping in, and some days not turning up. It seemed Willie had nothing to live for. His desperation continued for most of his life, until his sister Audrey married and had a child. The joyful Willie returned, at least for a little while.

Enoch, Kenneth's best friend, attended Eastbrook Brotherhood, a Sunday afternoon meeting place for over two thousand men. He invited Kenneth to join him. A few weeks later, the evangelist Gypsy Smith spoke quietly and gently about what Christ meant to him. His words moved Kenneth to accept Jesus that day. He began to read his Bible daily. He attended chapel every Sunday, becoming a Sunday School teacher and preacher on the local Methodist City circuit. He carefully wrote his sermons to provide a day-to-day interpretation people could follow and apply in their lives, meticulously recording where he preached, documenting the date and the sermon title.

Kenneth was never a pious Christian, sharing a practical, simple Christianity of love and charity. He noticed the poverty around him and how excessive alcohol disrupted family life. He read about politics, becoming acutely aware of the problems of social injustice. Those early years laid the foundation for Kenneth's lifelong belief in pacifism and peacemaking.

He loved visiting art galleries and museums. He attended night school for light and shade classes, specifically using pencil for detailing shade to create more realistic pictures. His photography class also strongly emphasised 'light and shade' especially using black and white. Referred to as *'Chiaroscuro'* light and shade is using strong contrasts between light and dark affecting a whole composition. When David went to art school, he knew nothing about light and shade lessons until my father told him. David questioned why

the method was not then taught in art schools, as it seemed to him a relevant and important lesson.

Kenneth purchased his first Kodak Brownie camera before leaving school, learning to develop and print his own film. On 29 June 1927 he travelled to Giggleswick in Yorkshire to photograph the total eclipse, thrilled to stand alongside the Astrologer Royal Sir Frank Dyson.

Returning home from work one day, Kenneth found a letter on the mantelpiece addressed to him. It was handwritten in beautiful copperplate handwriting. Not prone to receiving letters, Kenneth, puzzled about who would write to him, having no idea his life would change forever. The letter was from Laura Thompson, his Sunday School superintendent, literally asking for his hand in marriage. He responded enthusiastically and positively.

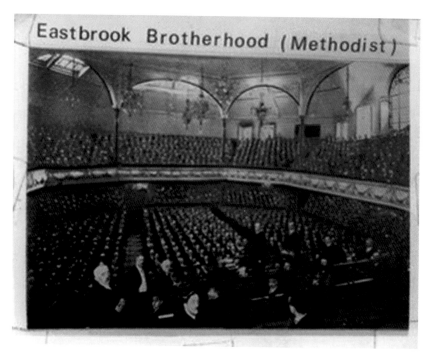

Eastbrook brotherhood with 2000 men.

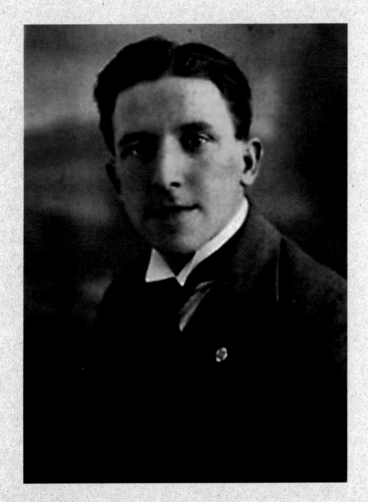

Kenneth Hockney as a young man

5

MARRIAGE AND SETTLING DOWN

Kenneth couldn't believe his good fortune. He had prayed that he might find a woman who was a good Christian. Laura appeared to fit his criteria perfectly. She was attractive, fashionable and a devout believer. I am not sure what was actually said between them; Kenneth didn't seem to respond except a simple 'yes'. Whether real love ever came into their relationship I will never know.

I never saw them link arms and walk together, never heard them say 'I love you' or use their first names. They referred to each other in front of us only as Mum or Dad.

They began looking for a house to purchase. Laura felt Kenneth rather hasty as he set a wedding date for Saturday 6 September 1929. She felt they should have more time together, but Kenneth had responded to Laura with his heart and saw no reason to delay any further. They had met many times through Sunday School and Eastbrook. Laura was already twenty-nine years old, and if they wanted children, they shouldn't leave marriage too long.

The house was perfect for their start in life together, and it was close to Laura's parents. Kenneth paid a hundred-pound deposit he had saved over the years. I calculated a quick sum: Kenneth finished school at fourteen and was now twenty-five. In eleven years, he had saved over ten pounds a year after paying his mother weekly board, clothing himself and enjoying the not-too-cheap hobby of photography. My mother constantly told us he was useless with money!

The through terrace* house with sitting room, kitchen, two bedrooms and an attic would be comfortable and large enough when children came along. Sixty-one Steadman Terrace stood at the top of a steep hill, a mountainous climb to the top requiring Olympic energy, especially when pushing a pram.

An outside toilet was fitted with the new 'tippler' system, using grey water flushing from the kitchen and bathroom to a holding tank, saving fresh water. Their house was well equipped for its day including a bath, covered during the week with a kitchen top and uncovered on Friday night. It was filled by hand with hot water from the boiler. The waste outlet flowed to a holding tank for the tippler toilet.

* Through terrace – indicates it has a back and front entry.

At the bottom of the street a wash house fitted with sinks and small bathrooms serviced back-to-back dwellings that had no internal washrooms. An infants' school was close by, as well as shops, and Kenneth could take a tram into the city for an easy walk to work.

The total cost for the furniture purchased second hand from Laura's father amounted to thirty-six pounds, ten shillings and sixpence with repayments at two shillings a week.

Bedroom Chest – three pounds
Book case (Rosewood)– six pounds
Table – three pounds
Bedroom Carpet – one pound ten shillings
Tin box – one pound
Carpet – two pounds
Steps – seven shillings
Suite – seven pounds
Bedstead and mattress – seven pounds
Sewing machine – two pounds ten shillings
4 x pans – two shillings and sixpence.
Pillows – five shillings
Sundries – two pounds fifteen shillings.

On 6 September 1929, with family and a few friends present, Kenneth Hockney married Laura Thompson at Eastbrook Hall. Some of the children from Sunday School formed a guard of honour. A formal high tea catered at the Cooperative Rooms was simple and traditional for the day. Willie, Kenneth's brother and best man, was a man of few words. He wrote in his diary:

Kenneth and Laura got married Eastbrook Hall. I was best man. Tea at Co-op Café. Ken and Laura left 5-7 on a train to Morecambe for honeymoon.

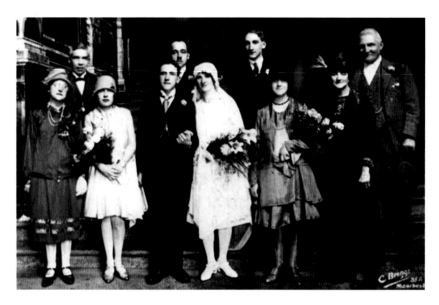

Back: L to R: James Hockney, William Hockney, Robert Thompson, Charles Thompson. Front: Kate Hockney, Audrey Hockney, Kenneth Hockney, Laura Hockney, Lucy Wigglesworth, Hannah Thompson

Morecambe was often referred to as Bradford-by-the-Sea, as many Bradfordians retired there. Within a few days both were back at work, living at their new home at 61 Steadman Terrace.

While Kenneth continued working at Stephenson Brothers, Laura maintained the house. She kept a meticulous record of income and expenditure based on Dickens's Mr Micawber:

Annual income twenty pounds, annual expenditure nineteen [pounds] nineteen [shillings] and six [pence], result happiness. Annual income twenty pounds, annual expenditure twenty pounds ought and six [pence], result misery.

Every penny of housekeeping expenditure was accounted for. Every entry book was saved, becoming a historic record of costs

over sixty years when the records were discovered after Laura died. Interestingly, her diaries stopped abruptly in 1929. She wrote nothing about her courtship, wedding, honeymoon, or children's births. Perhaps she was too busy? She resumed in 1954 and wrote until, crippled with arthritis, she could write no more.

That same year of marriage economic depression hit the United States and began to affect British workplaces with a vengeance. Over seventy per cent became unemployed in the North of England in a desperate year for industry and commerce. Factories and mines were hit hardest, but Kenneth, with the grace of God, retained his accounting job. His salary remained static with no wage rise until after I was born in 1939. Ten years and five children expanded the Hockney family to seven, causing a detrimental impact on the family budget of three pounds fifteen shillings a week. Working weeks were fifty-two hours without overtime.

Eastbrook Hall continued to be their place of worship. Laura maintained her role as Sunday School superintendent and Dad a Sunday School teacher until their children arrived. Married life must have taken some personal adjustments for Laura, as she complained to her mother about what Kenneth wanted of her, but her mother quietly suggested she grin and bear it.

On 25 May 1931 Paul, their first-born, came into the world, followed by Philip, 8 August 1933, Margaret 18 June 1935, and David 9 July 1937. In January 1939, Laura became pregnant with me. Another mouth to feed.

6

WAR – EVACUATION – REUNION

I was seven-and-a-half months in the womb when war was declared on 1 September 1939. Laura was in deep despair, with no idea what was to happen to her family as she and my four siblings were to be evacuated to Nelson in Lancashire.

There were so many questions concerning not only my mother but most families who were split for the decreed evacuation. No one knew how long it would last.

Where will my children be housed? Who will they be with? Will they be able to stay together? Who will the children be housed with? What will the people be like? Will they have the same beliefs as us? How will we cook and wash? What if we get bombed, and how will Dad cope on his own?

Mum's head spun with questions. She prayed hard, but no answers were forthcoming.

Being separated from her family to live with strangers had never been a proposition for Laura. She prayed her family would stay together, knowing in her heart it was more than could be expected. This time, God did not answer her prayers. She kept her despair to herself, forcing a smile and singing while preparing Paul and Philip in white shirts, short trousers and bright red blazers; their hair combed and neatly parted. She looked at them as her angels. Margaret wore an ice-blue bow in her hair and David, then only two years old, wore a Boy Blue outfit, which I wore myself in a family photo four years later. Mum wore her coat and felt hat.

St Luke's Hospital maternity section in Bradford had been commandeered for wounded soldiers, instrumenting the transfer of the maternity unit to Langroyd Hall in Colne, a mile over the Yorkshire border into Lancashire. Laura was unsure if the staff she knew so well at St Luke's would join the new unit. She preferred familiar friendly faces around her when giving birth.

Paul and Philip were excited. This was their first adventure alone. Mum woke early on Friday morning, making sure Kenneth had a good breakfast before he left for work. Paul and Philip hugged him before he left. Later that same morning Laura walked to the station, pushing a pram with David inside, Margaret trotting beside her on reins while Paul and Philip walked together in front.

By the time they reached Forster Square Station, Laura was inwardly distraught. She tried her best to smile, assuring her two

boys all would be well, but her heart was heavy. Climbing into a carriage, Paul and Philip scurried to an open window, pushing their heads through to wave their goodbyes. To see them you would have thought they were off on a long holiday. This was an adventure, an exciting journey, and their first time on a train. A whistle blew. It was time to leave. The crowd of mothers and children burst into tears, some so afraid of their parting. Clutched hands let go only as the moving train forced them to bid their last goodbye. Laura stood like a sentinel, a forced smile on her face for her boys, but fear within as the train pulled away. White steam hissed and billowed onto the platform, obscuring that last moment to wave goodbye. Deeply distressed, she returned home to prepare herself for her own and Margaret and David's journey the coming Sunday.

Instead of their usual attendance at Eastbrook Hall that Sunday morning, the family walked past the worshippers to the station. This time it was Kenneth feeling empty and lost; his wife and the rest of his children were soon to be gone. He had no idea when he would see them or when they might return. It must have been terrible without the means of communication we have now – no mobile phones, not even a fixed telephone line to the house. Most communication was at a snail's pace by letter, or by telegram. Kenneth stood silently watching his family leave, their final goodbyes over, faces solemn and sad as the train pulled slowly away. The family separation was a reality.

Kenneth stood watching the back end of the train pull away into the distance. Mesmerised, he found himself staring into an empty space long after the train had gone. He turned and walked back to an empty house. No shouting, no laughter, no children's voices, and his heart heavy. He was left alone.

Families throughout Britain were issued with gas masks, which they had to carry at all times. Rationing coupons for food, clothing

and essentials became operational immediately. As Laura was a vegetarian, she was able to access additional cheese and vegetarian products in lieu of meat, helping expand the meal choice through innovative cooking. No one realised then that the austerity of rationing would continue until 1954.

Laura's concerns became real on arrival at Nelson station, evacuation arrangements seemed haphazard. Selection of evacuees felt more like a Roman slave market. They were eyed up and down to visually assess their suitability to their host. One by one, evacuees left with host families. Heavily pregnant Laura, Margaret and David were the only ones left. Anxious, trying to keep a brave face, Laura felt very alone. What was to happen to them?

When hope was virtually lost, a Mrs Lund drove in from Nelson, readily welcoming Laura, David and Margaret to her home. The Lund's three-bedroom semi was a tight fit, but with consideration and kindness Laura and the three adult Lunds managed. A cot was squeezed into Mum's room ready for my arrival.

The Lunds were exceptionally kind. One bedroom was allocated to Laura to sleep with David and Margaret in a double bed, with a roster negotiated for access to toilets, bathroom and kitchen. It could not have been easy using other people's things, lacking personal familiar kitchen tools and surroundings. To help maintain a healthy diet Laura sometimes exchanged clothing coupons for additional food coupons.

On the morning of 23 October 1939, I began my birth journey, ready to join the world. Laura woke Mrs Lund at 2 a.m. to organise an ambulance for her journey to Langroyd Hall. I joined the Hockney family on the cusp of Libra and Scorpio at 5.30 a.m. on 23 October 1939, and for Mum, just in time for a cup of tea. I was the easiest birth my mother ever had, yet I was born with eczema on my head, diagnosed by nursing staff and attributed to

my mother's distress prior to birth.

My birth was registered as Colne in Lancashire, determining I was *never* a native Yorkshireman. There was such an outcry from Yorkshire mothers, adamant their children must be born in Yorkshire, that a month later, Langroyd Hall was made an honorary part of the county of Yorkshire, at least for the duration of the war. It was too late for me. Though all my younger years were spent in Yorkshire, my birth status remains registered as a Lancashire lad. Nevertheless, I now had a Mum and Dad, three brothers and a sister.

Every Sunday, Dad caught a bus from Bradford to Keighley, changing for the drive over the moors into Lancashire and the cotton town of Nelson. It was a short but blessed relief for Dad to see Mum and his family. Stopping at Colne to visit Paul and Philip, he brought presents of flowers and sweets. Mum and Dad abhorred their separation, but remarkably we managed to be all reunited in Bradford early December 1939 – the best Christmas present Mr and Mrs Kenneth Hockney ever received.

Though life was far from normal during wartime, the family settled into a routine until the night of 21st of August 1940. Sirens warned of approaching enemy aircraft. A neighbour and our family of seven squeezed into the staircase cupboard. It was pitch black and the sound of bombs very frightening. The bombs were designed to create a screaming whistle as they sped to earth from the aircraft, with the whistle stopping a second before the bomb exploded. That one second brought a terrible fear to those sheltering. A bomb seemed to explode on Mum's back; she felt the impact through the wall, expecting to see devastating damage outside when it was over. Philip crawled to her through the pitch darkness, asking her to pray. She did.

Until the day she died, Mum believed God saved us, thanking Him for his grace keeping the family safe. When the all-clear

sounded, an inspection of damage revealed every other house in the street had their windows blown out except ours, remaining intact. A wood yard at the bottom of the street was badly damaged and a church roof blown off. Much of the city's retail area was devastated with Lingards store completely destroyed and the roof of the Odeon cinema collapsed. Fortunately, the cinema was empty.

It was the only time we experienced such a closeness of devastation. Life for us resumed to whatever sense of normality exists during a state of war. Shopping, household duties, Sundays at chapel, school and work, helped maintain a sense of routine for the Hockney family. But that was soon to change with some alarming consequences. Dad's personal philosophy of life at Stephenson Brothers caused changes affecting his work relationships. As a pacifist, he was tormented verbally and physically by work colleagues who despised his perceived weakness and cowardice. However, the company needed Kenneth to maintain the accounts. Not only did he confront bitterness at work, he also faced it at home. The word 'Coward' was painted on the house wall every night by a neighbour. Every morning, Dad rose early to wash it off before going to work. When I grew older and understood my father's belief, I thought it must have taken a special kind of courage to stand up for what one thinks is right, especially during wartime when a large majority condemned his stance. I admired my father's tenacity. Years later, President Kennedy said:

'Until we recognise the conscientious objector, war will always exist.'

Bullying and teasing began to affect Paul and Philip's relationships with other schoolchildren. Sticks and stones hurt, but so did the names and callous behaviour towards them. They were puzzled why Dad's belief differed to the majority. They innocently

questioned why he didn't fight. Some thought him a coward. Even Mum felt he should do more. It was many years before I fully comprehended his position. By then I was questioning the Christian belief 'Thou shalt not kill.' Personally, Dad was strong enough to take whatever malice was thrown at him, but it was unfair his wife or children should suffer abuse because of *his* belief.

There is no doubt that any man who was called to fight endured atrocities they would never have believed human beings capable of. Like Kenneth's brother Willie, they returned the worse for their experience, and it is understandable some men felt bitter against those who didn't fight.

To avoid further confrontations Dad made the decision to seek a place to live other than Steadman Terrace, finding a three-storey terrace house with a cellar at 18 Hutton Terrace, Eccleshill. Three miles from the city centre, the terrace stood like a rampant castle, with sweeping views across a valley to open fields and woodlands and Horsfall golf links, Horsforth Church, and Apperley Bridge and Rawdon. Only a few mills polluted the air on this side of the hill, so our view was greener and the air fresher than Steadman Terrace.

In May 1943 our family moved to our new home, away from the anguish and intolerance.

Our new neighbours were seemingly non-judgemental, though many had husbands fighting on various fronts. One family neighbour had escaped German occupation from Guernsey in the Channel Islands. They attended our Methodist chapel and their father was a pastor in the Congregational chapel.

In our later years David, Margaret and I hold a loving admiration for Dad's courage at a time of war. I never considered him a coward, but then I chose to create his archives and discovered the kindness he gave to his fellow man, helping and saving the lives of others being perhaps more meaningful than fighting wars.

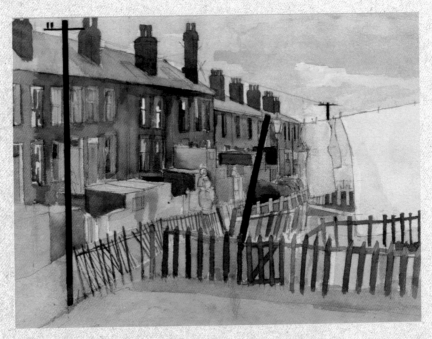

" Hutton Terrace Eccleshill" 1954
Watercolour and pencil on paper 10¼" × 14¼"
© David Hockney
Collection: Bradford Museums and Galleries, Bradford, UK

7

MARRIAGE AND BEYOND

Our move to Hutton Terrace meant a fresh start. No one knew anything about us, nor the reason for our move. The unpleasantness of neighbours and school children's taunts disappeared. The family breathed a sigh of relief. This new house was to be our home until we left to pursue our own individual paths, leaving Mum and Dad alone.

Just two months after moving in, workers cut down the decorative iron railings front and back, leaving a signed receipt to say they were being commissioned for the war effort. Insufficient iron was being produced or made accessible to maintain the increasing number of bombs. The decree affected every home with iron railings throughout Britain.

The house was spacious compared with Steadman Terrace, with two attic bedrooms; the back one for David and me, and the front for Paul and Philip. Margaret was given a small room to herself opposite our parents', always cosy in winter as the hot water system was in a cupboard. Mum and Dad took the front bedroom with the view across the Airedale valley of gently rolling hills and copses of woods. A large cellar and an inside bathroom with a toilet provided comfortable utilities and the drudgery of using potties or walking outside in wet weather was avoided. For the family of seven, the physical change was idyllic. Our new neighbours were friendly and accepting. Welcome offerings of a cake or tart showed a kindness and thoughtfulness that was to blossom into friendships in the years to come.

We were not being judged.

Mum had not been told about Dad's decision to move to a new house, but I can only surmise in those days, men, as heads of household and breadwinners, made family decisions. Perhaps it may have been prudent if Mum had been consulted, but the house Dad chose was superb, and they lived there for fifty years.

Hutton Terrace overlooked a higgledy-piggledy field of garden allotments. Locals whose properties had no gardens, rented tiny plots to grow vegetables or installed a greenhouse to nurture tomatoes and marrows. It wasn't unattractive and added to the community spirit. Beyond the allotment, Eccleshill railway station was still operational. German prisoners of war wearing dark blue

jackets with large yellow circles on their back worked during the day. We often chatted to them, calling them all by one name: 'Fritz'. They seemed quite content to be prisoners avoiding the dreadful conflict in mainland Europe – so much so, that some stayed, settling down with wives after the war.

Beyond the railway station, the rail line obscured the rooftops of Ravenscliffe Council Estate, offering views to the woods and copses between Fagley village and Greengates, then beyond to the lush green of Woodhall golf links and the church steeple in Horsforth. To the left the view extended to Yeadon and in the valley, Apperley Bridge village. It was a view far more appealing and spiritual than the rows of the smoking chimneys and mills of Steadman Terrace.

Inside the back entrance, a small vestibule held coats and muddy shoes before entering the kitchen/ living room, the hub of the house. The front room was used only for occasional large family gatherings. A cellar became useful for Dad, repairing and renovating bicycles and prams. A cutout, hewn from a solid stone wall down to the cellar, accommodated a meat safe, maintaining an even temperature all year round. It was to be twenty years before we bought our first refrigerator.

When I revisited the house after Mum left to live in Bridlington, I was amazed at how small the living room was. Disbelief at how we had all crammed into this room to live our lives, cook, finish homework, wash clothes, iron, and eat meals with up to fourteen people at a time. The harmony, disharmony, laughter, tears and love crowded into this room. Surprising how relative size changes when we grow up!

Neighbours shared local news, chatting every day over garden walls or at local shops. Few homes had telephones, and face-to-face chat was how most local news travelled. Shopping became a routine, daily purchasing fresh food, as domestic refrigerators were

not commonly in use at that time. Supermarkets were yet to be invented, and shopping conducted at individual shops: the grocer, greengrocer, butcher, baker, newsagents and post office. Large speciality shops and department stores and the Kirkgate and John Street market catered for any other needs.

When Mum thought me old enough to run errands, she sent me to the butchers.

'Ask for a sheep's head,' she said, 'and if he has one, ask him to leave the legs on.'

The butcher's shop had a distinctive smell about it. Meat carcasses hung from hooks in the window and from a rack screwed to the ceiling. Sawdust covered the floor, soaking up blood.

Naive and slow, disbelieving Mum would tell an untruth, I carried out her strict instructions. Waiting patiently at child height behind large-bottomed ladies in overcoats, I noticed their hats with feathered plumage. As ladies chatted to each other, their mouths moving fast as words were put together, the feathers on their hats shook or wobbled. I was mesmerised.

'Next.'

I stepped forward.

'Mum said, can she have a sheep's head Mr Cariss, and she said would you leave the legs on please?'

'Ah'll give ee a clip owert ear-ole wi thi cheek,'* he said.

I was rather nonplussed. It was the first time Mum had played a joke on me. I had been conned. There were murmurs and giggles from those customers behind who had heard my request.

'She's a cheek, leave the legs on – we'd all like that,' they half-grumbled.

I was growing up!

* I'll give you a clip over your ear with your cheek.

"At the Grocer's*" Circa 1954
Gouache on paper
14½ x 19½"
© David Hockney
Collection Bradford Museums & Galleries, Bradford, U.K.

'Well could I have four thick sausages instead please,' I asked as innocently as a newborn lamb.

From a shiny pink bunch of sausages hanging in the window he sliced off four. All meat was cut fresh, no pre-packaging.

'Is that all today?' Mr Cariss asked.

'Yes, thank you,' I answered.

He looked straight into my eyes as he gave me the change.

'Leave the legs on indeed.'

He gave me a wink and handed me the sausages. I ran home, pleased I had run my first errand. There would be many more cons and jokes as I grew up in the world.

Shopping took time, because until the advent of supermarkets, customers were served their shopping lists one item at a time. The grocer behind the counter, cut, weighed or packed butter, sugar or bacon, placing each item on the counter in front of him to add up the total mentally before loading purchases into our own bags or baskets. No plastic bags then. Seems we are moving in a cycle. There was never a rush. Shoppers expected to wait, and the time spent queuing was the time to gossip. Mrs Ramsden would tell Miss Bell how Jim Hardcastle fell off a cow and broke his leg. Then I follow Miss Bell into the bakers. She repeats the story to Mrs Whittingham. It was the way local news was transmitted, face-to-face, with expressions, tones and dramatic vocabulary added to make any story more interesting. What started as authentic news often changed to fake as the story was retold.

Teatime became special as we all sat down for tea together, joined by Dad and my elder brothers from work. Stories of the day were shared. Whatever had happened at work or school became part of our conversation. Some got me into trouble.

We never received corporal punishment. Mum and Dad never beat or struck us. Rather, we were sent to bed without tea. I was

always a storyteller; my stories often becoming fabrications of huge proportions. Although we were never hit, Mum thought I should be taught a lesson with soap. She pushed me to the floor, using Lifebuoy soap, washed my mouth. With bravado I spluttered, 'How wonderful it tastes!' stupidly causing the cleaning process to continue far longer than I hoped, or mother planned. 'Here then, have some more,' Mum said as she pushed the soap deeper into my mouth. I learned to keep my mouth shut and kept my own counsel from that day on.

For entertainment we made our own adventures, exploring the fields and copses of woods around us. Using fine net tied to a stick, we caught tadpoles and newts, viewed through washed jam jars so we could watch them grow. More often they died before they developed. Seasonal crops of bluebells, buttercups and daisies were picked along with hedgerow. We filled bags of freshly picked blackberries and raspberries and wandered over sparkling streams tinkling music as they trickled through the woods and fields to the river. We gradually made friends with neighbours' children, and life was good.

The War Is Over, 8 May 1945.

The headlines blazed in newspapers and radio bulletins. People danced in the street for Victory. A calm fell across the country. Blackouts were removed. Streetlights turned on at night. Cars used full headlights and shop window lights blazed after dark. Buses were painted bright red or blue, gradually replacing the battleship grey of public transport. There was celebration everywhere, and a joy filled people's hearts. Street parties with tables decorated in red, white and blue, were laden full of cakes and sandwiches, as the neighbourhood welcomed men home from the war. Bonfires lit the sky and everywhere

there was celebration. Freedom was being enjoyed, but for the Hockneys life was to change for the worse.

A few weeks later Dad walked into work one Friday morning to be told his services were no longer required and given *one* week's wages in lieu. While Stephenson Brothers retained Dad during the war, men were now returning, wanting jobs. Adding machines and the invention of the comptometer had null and voided manual methods of additions. Dad became superfluous to requirements. He was sacked after twenty-five years of loyal service. No handshake, no watch, not even a thank you. Dad's personal pacifist beliefs had been tolerated only whilst he was needed, but the need had gone. There were no protective laws against dismissal at that time. Ten years later, a' contract of employment would have provided some protection. It was the bias against Dad's personal beliefs, which were held in contempt by his fellow workers, that hit him hard. It was a blow to his loyalty and an act beyond his comprehension.

With a family of five children, a wife and himself to feed, the Hockney financial situation instantly became disastrous. Jobs were being filled quickly by returning soldiers, the future looked grim. There was no doubt Dad had been a different drummer. I cite Thoreau:

If a man does not keep pace with his companions, perhaps it is because he hears a different drummer. Let him step to the music he hears, however measured or far away.

Dad heard a different drum, retaining his firm beliefs regardless of the obstacles they both faced, which were mainly financial. Though not a business man as such, Dad put his hand to anything he could to keep the family together.

Mum began work at a jam factory in Shipley but came home at lunchtime appalled by the language of the women working there.

Doll's Pram

The pity (as I see it) was that those possibly uncouth people offered an opportunity to share Mum's joy in Jesus. I don't think Mum gave it a chance, but then I was only six years old. Who was I to criticise?

Faced with a difficult future, Dad began refurbishing bicycles and baby's prams as well as making new doll's prams from scratch. There was a huge market for bikes and prams. They were unavailable, and he would apply his hand to anything that helped feed us, pay bills and maintain family togetherness. Prior to installing a home telephone, any advertising in the local paper for prams or cycles referred to a telephone number at our public telephone box outside Hutton School. Advertisements inserted in the Friday night *Telegraph and Argus* required interested clients to ring the number between 9 a.m. and 11 a.m. On Saturday morning Dad

heaved an armchair onto his back, carrying it up to the phone box to sit outside waiting for a call. If any member of the public approached to use the phone, Dad directed them to the next box a short distance away, nonchalantly continuing to read the morning newspaper and wait for a call.

Every refurbished pram was fitted with a new hood, which Mum hand sewed with needle and thread. pushing hard against the metal frame with her fingers – another reason, other than arthritis, for her crippled hands later in life. A decorative braid enhanced the pram presenting a professional finishing touch. David was mesmerised when Dad painted a decorative line on a bicycle frame or pram using a long sable brush. He marvelled how straight the line was, then with a twist of his hand created a small serif, perfectly formed.

Deliveries were usually made by David and me, with Margaret sometimes accompanying us. It was easier and less costly for us children to deliver than Dad, as we travelled for children's fare, saving a few precious pennies. Dolls prams easily fit under the staircase of double-decker buses, and our delivery saved valuable manufacturing time and cost for Dad or Mum. Often, we travelled to resellers in Dewsbury, Halifax or Huddersfield, or to private homes. Heckmondwike displayed coloured light illuminations around the town square near Christmas, and it was a real treat to get a delivery there. We rode buses upstairs at the front whenever we could, because there was so much more to view. It was exciting looking at the countryside. I never tired of looking, even on the same repetitive route. There was always something to see.

Every day Dad worked physically, at the same time attending night school to study for a certificate as an Auditor and Commercial Accountant.

Both parents worked long hours, struggling to make ends meet. The whole family chipped in with allocated chores. By the time

we were twelve years old, we had learned how to prepare and bake a dinner. Margaret washed and ironed clothes. Philip and Paul nurtured the garden. We younger ones washed and dried dishes and pots, sometimes keeping our own rooms tidy. We polished shoes, including the 'last' underneath. Dad sometimes used old bicycle tyres to re-sole shoes, extending their life a few months more, but making them uneasy to walk on. Scrap food was never thrown away but usually recycled into another dish referred to as 'bubble and squeak'.

Family finances gradually worsened, forcing Mum and Dad to re-mortgage their house to help settle accruing debt and maintain a new weekly budget until a new order for a pram or bike was received. The weekly budget was very tight, as accrued debts requested immediate payment. It became Mum's department. Uncle Robert, Mum's brother, gave her five pounds to help. She felt ashamed but took it, feeling quite humbled. Aunt Audrey, Dad's sister, worked at the Yorkshire Electricity Board and generously ordered a Thor washing machine to ease Mum's housework drudgery. Robert had served in the army, fighting against Rommel in Tobruk. Dad felt rather inferior when his incapacity to properly feed his family was discussed by wider family members but tried to maintain his pride and his belief in non-violence. Some people who had previously befriended him, isolated him. Our situation seemed harder than during actual wartime. Perhaps courageous stories of escape and bravery filling newsreels and newspapers didn't help Dad's cause. At age six I didn't really know Dad, but I did know he didn't have a rotten heart. Later in life, when I came to understand him, I believed him to be one of the most courageous and generous hearted men I have ever known.

Gradually debts were paid, and life continued. Somehow, we never went hungry and never felt denied anything. It was a difficult

time for Dad, struggling to make a future that could be prosperous. His night school certificate course paid off when he passed his exams with flying colours. His twenty-five years of accounting experience held him in good stead and with the certificate, he could demand a far higher salary.

One might have thought that, being an accountant, Dad would understand profit and loss, but he never understood marketing. He was reluctant to charge too much for his labour, and never added a fair percentage to materials in case his selling price was considered too high and he wouldn't sell anything. He never realised he had a captive market. People *needed* prams. Most would have paid double, especially near Christmas. Consequently, effort exceeded return with very little reward.

With Dad's new certified credentials, he began applying for jobs. He was considering how much to ask, thinking about seven pounds, when Philip said:

'Ask for nine pounds, dad.'

He got the job, and nine pounds, at Parkinson Ford on Manningham Lane. This was double what he had earned at Stephenson Brothers and the start of an upward trend.

In 1947 we had the first family holiday I remember, staying at Great Aunt Nell's in Hull. She lived in Mayfield Street, Spring Bank, an area that had been heavily bombed, but her house and a few others still stood. Areas of destruction had yet to be cleared and rebuilding war damage was yet to start. We cooked with whatever food was allowed in our ration books, but fish was plentiful in Hull, a main port for trawlers fishing in the North Sea, Faroe Islands and Dogger Bank.

Great Aunt Nell was a loveable eccentric. David and I adored her. She dressed rather 'blowsy' and was quite buxom with permed light-blonde hair, white frilly blouse, a shiny black belt around her

waist and smart black skirt and shoes. It was how she spoke that made us laugh. 'How har you today?' she asked, emphasising the 'h' in front of 'ar'. 'Har you having a good time?' Seemingly, adding an 'h' implied she was being posh. Aunt Nell smoked, using a long cigarette holder with an extended gold band holding the cigarette. (It wasn't real gold of course.) A considerate smoker after a meal, she lit her cigarette, inhaled deeply, lifted the hem of the table-cloth and blew her smoke under the table. She delighted us with her pretence, and we thoroughly enjoyed her company. She never worried what the neighbours thought. Ever!

Nellie's son Charlie was a carpenter and a funeral director. Behind some large wooden gates adjacent to the house sat a Rolls Royce fitted out as a funeral hearse. Twelve-year old Philip, pretending to drive, began pressing buttons. Apparently, a button not a key was required to start the ignition . Philip backed into the garage doors, much to the consternation of everyone, especially Charlie. The car was locked from then on.

Sleeping accommodation was 'squeezed'. I slept in the bottom drawer of a chest, with a pillow as a mattress and a blanket for warmth. Paul, Philip and David were squashed three to a bed.

Dad adored the city of Hull and its surrounding countryside. We rode the New Holland ferry across the River Humber and a train to Cleethorpes, a seaside resort in north Lincolnshire with a hard-to-walk-on pebbled beach. Arriving into the station, I shouted with excitement on seeing a large van delivering bread with 'Hockney's of Hull' emblazoned on its side. The catering firm still exists, with the addition of a pub on Anlaby Road simply called 'Hockney's'.

Our holiday was a breath of fresh air, both mentally and physically. We connected with distant relatives in Withernsea and Thorngumbald. In 2005 I knocked on the door of a cottage in Thorngumbald where my grandparents had visited. In my hand I

held a photograph showing my relatives outside the picket fence, still standing. The cottage looked exactly the same as in the photograph, so I knocked on the door, to be greeted by a young woman. When I showed her the picture she was thrilled. There was little external change since the late 1890s. The lady had delved into its history and was ecstatic I could fill in dates and names for her.

Every October David and I accompanied Dad to Hull fair. It's history dates back to 13th century. As little boys, the history didn't interest us, rather the excitement of enjoying rides, eating brandy snap, toffee apples or fairy floss. All northern fairs congregate for a final gathering before the winter season. Hull Fair after WW2, spread over some wasteland, overflowing into nearby streets, the final gathering before the winter break. Filled with bright lights, flashing colours, loud music competed for a variety of rides from Helter-Skelter slides – dodgem cars – mechanical swings, and the thrill of a 'Wall of Death,' where motorcycle riders rode around a vertical wooden cylinder usually 20-36ft in diameter. Riders revved engines with pungent fuel additives tickling our nostrils, all adding to the carnival atmosphere. The riders mounted their bikes gathering speed until their steeds were ridden perpendicular to the vertical wall. Held in place by the science of friction, we thought it magical, wide eyed and heart thumping at their skill.

Crowds jostled as we held hands tightly weaving past a row of 'Original Gyspy Smith,' fortune teller stalls, set up just a few feet away from the front door of resident's houses. Their small curtained stalls lured inquisitive clients to sit at a round table usually covered with a red chenille cloth and a glass ball mounted on a wooden stand in the middle of the table. How could they *all* be original, I asked? Dad just smiled, never lured into their fortune telling capers. The gem of all rides for we small boys was the magical steam roundabouts carrying beautifully decorated horses ridden

by excited youngsters, (as well as my father), their motion up and down, and round and round imitated the movement of a real horse. Steam organs at the centre of the ride played loud magnificent music, designed to be heard above the noise of fairground activities. To two small boys the fair became a magic wonderland. Dad contentedly observed the delights of children squealing and laughing with excitement. We slept happily on the bus home ready for bed and fairground dreams.

The Hull Fair visit became an annual tradition until we moved on in our lives and to other interests.

A strange event happened on Saturday Feb 19th 1949 which Mum had recorded in her diary.

John had been shopping this morning. When he came home, he sat on a stool near the fire and said, 'Mummy, I was thinking when I was coming down the road, I saw an old lady with a bent back – she couldn't see the sun – she walked with a stick. I helped her across the road and then brought her home. I sat in a chair and then, it wasn't the old lady at all, Mummy – it was you!'

[Mum said], 'You must have been dreaming' – but John said, 'No, I was outside, and it was still daytime' – so I said, 'Well John, you must have been day dreaming'.

'Oh,' said John, 'Is that day dreaming?'

Strange and unresolved indeed.

The Artist's Father, 1977, ink on paper,
17" x 14" in/ 43.2 x 35.6 cm

8

A LAUGH A DAY HELPS THE LUNGS THEY SAY!

KENNETH HOCKNEY

My father was funny, kind and hardworking. Passionate about social injustice, he fought every which way he could to make a difference. He did make a difference.

A lover of Laurel and Hardy and Charlie Chaplin, he presented himself in a similar vein. A small man with a prominent round to his back and shoulders from sitting over a desk for years, he loved wearing a clip on bow tie, to which he affixed brightly coloured stationery dots to add colour to his world. He wanted to make people smile. Walking down the street with him, most people did smile!

Woolworths sold white paper collars for detached collared tunic shirts, the ones that require collar studs to attach a collar. Readers should understand cardboard collars could not be used more than a couple of times, but for economy Dad covered them with a coloured adhesive material patterned in stripes or checks so they could easily be wiped clean and worn again. Yorkshire thrift?

He never left the house without a walking stick, of which he kept a rather large supply as he frequently forgot where he left them. Well prepared with an array of pens, pencils, rubbers and a notepad, Dad found writing was second nature to him, and he documented anything he felt important to keep for reference. He sewed or taped extra linings into his jacket or coat, so he could carry newspapers, magazines, books and cameras around on his person, adding a largeness to his torso. He wore homemade badges promoting the harm of smoking or the need for peace. Around his neck and duplicated around his wrist a notice proclaimed his diabetes and gave instructions in case of an emergency. It was Dad's diabetes that complicated his life. He carried sweets in case he had a hypo but often ate them, having none left when they were needed.

Dad introduced David and I to the delights of cinema, viewing both silent and talking films, as well as live theatre. We saw Charlie Chaplin's 'City Lights' nine times, laughing at every gag we knew by heart, time and time again. I still have a copy and laugh just as

much today. Dad had seen Charlie Chaplin performing live when Chaplin was part of Fred Karno's Army – a comedy vaudeville troupe, very successful in British music halls and before he left for USA.

Many cinemas, as a novelty, still showed some silent films with comedians like Ben Turpin, Harry Lloyd and the Keystone Cops. At our local matinee for kids *Perils of Pauline* became a great favourite. Every week she would be in a life-threatening predicament, tied to a railway line or left dangling from a flagpole high above a busy street. The next week the hero always saved her.

It was laughter that made a big difference to us during wartime, and in the nine years of Austerity Britain that followed. It helped the lungs, as David repeatedly tells his visitors today. We thrilled to watch Laurel and Hardy live on stage at the Bradford Alhambra Theatre. I had only ever seen them in black-and-white films, but here they were, live. Oliver was terribly overweight and very red-faced. He died soon after returning to Los Angeles, though the thrill of that day remains a magical memory of seeing them perform, and in colour!

Each Saturday David and I regularly met Dad in town after he finished work. Scoffing a fishcake and chips out of paper behind the Odeon cinema, followed by a half pint of sarsaparilla on tap at Allen's herbal shop (to purify our blood), we then went either to the cinema or the theatre. Dad adored musicals and joyful movies. He never took us to see horror or violence, or not intentionally. Newsreels became part of the picture programme, as prior to the invention of TV it was the only way the news was shown publicly. If part of a film became violent, Dad put his hand over our eyes. It was his censorship, though we often tried pulling his hand away. Watching movies and theatre was not just entertainment; it became a learning curve of knowledge.

One Saturday afternoon Dad took us to the Alhambra Theatre, sitting in the sixpenny seats at the back of the balcony to watch *La Bohème*. Dad had made a mistake, thinking it was a variety performance, but the opera became a turning point in David's life. The orchestra, usually consisting of six or eight musicians, had swelled to twenty. The music, the scenery and costumes captured David's imagination, and from that day classical music and opera captured his heart.

Each week I became distressed after these exciting and thrilling outings with Dad. As soon as we returned home, Mum became critical, complaining *we* spent money *we* didn't have, but her wrath was for Dad, David and me. She included all of us. My parents arguments were never private or discussed away from we children. I felt terribly guilty. David simply pushed it aside and ignored it. I wet the bed until I was fourteen, troubled about the constant arguments, but was still prepared to meet Dad every week. The laugh was worth it!

Somehow, Dad rejected Mum's confrontations. It seemed even '*Job*' wasn't allowed to enjoy himself! Perhaps Mum was right when finances were difficult. But for those two hours with belly laughs, our souls and spirits were lifted far higher than the spiritual confrontation with Christ three times each Sunday. I never believed Mum should have included her children in her daily criticism of my father. Sadly, every time we met Dad for the cinema, we returned to the same repetitious conflict when we came home.

Mum was never keen on movies, only watching something of a spiritual nature at chapel, or *Ben Hur*, *The Ten Commandments*, *Samson and Delilah*, or Maureen O Hara and Walter Pidgeon in *How Green was my Valley*. Roddy McDowell, who I met in his home in Los Angeles many years later, played the young boy in the film. Mum enjoyed Disney's films, plus the local repertory

theatre offered half price tickets of sixpence at the 6 p.m. show each Monday evening, but that was some years later.

Dad's humour was encouraged whenever the family gathered for Christmas or birthdays, and he brought out his bag of tricks. There was a tired set of playing cards sewn together, a ball on a string which when slightly tightened at our command, would stop. We were in awe! He had a penny with a hole drilled through it and a length of elastic, pinned into his sleeve. When he offered the penny, it should have sprung back up his sleeve, but sometimes caught on his cuff. When visitors arrived, he covered an old coffee tin with a wrapper labelled, 'For the Blind'. Guests embarrassingly offered a few pence or a silver coin. He was always careful to see how much they gave. Later, laughing loudly, he announced it was for the *venetian blind* and returned their offerings. Dad was old-time music hall; the gags, the jokes and the fun. He loved old-time songs and, though tone deaf, would heartily sing, *Why Don't Santa Claus Bring Something to Me?* and Australian music hall artist Billy Williams's *Little Willy's Wild Woodbines*. I was fortunate to go with Dad to the last night of the Collins Music Hall at Angel Islington in London. A memorable pleasure and highlight before cinema replaced live music hall performances.

Christian love on Sundays, back to quarrels the rest of the week. If my parents had been able to resolve their differences, blend their skills and energies, Mum and Dad would have made a formidable pair. I never believed finance was their only problem. In Mum's opinion, Dad had stopped believing in God, which was untrue. I know from letters I found in his archive. What he saw in the organised church was its lack of practical charity and love to all people. He felt the church made judgements, basing any support on how they assessed each individual. For him the issue became political. As Dad proclaimed, Jesus accepted everyone without question,

leading to many more questions and limited answers from our youth and beyond.

On a recent trip to a war museum in Laos, I watched a film, horrified when a padre prayed for the safety of the US aircrew that was to drop thousands of cluster bombs on the innocent people of Laos, who today are still maimed from cluster fragments.

Dad considered life around him, the act of birth and the functions of the human body. He reasoned we eat and drink matter that sustains us, and we get rid of waste. Our eyes see, ears hear, noses smell, mouths taste and chew food, fingers and hands touch, our own bodies are beyond our imagination. Yet we abuse them, torture them, cut off arms and legs and yet we can still function. The brains we have been given can be used for good or evil, we are given choices. He was in awe of nature, of the physics behind all life. David Attenborough has taken us to realms of the planet we would never have believed had he not developed equipment that filmed minute insects and their behaviour. Yet Dad never accepted that human beings continue to destroy. It isn't God pulling triggers or shooting missiles, it's people. Dad saw what was happening; his heart was there. His heart of kindness and concern for his fellow man, became a path to follow.

Dad was always late, *just*! He *just* missed a bus, *just* got to the post as the mail van pulled away, *just* missed a train, was *just* too late for the theatre and had to wait for an intermission, and *just* sometimes didn't get there. Even though he wore two watches, one on each wrist with the time set fast on one, he would always be late as he forgot which watch was correct. A letter he wrote to Fattorini's the jewellers in Bradford requested setting '*one watch to gain rather than be accurate*', as then he wouldn't be late. They refused any adjustment on the grounds their quality watches would always be accurate at all times.

A prolific letter writer to world leaders, politicians and church leaders, Dad frequently received answers. Sadly, he allowed a stranger to borrow the originals of his replies and never saw them again, nor the stranger. Responses came from Gandhi, President Nixon, the Pope, Colonel Nasser of Egypt, Khrushchev, the Archbishop of Canterbury, and many others.

In one letter to the Pope, Dad asked him to sell the solid-gold telephone on his bedside table and give the money to the poor of Mexico. Objecting to British bombing of Cairo, he wrote to Col. Nasser receiving an acknowledgement card at Christmas.

Dad's passion for humanity continued, urging bans of all nuclear weapons, abolition of the Vietnam War, as well as his own personal opposition to tobacco companies. A man in many ways ahead of his time, he led a one-man crusade against smoking. He designed and paid for his own posters and badges, pasting them on billboards positioned near bus stops where they could easily be read. When the National Front pasted one of their posters over a Bisto advert he wrote to Bisto, who put another of their posters over the National Front's, thanking Dad for his awareness.

Fanatical about his anti-smoking cause, Dad designed his own badge. The first was round, had a simple white background the shape of a lung in orange, and a small black dot located on the orange. In a way this was quite clever, because when people asked what it represented, they were lectured with all the reasons why

Pictures of badges

smoking was harmful. He was interviewed on local Radio Leeds one Christmas Day morning. At the end of the interview Dad was asked if his children smoked. His response was a hardly audible 'yes.'

Most of Dad's letters to important people used *noms de plume*, depending to whom he was writing. If to Khrushchev, he would use 'Yenkcoh', which is Hockney reversed, but provides a slight Russian connotation. Others he commonly used were K Aitch ('aitch' being the pronunciation of the letter H), or Ken Law – Law for the first half of Laura.

Some of his letters showed some naivety. He wrote to the local Morrisons supermarket manager, praising the perforation marks of Izal toilet rolls. *'They always tear to perfection'*, he wrote.

Dear Sir

Recently I bought a packet of IZAL soft tissue toilet rolls. I find the perforation of these P E R F E C T: as I have purchased different makes of toilet rolls, where the perforation has been A W F U L. One never knows where they are going to tear, very often in the wrong place.

I wish to add that I have no connection with any of Izal's agents whatsoever but write as a very satisfied customer. For the I Z A L S O F T T I S S U E TOILET ROLLS.

Yours faithfully

Ken Law

Perhaps if he had written to the manufacturers, he would have received a dozen rolls free. Other letters written to we children when away from home, suggested we use All Bran every day, or the next letter suggested yeast Vite tablets. *Just spread it on your food, it will keep you healthy.* Dad wrote as he spoke.

'*Now then John, how are you?*

I'm OK – I hope you are. I am feeling much better now after spending seven weeks in St Luke's Hospital, and the Bradford Royal Infirmary. Actually, the nursing sister asked if my bowels were alright, so I said yes, I take All Bran at home. Her reply was, 'Oh that's good, will you arrange to have some brought to the hospital?' This I did. Mum takes it and is very good for your health.

Now John I can recommend it to you both. It has done me a world of good. Take it every day. Just spread a good spoonful on your food. All Bran can be bought in the big stores or in health shops.

Remember to get the All-Bran Habit.

Cheerio John, Cheerio Alwyn.

With Love.

I saw the humour of his suggestion, imagining myself at an expensive restaurant spreading a spoonful of All Bran over my steak au poivre or lobster thermidor?

To economise on newspapers Dad became a member of Bradford Mechanics Institute. For five pounds a year he could pick up two-day old newspapers . Once he brought home the *London Times*, *Daily Mail*, *Daily Express*, *Yorkshire Post*, *Manchester Guardian* and *Daily Worker*. He circled a particular article in each of the papers pertaining to a singular issue. Dad asked Margaret, David and I to read the article carefully in all the newspapers and tell him what we thought. Each paper obviously reported the news with their own political slant, so it was difficult to decide which report was truthful.

'Exactly!' said Dad triumphantly. 'They all push their own bias. Always make sure you seek the truth for yourself.'

Easier said than done, but it taught us a wise lesson we have never forgotten.

When Dad reached forty, he required hearing aids. The early National Health Service hearing aids were purely amplifiers, picking up every sound as well as speech. Noise was not filtered as it is now, and little did any of us understand how hard it was for him. We do now, as we are all deaf. Noise interferes with hearing. All of us wear hearing aids of differing strengths. Socially, it is not easy to sit in an uncarpeted crowded restaurant, as the sound amplifies and takes the joy from an evening meal's conversation.

I don't think Mum ever understood just how difficult it was for Dad. I know I can't cope with missing a vowel here, or a word there, as it interferes with the whole point of a conversation. Margaret and David especially have great difficulty dealing with simple conversation. Neither attend many public functions as it is too difficult to hear.

The last time I saw Dad alive was September 1977. David invited my mother, father and me to Portmeirion in North Wales, before I returned to Australia. Arriving late for daily lunch, we were offered a salad. Sitting at a table for four, we began to enjoy our meal when I felt the table shaking. David was holding himself, laughing, unable to speak, nodding his head towards Dad. To cut his lettuce, Dad produced from his pocket a quite large cardboard sheath with the word 'scissors' emblazoned in fluorescent letters. He was cutting his lettuce with the scissors. David and I saw the funny side, honestly believing it to be a great idea when arthritis causes joints to fail. Mum was horrified. Beginning to cry she objected to our mirth.

'I have to put up with this all the time,' she said.

We thought it a sensible (but funny) method.

Sykes Wardrobes in Bradford offered high-quality second-hand

Kenneth Hockney bow tie resplendent after cutting lettuce with scissors.

clothing, usually from deceased estates. Dad outfitted himself with whatever suit he needed at the time, with any alterations, courtesy of my mother. The quality was excellent. David and I saved a few pounds outfitting from Sykes Wardrobes.

Long before fluorescent safety jackets were worn, Dad made up armbands of orange fluorescent material, so he could easily be seen at night when crossing the road. Often scorned and laughed at, he never changed, never worrying what the neighbours thought. Today they are sold as safety protection.

Writing was second nature to him, always prepared with an array of pens, pencils and a rubber and note pad. His writing was

not very reflective, but he recorded anything he felt important for reference. Unfortunately, medical emergencies often arose, as he became so absorbed in his work he forgot to eat, leading to hypo's and hospitalisation.

Mum was a Liberal supporter all her life, often singing the song *Lloyd George knows my Father*. Lloyd George supported the poor and working class when he introduced the introduced the Education Act giving all children opportunity for proper education. He declared war on poverty. Lloyd George often worked independently of his party, drastically reducing its political power and fortunes. The Liberals never became a contending party again, though Mum continued voting Liberal and persuaded my brother Paul to join the party. She never spoke about Parliament but became sad at the horrors of war and how the wealthy took advantage of those they considered to be lesser human beings.

In a way Dad reminded me of Mr Kite in *I'm Alright Jack* played by Peter Sellers. There is a line where Kite speaks about the illusion of Russia – cornfields and the sunset at night. Had Dad travelled to see for himself he may have realised the horrific differences The Soviet Weekly published each week. With travel we learn first-hand the realities of seeing how people live and work each day. I have travelled to Europe, Vietnam, China, Laos, Malaysia and Thailand, Japan, Cambodia, Russia, USA, Canada, New Zealand. One see the results of political bureaucracy and has a greater understanding.

Reading letters Kenneth had written during his life, I realised he was at times naïve. He never travelled out of England until David paid for himself and Mum to visit Oberammergau in Austria for the passion play, and to Paris when he was about sixty years old. Perhaps if he had become a seasoned traveller and seen the world, learning first-hand how people lived, the obstinate part of him might have

Poster of mouse

mellowed. My old French teacher at school, Alex Eaton, who was a leader in the Peace Pledge Union, once told me, 'Your father is a wonderful advocate for peace, but wow, is he stubborn!' There is no doubt once he held an opinion Dad was difficult to budge, yet his heart was always trying to help humanity.

He made a poster of a mouse approaching a mousetrap with cheese as a tempter. He headlined the poster 'DEATH AWAITS YOU'. David cheekily and correctly added his own version: 'EVEN IF YOU DO NOT SMOKE.'

The passion Dad held as a younger man for the church as a whole began to wane. By the 1950's he was questioning the established church teachings, alleging they were more interested in property development than the compassionate concerns of Christ and helping the poor and needy. Though he still held a firm belief in God, he stopped any regular attendance at church, though sometimes attending the Quakers or Salvation Army.

A letter he wrote to Mr and Mrs Tempest of Bradford on 11 July 1978 explained his point of view: *"I do not believe in the virgin birth or the physical resurrection, but I certainly believe in Jesus Christ and his wonderful sermons. If his sermons were carried out today, then I feel sure there would not be the crime and unhappiness in the world today."*

As a matter of interest, several years before I actually met my wife, I prayed that God would lead me to the person who most suited me and hoped that our children would be guided and blessed in their way of life. And this prayer has been wonderfully answered.

Kenneth Hockney adored and admired all his children. He had no favourites, accepting each with their own beliefs, goals and characters. He was non-judgemental, except on the subject of smoking, when his anger exploded if he caught us inhaling. His failure perhaps, was to appreciate everyone makes their own choices in their world. Yet I realise behind his angst was a caring concern for the health of others. He didn't always live in the real world but am sure he would have been more than happy today seeing the world ban on smoking in cinemas, department stores, clubs and public places, all now free of the smell of tobacco smoke. I personally stopped smoking some forty years ago. It was my own choice, for my own health. Paul stopped, as did Philip and Margaret, with David continuing to inhale cigarettes with delighted ecstasy. It is alleged he holds two thousand packs topped up at his Los Angeles home in case of an earthquake.

Prior to the invention of digital cameras or camcorders, for any major event shown on TV Dad meticulously set up information about the scene, or item he wanted to photograph on the top of the TV. When man first walked on the moon, Dad photographed the event on TV, even setting up his own mischievous propaganda to promote anti-war messages. A man before his time?

'How long will you be using the table?' my mother asked.

Instead of responding to a perfectly reasonable question my father looked at her, and rather exasperatingly replied:

'You know how important these banners are, I have to finish them.'

Why a simple answer to a simple question could not be given became an issue between them. Like many of Dad and Mum's activities, there seemed to be little constructive communication between them. No display of real love or joy. It deeply saddened me.

On a practical basis, Mum needed the table set for tea. Dad needed it to complete his posters.

David's painting of *My Parents* so truly depicts their situation of exclusion.

From where she was sitting in her chair, Mum couldn't see the message Dad was painting. Instead, she saw only black material, jars of water, pots of paint, and a heap of different sized brushes stuck into a large Ovaltine tin, the label removed.

Dad removed any advertising unless he was being paid. Even the Morrisons supermarket bags given free with groceries he turned inside out, because he felt he was advertising for free. He told us in no uncertain terms we should never come home with a Coca-Cola T-shirt unless we had a contract payable to us from Coca-Cola for promoting their product.

Dad's banners had to be finished for the Easter Monday march from Aldermaston to Trafalgar Square. His designs bore slogans such as 'CIVIL DEFENCE IS FUTILE EXPENSE' and 'BAN THE BOMB' or 'STRONTIUM 90 KILLS CHILDREN'.

Whatever the message, every banner was painted in bright fluorescent orange or yellow on a black cloth background, ensuring the message was clear and could easily be read from a distance. To create the fluorescent brightness, each letter was first painted

'Dad removed any advertising unless he was being paid. Even the Morrisons supermarket bags given free with groceries he turned inside out, because he felt he was advertising for free.'

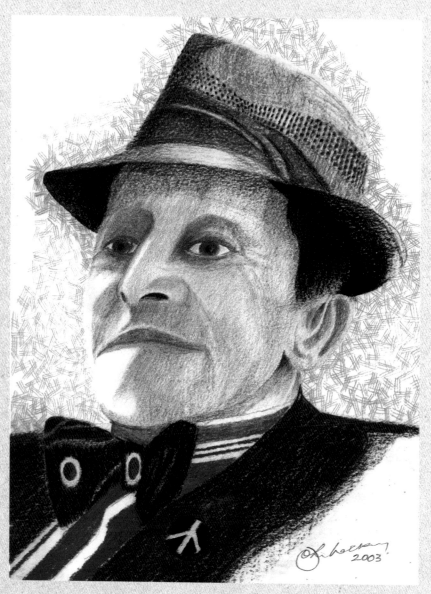

Col. Crayon Drawing of Kenneth by JH

in white, sometimes two coats onto the black material. Then the fluorescent colour was painted over the white, providing a solid impact of fluoro-coloured brightness. Dad had perfected his art of making banners. He never marched with one; others were delegated to do that. He carefully positioned holes so if a strong wind arose the banner wouldn't act like a sail. It was often difficult for two people to hold them for too long before being replaced by others. Once, on a march near Selby in Yorkshire, two members were nearly blown into the path of an oncoming car because the banner caught the wind. Still, they gladly continued performing their task in the name of peace. At every opportunity Dad walked in front, taking photos of his banners and the marchers.

The responsibility for making large banners for the Bradford branch of the Campaign for Nuclear Disarmament, was awarded him gladly, because he took such care and the fluorescent lettering stood out against the black background. Most other banners were black or red lettering on a white background and were lost in city street environments.

Dad had a problem when he was concentrating on the task at hand. If he didn't eat properly at a regular interval, he could well experience a diabetic coma. Mum wanted to make sure he ate something. Once involved in a project, he seemed oblivious of time, frequently missing proper meal times.

To pack up all the paints, brushes and black-banner material off the table and have to return later would break the momentum of Dad's planned activity and his deadline. It was often this non-communication that created a tense atmosphere. Dad won, this time, and tea became a sandwich watching the six o'clock news on TV. Inside each parent, resentment remained silent.

On Easter Sunday 1968 Mum and Dad caught the night milk train to London, with David meeting them as arranged at St

Pancras to drive them to his flat for breakfast and a rest. The journey from Bradford took about ten hours, stopping at virtually every station en route. After breakfast and a rest, David and Dad were to catch the train to Reading, but Dad was edgy, refusing to go with David and Mum in case they were delayed, making him late with his banners. Mum went to the flat with David and Dad joined the train to Reading. Unfortunately, the energy he had used finalising his banner masterpieces, and perhaps lack of proper rest on the overnight train, caught up with him. He awoke to find himself in South Wales. In typical Kenneth style, he blamed British Rail for his problem, arguing it wasn't his fault he fell asleep. Late that afternoon he arrived in Trafalgar Square. The march was over. He was vexed he had fallen asleep and full of remorse when he eventually found his fellow Bradford contingent, who were rather upset Dad and his banners had missed the event.

Kenneth Hockney always had a humanitarian project to complete. He fought long and hard for the Abolition of Hanging Act.

Tim Evans, a Welshman living in Notting Hill, London with his wife and daughter, was falsely convicted of their murder. During his trial, Evans accused John Christie of the murders. Three years later, Christie was found to be a serial killer and responsible for Evans's wife and daughter's deaths. An innocent man was hung. Later, Derek Bentley, an Englishman with a mental health problem, was hanged for murdering a policeman during a burglary attempt with his friend, sixteen-year-old Christopher Craig. English law at that time had a 'joint enterprise' clause. Though Bentley didn't carry the gun or pull the trigger, he was an accomplice by law, and was hanged.

It triggered a campaign to abolish hanging. Forty-five years later Bentley was pardoned.

In 1965 Sydney Silverman successfully piloted the Act through both houses, inviting my father to be present. Silverman recognised the support and many letters Dad had provided over the years. He felt Dad's writing to newspapers and authorities had helped sway opinion.

Dad's diabetes and his pursuance of writing and working became a conflict. Mum tried her best, but Dad's determination to finish what he was doing finally resulted in him collapsing face down in the street, badly injuring his face and losing his false teeth. He was taken to hospital. As soon as David received the call, he booked a flight on Concorde. From his bedside Dad asked David to look in the attic where some spare false teeth were kept. When David arrived, he took a photo of the shelf displaying numerous jars of teeth labelled, 'Best Teeth, Next Best Teeth, Poor Teeth'. He naturally took the best teeth to hospital. On 15 February 1978 Dad began to recover, but early the next morning he had a fatal heart attack.

I thought Dad would live forever. He was one of a kind who come along to contribute to change they believed in. Now he was gone. The shock confronted our family. The day of the funeral, snow prohibited a larger gathering of well-wishers, family and friends. David arranged to take my mother to the memorial service. Both were highly emotional, finding it very difficult to speak. The weather threatened deep snow and drifts making it difficult for would be mourners to attend.

Mum began to get ready, put on her brown felt hat and soft green overcoat, having difficulty fumbling with the buckle, obviously distressed. David looked at her across the room, he too was emotional. Very softly, David asked Mum to sit down a moment. Taking a pad, he drew a quick sketch of Mum using a sepia Pentel pen. Of the many portraits David made of Mum, this

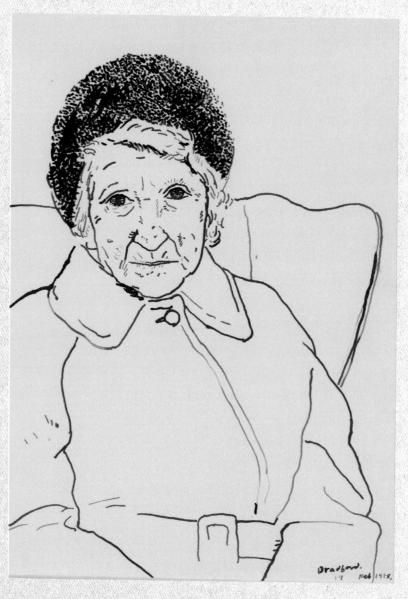

Mother, Bradford. 19th Feb 1978,
crayon on paper
30¼" x 22½" / 76.8 x 57.2cm

simple drawing captures her sadness, bewilderment, and anxiety for her future. He felt it too, I think that is why to me the picture is one of the best of my mother. Dad was cremated.

Back in Australia, I was having a trial separation. I was staying with a friend, so knew nothing of my father's death until six weeks later when I visited the house to listen to telephone messages. Paul had apparently tried to reach me quite frequently, without success. Hearing the news, I was devastated, sat down, and wept, feeling guilty, sad, and deeply distressed that I had missed saying goodbye.

Suddenly I felt a great calm. I looked up, and there standing in the room was Dad, dressed in his suit and usual bow tie with dots. He looked straight at me and said, 'Don't worry, John, it's OK', the finger of his right hand pointing upwards – a habit he had whenever stressing an important point.

Then, he was no more. His forgiveness greatly helped heal my grief.

Only later when I returned to Yorkshire was I able to sift through some of the letters sent to the family. Norman Stevens from Bradford, himself a successful artist and art college friend of David's wrote:

Dear Mrs Hockney

We were all very sad when we heard about Mr Hockney, and we among others have some fond memories of him.

I remember when I first met David at Bradford College of Art, how proud he was of his dad, telling us about the Christmas cards from various world statesmen and of Mr Hockney being invited to parliament by Sidney Silverman to see the no-hanging bill go through. It was certainly good for me to meet someone like him at my age, but then it was good for me to meet the Hockneys. I don't

think any of us would be where we are today without David's energy, enthusiasm and single mindedness at Bradford. On reflection we can see where some of those qualities stemmed from.

Eric Busby, who was a partner in Busbys Department Store in Bradford, and the Lane Art Gallery:

Dear Paul,

My heartfelt sympathy to you, dear friend. Now the head of the family, and especially to your mother. What a sad shock for you all in the midst of this bitter winter and when your father seemed to be in good health, well able to enjoy David's London exhibition.

Your father will be greatly missed as you so rightly say, "A deeply caring person." He was a good kind man, I greatly enjoyed conversing with him, one felt too that he had suffered for all those he wished to help, unmindful of his own need and living a truly Christian life of self-sacrifice. A Man with a message and the courage to care nothing for being considered eccentric by ignorant minorities.

He was rightly proud of his family but in a disarmingly modest way which also did him great credit. One can think of him now as one who has earned the saying "Well done, good and faithful servant."

Frank and June Lisle – Tutor at Regional College of Art Bradford:

Dear Mrs Hockney

We were very sorry to hear of the death of Mr Hockney. It is a great loss after so many years together. He was a remarkable and

lovely man, and everything was richer and livelier when he was there.

Colin Siddons, on behalf of the Bradford Communist Party:

Dear Mrs Hockney and family

We of the Bradford Communist Party were very sorry to hear of the death of Kenneth and realise what a sad blow it must be for you. What a great worker for peace and friendship between peoples Kenneth was. We recall particularly those wonderful posters he made for peace demonstrations in Bradford and elsewhere. The designs were artistic and the method of assembling the huge posters masterpieces of mechanical contrivance. Three years ago Kenneth opened the 'Morning Star Bazaar,' the short speech he made was a little jewel. Sectarian bans and attitudes were unknown to him, and he was delighted to work with us and we were delighted to work with him.

We shall miss him very much and realise that you will miss him a lot more.

F Marsden – Hon Treasurer Bradford Branch – Arthritis and Rheumatism Council:

Dear Mrs. Hockney

It seems hard to believe we shall no longer see Kenneth's dapper figure at our future functions and will be greatly missed. We send our deepest condolences.

There are many more, all in the same vein. He will be missed.

The last remaining Hockney was dear Auntie Audrey, Dad's sister, who I hoped would have shared some of the Hockney truths.

Alas, when I eventually travelled to England to see her, Alzheimer's was so advanced she didn't know me when I visited her in a nursing home in Bradford. I offered her a bunch of flowers as I kissed her and said:

'Hello Auntie Audrey.'

She answered saying, 'Thank you, but who are you?'

She was clutching a book under her arm. I asked, 'Are you enjoying your book?'

'I am', she replied, showing me the cover. 'Lust under the Elms', she said, with a wink of her eye.

'Is it good?' I asked.

'My word', she said, leaving through a doorway. I never saw her again; my last hope of the Hockney connection gone.

I asked the location of Dad's memorial plot. I was told it was in Rawdon Crematorium. What was most odd, no one at the cemetery office had his name or any record, yet I was assured his ashes lay there. I wasn't too upset; Dad had made his own connection with me. I will never forget that moment as long as I live.

Left in the attic at Hutton Terrace were all Dad's letters, newspapers, magazines and photographs, as well as knick-knacks and books. Fourteen years after his passing, I stood in an empty house in Bridlington, ready to sort through Dad's papers and letters. Some family members preferred to throw his papers into the tip, but David, Margaret and I felt there was some worth in creating an archive.

I had been hospitalised in Sydney with endocarditis for eight weeks. David asked if I would like to convalesce in Bridlington, making the archive. He would help financially. My wife, Helen, thought it a wonderful opportunity and was happy for me to be away for as long a time as was needed.

My sister Margaret and her partner, Ken, had moved to a

larger house, accommodating my mother in a self-contained flat. Margaret's previous house had not yet sold and was empty, perfect for my task. I had a comfortable attic bedroom, using the other three floors for photographs, letters and newspaper cuttings, paintings and rubbish.

From start to completion took six weeks, working eighteen hours a day. It was never a chore, but a joy. I often wept, wishing I had known and understood Dad more than I did. The archive revealed his compassion and care of anyone who needed help. A member of the Peace Pledge Union had once called when Dad was out. My mother was in the garden. The visitor asked if Dad was in.

'No,' came her reply, 'He's out doing good!'

He was!

I threw a great deal of rubbish into the tip, retaining the wonderful things he had done, but also some oddities of no value except as reminders of his eccentric nature. Some material featured his naivety and lack of world knowledge, but I feel this could be excused because of his love for his fellow man. All letters, catalogues, photographs and newspaper cuttings were cross-referenced to a main catalogue and stored in archival boxes in Margaret's new house.

I returned to Australia via Los Angeles with some selected material David and I made into books for each sibling. There is humour as well as sadness, but I will never forget this little man who taught us much, especially, 'Never worry what the neighbours think.'

In the front of each book I wrote:

Dare to be a Daniel, dare to stand alone!
Dare to have a purpose true! Dare to make it known.

And,

> *If a man does not keep pace with his companions, perhaps it*
> *is because he hears a different drummer. Let him step to the*
> *music he hears, however measured or far away.*
>
> <div align="right">Henry David Thoreau</div>

Mum tried to help Dad with his diabetes, making sure he ate and rested at the right time. It was a virtually impossible task. I can't say he was stubborn on this issue, more he concentrated on the work to hand, consequently forgetting to eat. His projects took precedence over anything else. It must have been frustrating for Mum waiting (as she does in David's portrait *My Parents*).

They enjoyed trips away to Morecambe or the Lake District with friends from Eastbrook Hall, and also met David in Paris, London or Bradford. Mum made quite a few trips to Los Angeles after Dad died. I met her a few times over the Christmas period, being treated like a star. Katherine Helmond, of *Who's The Boss* fame, and her husband, David, were great fans of Mum. Unfortunately, Dad had died just when David found his real success and recognition. He would have loved the opportunity to meet David's Hollywood friends and to visit Hollywood studios.

Mum must have begun reflecting on life and God. In a hand written note (I suggest it has been copied), I discovered between some condolence letters, she had written the following:

The eye cannot see, nor the ear hear, the things God hath prepared for those who love Him; for He reveals them to us by His Spirit.

One's aesthetic response to God we find in nature.

God in the sunrise; God in the sunset; offering two entirely different revelations of Himself, the eastern view at dawn inviting joy and work;

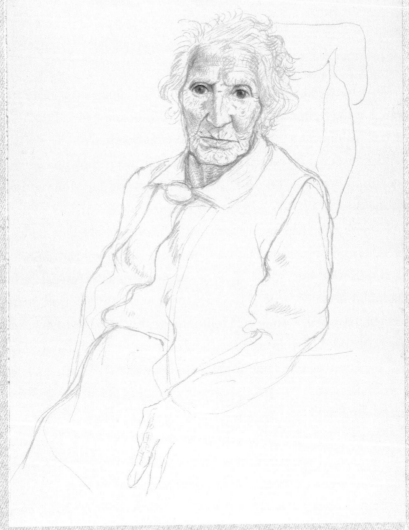

"Mum, 10 March 94" 1994
Crayon on paper
30¼" x 22½"
C David Hockney
Photo credit : Richard Schmidt
Collection: The David Hockney Foundation

the Western opposing view proposing a tranquil thought of rest. That is what sunsets are made for to give you mental repose.

Idea of God's appeal to the human eye!
In the silent majesty of big trees; in the august austerity of high mountains; in the confident onrush of rivers cascading toward the sea and never coming back, until – chastened and humbled – they return in quiet showers falling on still pastures and in snowflakes on the hills. That sort of thing.

God's self-disclosures to the human ear.
In music, of course; and in the eternity message of the surf; and in the cadences of a voice beloved.

These messages are in the nature of spiritual oxygen.
Without them we cannot live as spiritual beings. When people become anaemic spiritually, it may be for lack of oxygen. Perhaps there are no sunsets where they live. Perhaps they never see mountains or hear a waterfall. We get our spiritual oxygen through the eye, and the ear – and the other senses.

You can't live without it – but you must work for it.
You can't breathe it. It is not free. It is the soil in the plants, in the wheat, in the meat; but not free. Spiritual nitrogen, on which the soul feeds, must be captured. You must invest, you must be willing to wait with the patience of a farmer, you must not quit sowing because there was a drought. But if you strive, God will be reveal to you by his Spirit, some self- disclosures which he cannot give you in a sunset, or by a starlight, or music.

Many people who can breathe, are hungry.
How to acquire needful nitrogen. The investment of one's life in the

up-building of other people, the steady alignment of oneself with the forces that lead up and on; costly adventures sometimes; the more costly, the more rewarding.

If we are immortal at all – we are immortal now. If we are to survive, the future life will be a continuation of our life now. It will be different only in respect to its larger freedom, and the chief attribute of that freedom will be our escape from the dread of death and transition.

We all have ambitions, and many of them lack fulfilment. All our ends are uncertain but this. Whatever we may or may not come to, this is inevitable. It is the shadow that clouds our sky. Our friend has emerged from that shadow.

It is given to some men to achieve immortality in two worlds. They go hence– but they linger here. This is very fortunate for them. They have earned a right to live on – Here and Elsewhere.

We shall not weep for them they do not need our tears.

The discussion she wrote stirs up some of the issues I questioned, as a young man. We used to sing '*All things bright and beautiful*'

> *All things bright and beautiful,*
> *All creatures great and small,*
> *All things wise and wonderful,*
> *The Lord God made them all.*
> *Each little flower that opens,*
> *Each little bird that sings,*
> *He made their glowing colours,*
> *He made their little wings.*
> *The purple-headed mountain,*
> *The river running by,*
> *The sunset and the morning,*
> *That brightens up the sky.*
> *The cold wind in the winter,*

The pleasant summer sun,
The ripe fruits in the garden,
He made them every one.
The tall trees in the greenwood,
The meadows where we play,
The rushes by the water,
We gather every day.

The words raise more questions for me, especially as David Attenborough teaches how the natural world survives. My basic knowledge of physics and outer space discoveries trigger to comprehend far more than the 'God moves in mysterious ways' philosophy. The mystery of life itself is thrilling, and I constantly search for meaning.

Mum attended chapel as regularly as she could at Thackley and Eccleshill but saw the demise of her Methodist chapel in Stony Lane when due to a drastic drop in regular attendance it was eventually sold off as a doll factory. Only memories remained, and it became too far for Mum to walk the mile to Norman Lane Chapel, so she didn't go unless someone picked her up in a car.

When we attended chapel as children there was no TV. Cinemas had restricted openings on Sundays, but inevitably, with relaxed laws and in deference to the Sunday Observance Society, a different social system gradually eased, and Sunday openings absorbed into British life. Only a few chapels remained, with their stalwart groups of followers, but eventually more chapels closed as older members passed away and younger people enjoyed alternative interests on Sundays.

New inventions made domestic life easier, becoming part of everyday life. David bought Mum a microwave, but she got mixed up, calling it a video.

'Oh!' she said, 'I just put it in the video and it's hot in no time.'

It was as hard for Mum to adjust to the growing speed of communications as it is for me today no matter how hard I try. Even my guitar she called a banjo. Her nephews and nieces popped in, helping with small jobs under the watchful eye of Paul, her only son left in Bradford, or his wife, Jean. Much of her day-to-day living was organised by Paul. David, Philip and I were too far away to offer practical help. Mum had a hip replacement at ninety-three and walked remarkably well. Most of the time she read or played scrabble. She knew all the special two- and three-letter words and won most of the time. She was a poor loser, quite upset if she didn't win. Radio became her good companion, as she listened to her favourite programmes, *Mrs Dale's Diary* and *Woman's Hour*, as well as watching TV's *Coronation Street* – one of her top views. It was as if she lived in their street, talking about the characters as if she knew them from next door.

Every day she anticipated blue airmail letters from we who were overseas, feeding her all our news. She didn't get them but expected them.

Mum struggled living on her own, it wasn't easy. There is a loneliness, an emptiness that until we experience it we cannot totally appreciate that human sensitivity. The touch and closeness of intimacy. Mum had her faith, and I recall David using her as a model for a picture he made, "My Mother with A Parrot."

The etching he created was based on Flaubert's wonderfully descriptive story of Felicite in *A Simple Heart*. My mother is looking down wearing a dark-blue dress with mustard dots. The parrot is next to her detached from her shoulder but looking at her. In the story Felicite sees the parrot as the Holy Spirit. It is the only thing Felicite loved that came back to her. It is a blind love of faith and belief. The picture encouraged me to read Flaubert's story. I think

David saw my mother as 'A Simple Heart.'

On my mother's eighty-fifth birthday, David had an exhibition opening for *Vogue* Paris. My mother became guest of honour. She wrote in her diary:

We visited the gallery, and David was presented with a copy of Vogue in a leather case. Dozens of photographers and thousands of people were there. We later went for dinner where after a meal and near midnight a huge cake was wheeled in on a trolley iced with the front page of Vogue catalogue – all edible. To celebrate my 85ᵗʰ birthday, next morning I was measured for a suit at Coco Chanel, leaving for the suit to be sent on to David. It is a beautiful fit and of the finest of wool.

Mum wore the suit when accompanying David to Buckingham Palace to receive his Companion of Honour from the Queen. She could have had champagne but chose tea instead. Her visits meeting the famous kept her alive with something to look forward to. David rang her regularly. Her arthritic hands grew worse and she found it difficult to hold a cup or plate, and her writing became illegible. She had a helper to write as she dictated letters, but the words were never as intimate as when she wrote independently.

Every year, other friends died. Her own family of sisters had long gone, leaving her quite alone except for her children, who were spread across the world, so the telephone took over from written communication. Amazingly, my mother's hearing was clear and sharp, making conversations on the phone easy, and she heard our voices rather than read words.

Mum was disappointed David would not be attending her ninetieth birthday party. All her other children were there, her grandchildren and great grandchildren, including the Australian contingent. David remained part of the celebrations, designing special badges for the types of guests. We siblings had a badge, 'Happy Birthday Mum,' The grandchildren, 'Happy Birthday

Photo of badges for Mums 90

Grandma.' And other guests, 'Happy Birthday Laura' or 'Hi I'm 90 today.'

She was very much her bright cheerful self on the day, being fairly healthy for her age and her brain as sharp as ever, Mum could no longer live on her own, though she treasured her independence. In Margaret's new house, a self-contained flat on the ground floor had its own entrance and she could entertain guests if she wished. Moving to Bridlington would help relieve Paul and Jean, who had looked after her for so many years in Bradford.

In 1993, Mum sold the house she had lived in for over 50 years; the house with all its memories, good and bad. When she left Hutton Terrace, Mum had just one neighbour she knew. Doris initially travelled to Bridlington to see her, but time took its toll and she too passed away. I have wondered how I would feel if all my family and friends had gone. Can you trust again? Can we make new friends? It's a question that I do think about from time to time.

Mum enjoyed Margaret's house in Bridlington, especially since Yvonne, a helper, was hired to assist her daily needs, and to push her in a wheelchair enjoying the fresh bracing air of east coast Yorkshire. The promenade was just across the road from the house. David would drive from London to spend time with her, looking at the Yorkshire countryside and revisiting its beauty.

Though she was mentally bright, Mum's health began to require a nursing situation. In 1997 Mum took residence – much against her will – at a small nursing home called Rosegarth, a short walk from Margaret's house. She was not happy but accessed twenty-four-hour care as needed. Helen and I took her to Scarborough while on a visit, but she cried when we returned to the nursing home. There is a chilling sadness when the person who brought you into the world, fed and clothed you, gave you a life, is in tears because she doesn't want to be with people she does not know. It was hard for us too, we had to return to Australia – but it had to be.

Mum passed away on 11 May 1999 aged ninety-eight years and five months. She so much wanted to be 100 and receive a certificate from the Queen. She did meet the Queen personally on the occasions she visited the palace with David. Mum joined her husband, her sisters and parents. Her end of life promoted her to the Lord she always looked forward to being with. If there is a heaven, she will be considered a good and faithful servant. She was a true believer.

Her celebratory service was attended by many of her Junior Church members who made a two-hour journey from Bradford to the east coast. They recalled her kindness and her teaching that we should care for those around us. Now, ageing themselves, they continue to honour her memory and name never forgetting the way she encouraged members to take part in services and be upright in thoughts, words and deeds. It was obvious from her memorial service she was well loved, and her example and belief a standard for all to follow.

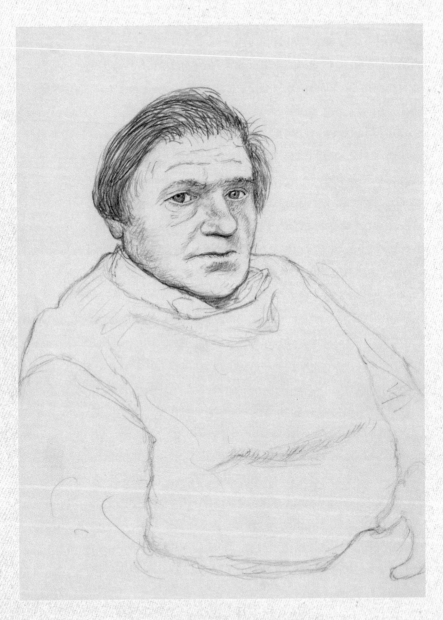

Paul Hockney, Bridlington 1st May 1999
Pencil on paper using Camera Lucida,
10' x 7'' / 25.4 x 17.8 cm

9

Paul Hockney

BORN: 25 MAY 1931 – DIED: 1 JULY 2018

Confident, funny, considerate, creative and helpful is the only way I can describe my eldest brother, Paul. Eight years older than I, his early family experiences differed from my own. He saw the family grow from himself to four other siblings and was artistic before David. He won the art prize at Bradford Grammar School; with David continuing the following years when Paul left. He was always creative in painting and drawing. He continued creating until he died, using an iPhone and iPad to create cards that sell in Salts Mill, Bradford. After his retirement from his accountancy practice, he took up the brush again, and cared for his wife Jean.

Paul must have been born with a funny bone. His arrival as first-born child to Kenneth and Laura Hockney on May 25th 1931 was on the cusp of the Great Depression years. Seemingly born with an inbuilt humour of good Yorkshire wit, his jokes and tricks were an everyday occurrence. I secretly pinched some of his mimes and jokes in my own teen years.

Beginning school at the tender age of three, he attended Hanson Babies' class. When he played with other children, he most often became a leader. According to Mum he would be 'boss of the sandpit' but in a nice way, he was never a bully. Early each afternoon they slept on canvas stretcher beds before being taken home.

When he attended primary school, he began to draw. His class were told a story which they interpreted in a drawing. His skills of comprehension and interpretation were recognised at an early age and though he was untrained, his pictures were meaningful and relevant to the story.

On his eleventh birthday, Paul sat the Grammar School entrance examination, not just passing but winning a scholarship to the Bradford Grammar School. An honour indeed! He was bright and eager to learn.

Mum recalled when he set off to school that first morning in 1942 with his brand-new uniform, leather satchel and gas mask. She shed a tear as he walked proudly down the hill to begin his formal education and his lifelong association with (and eventual board member of) Bradford Grammar School. Paul was a Yorkshireman through and through. He never left the county he loved to live elsewhere. He loved The Yorkshire Dales, or the scenic cliff walks of the Yorkshire Wolds; in rapture of the countryside around him.

He won the art prize and hoped he would eventually be employed in an artistic capacity. On leaving school, Paul collated a portfolio of his work, visiting various advertising houses in Leeds, but success

denied him. My father suggested he consider accountancy. On the opposite side of the scale from art, Paul accepted a Chartered Accountancy career and pursued it.

Through contacts of Aunt Audrey's, Paul was accepted by Williamson, Butterfield & Roberts, Chartered Accountants in Darley Street, Bradford. There were often times of disappointment when exams were failed, but his tenacity paid off. He continued his studies while engaged on National Service at RAF Wilmslow, eventually qualifying as a chartered accountant specialising in tax law. After lecturing at Leeds Polytechnic, Paul formed a partnership with a friend, David Yorke.

His qualification and specialisation in tax law was a boon to the young David Hockney, as Paul became aware of relevant laws pertaining to art deals. David, oblivious to precise accounting practices, had to be brought into line after he wrote cheques willy-nilly, neglecting to complete stub details. It became Paul's task to advise David about his financial future, and accurate accounting was important from the start. So began their long years of association. Paul's own artistic interests – to sketch his beloved Yorkshire – and his closeness to the art world in a small way compensated for his own early disappointment. It was Paul who encouraged Eric Busby, owner of the Lane Gallery in Bradford, to offer David a one-man show. In David's early days an exhibition of etchings in Bradford promoted his local stature as coming home. Fortunate were the purchasers of his early works – at that time sold for just a few pounds.

Paul's teenage years were spent at Eccleshill Methodist Chapel youth club, and badminton and tennis club. He starred in Norman and Norah Todd's excellent plays, as well as producing youth club Gang Shows like *Oodles of Noodles*. Dried noodles with a chicken flavour had just appeared in grocery shops, and the name for the

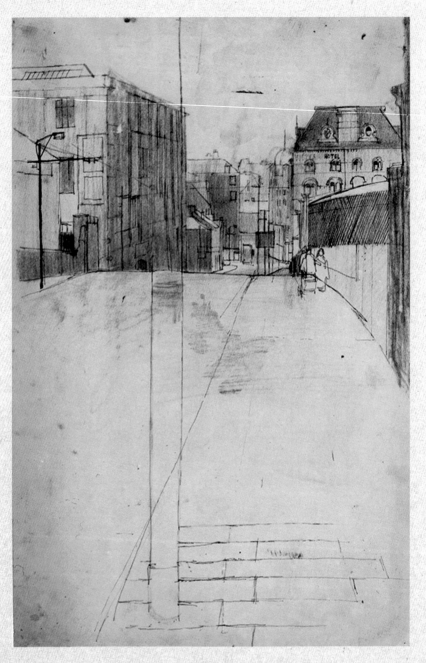

"Bridge Street, Bradford" 1956
Pencil and indian ink on paper
21⅝" × 13¾"
© David Hockney
Collection The David Hockney Foundation

show was created from that source. His love of Gilbert and Sullivan lured him to the join the local amateur society, using his good tenor voice. He never became a lead singer, happy to be part of the chorus and putting his heart and soul into any production.

Paul had another love, that of Yorkshire and its by-ways; he rambled, cycled and hiked. On a Saturday night at midnight, youth club members including myself, would congregate at Thackley Methodist Chapel walking over to Baildon Moor or Dick Hudson's and back for breakfast in the schoolroom and morning service before home to crash, tired but content. The landscape on a summer moonlit night, cool and bright, provided a special uniqueness to the usually familiar countryside. There were no interfering sounds except the laughter, chatter and footsteps of the group.

Being interactive with other youth clubs in the Woodhouse Grove circuit, Paul visited Thackley Methodist Youth Fellowship. A shy fifteen-year-old, Jean Fowler, was serving tea. From that moment, they courted for seven years, marrying on 5 September 1955 and moving into their love nest; a one-up-and-one-down cottage at 15 Westfield Lane, Idle. As their family grew, they moved twice, first to 161, a semi-detached cottage, followed by a detached bungalow at 222. Janine, Simon, Lisa and Nicky adored their parents. Life was fun and happy with Paul around. It was obvious his loving relationship with Jean was pure bliss. Paul is the only Hockney never to leave Yorkshire to live elsewhere. His home has always been in the county he loves.

Paul's Christian faith was important to him, the only sibling to follow Mum's belief and faith. He sought local preaching duties and believed he should help people live their day to day lives with the simple message Jesus taught of 'Love.' His sermons were well thought out, often related to ideas of practical everyday living. I have never forgotten an address he made to Junior Church. Using

petrol company logos to remind us of our Christian responsibilities, he used *BP* for 'better person'; *Total*, for 'total commitment'; *Shell* was Wesley's personal crest and *Regent* was Christ. Even today whenever I see BP I automatically think of '**B**etter **P**erson'.

Although physically small in stature, Paul had the ability to project his voice to his congregation – a skill that held him in good stead when he proudly shared his views at council. A little man with a big voice. Politically, Paul was always a Liberal. As an enthusiastic Bradfordian and chartered accountant, Paul challenged how the city's finances were distributed. Frequently writing to councillors and the local *Telegraph and Argus* with little or no satisfactory response, he chose to fight the next election. The first election produced a disappointing result for him, but at the next opportunity he swept to power as the Liberal candidate for the Bradford seat of Idle.

Once entrenched in City Hall with a solitary fellow Liberal, their minority was often dismissed. But when opportunities for negotiation were raised, when majority Conservative or Labour parties needed an additional vote to pass a bill, Paul was wooed and cajoled to swing one way or another. He stayed close to the decision-making process, allowing him a casting vote, yet as a virtual independent he was determined to fight in the interests of citizens and a fair budget. The Liberals were a minority party but held persuasive power. Paul used it to advantage for his constituents.

Mayoral appointments were made according to the number of councillors in each party. Hesitantly, the Liberal party were offered their turn for mayoral duties in 1977. Both major parties had completely overlooked this important year, the 'Queen's Silver Jubilee.' It was too late to change the agreement and as his fellow Liberal had resigned, Paul became the lone Liberal candidate for Lord Mayor.

Paul and Jean as Lord and Lady Mayoress

Lord mayors Inauguration in coach

Councillor Paul Hockney was the breath of fresh air the citizens of Bradford needed. The city was struggling to revitalise itself. Paul was clever, witty and rather eccentric in comparison with previous mayors. He revelled in the pomp, donning the mayoral robes and chain as he and his wife, Lady Mayoress Jean Hockney, officially carried out their duties. There was an energy that returned to the once-thriving entrepreneurial city. The Bradford's Bouncing Back campaign was sold in California and anywhere Paul could coax people to visit the city.

I was fortunate to be in England for Paul's inauguration. He was going to have fun during his one-year term of office. So was Bradford! The mayor's chauffeur had served mayors for thirty years, deciding to retire after Paul's term ended because he had never had so much fun, and knew it wouldn't happen again. Shy Jean performed her own duties with grace and distinction.

Wearing full mayoral robes, chain, hat and regalia – Paul was a loyal Royalist – the Lord Mayor and Lady Mayoress traversed the city centre in a horse-drawn open carriage, a very regal affair but without the usual sophistication. Paul cocked his leg over the open door displaying his Union Jack socks and pointing to them. The crowds loved his naturalness and mad display as he was caught up in the moment. Faces in the crowd beamed and laughed as Paul took advantage of the moment, introducing what was to be an enthusiastic year of office.

Paul's Union Jack socks became a feature of his chosen mayoral charity benefit. Citizens madly knitted thousands of pairs all laughing and smiling at the antics of Bradford's unique Lord Mayor. Paul loved it. So did most Bradfordians. He flew in a helicopter with Princess Anne as she visited the city, pointing to a pub called 'The Queens', referring it to Her Majesty. Bradford, often referred to as the gloomy city, became bright with fun and laughter, helping the mayor's chosen charity that was to provide for disadvantaged kids to enjoy a holiday, often for the first time.

Each Lord Mayor selected a charity of their choice to support during their year of office. Paul's continued well beyond Jubilee Year. In fact, it still exists. The charity had to be community spirited and worthy of Her Majesty Queen Elizabeth's honour. So it was that the concept of Nell Bank was born, and now is a thriving reality.

Until funds procured for the charity had been confirmed, Paul's idea for a holiday camp for city children was deferred. Original unwanted RAAF huts suitable for basic accommodation needs were bought cheaply and transported to land at Ilkley. Three other Bradford Lord Mayors following Paul supported the Nell Bank charity project. On my visit in 2013 I asked Paul if I could see the Nell Bank site to discover how the area had developed from his

Paul and Jean having tea with Prime Minister Margaret Thatcher

Paul and Jean meeting the Queen

'It was Councillor Paul Hockney who began this wonderful legacy for Bradford, and all the future kids who will experience what Nell Bank has to offer. If Paul hadn't originated the idea, it wouldn't have happened.'

initial idea. He seemed a bit embarrassed and I couldn't find out why, but I coaxed him.

It was cold and blustery when we I arrived at Nell Bank one spring morning in 2013. From Paul's house the drive is less than five minutes to the Nell Bank site on the far side of the River Wharfe from Ben Rhydding. We turned into the driveway, spotting rabbits scampering away from the car. There were kids wrapped up in overcoats and hats being addressed by their leader as we followed the road to the main block. Bruce Fowler, then co-ordinator and original staff member, was waiting to greet us. We were invited into an open-top electric buggy. It was cold and breezy with a hint of light moisture touching our faces. We followed the tracks specially created for wheelchairs and 'height hands on' participation. The logistics have been well thought out – easy to reach from a wheelchair to uncover a lump of wood and see earwigs scampering for the dark. Tracks have been designed for all visitors, whether incapacitated or not.

Bruce was obviously passionate about Nell Bank, sharing his enthusiasm for a new additional self-contained cabin for the disabled, with beds, baths and showers as well as recreational facilities. No one is turned away or left out. Activities include sleepovers, engaging city kids on experiences they never dreamed of. There are no phones, iPads or computers allowed when they visit. The hundreds of letters received back from kids confirm their thrill at spending time in a natural environment. The concept has now widened and includes activities for older people as well as children and young people. From the moment visitors arrive to the time they leave, their whole experience is of discovery, utilising all their senses. There are trails for rabbits, badgers and hedgehogs; woodpiles undisturbed until willing hands move logs to reveal centipedes and earthly creatures that scamper off into the dark.

'The biggest reward,' said Bruce, 'Is watching the kids' faces. No matter if it is cold or raining, they are dressed appropriately for the occasion and they love being here.'

Bruce proudly told me, 'Two hundred and fifty thousand kids have experienced Nell Bank since it first came into being.' He added, 'It was Councillor Paul Hockney who began this wonderful legacy for Bradford, and all the future kids who will experience what Nell Bank has to offer. If Paul hadn't originated the idea, it wouldn't have happened.'

Paul continued as a councillor, representing Idle ward for thirteen years, before his own business commitments and family called.

His legacy remains not only as a tribute to Her Majesty the Queen, but to Paul too. In addition, Paul's life, supporting David Hockney as an artist and brother, allowed David freedom from financial obligation to pursue his artistic fervour.

On 1 July 2018, Paul Hockney died. His passing was not a sad affair. What I have written here is a fraction of a man who lived his belief as a Christian. His whole life was about giving to his fellow humans. He brought joy, love and laughter to a often dreary world. He dearly loved his wife, children and grandchildren and filled his life with light, helping others less fortunate than himself. The legacy he left at Nell Bank will live on and he will be remembered because he 'never ever worried what the neighbours thought.'

Philip Hockney - Australia 7th October 1999
Pencil on paper using Camera Lucida
11¾" x 7⅞" / 29.8 x 20 cm

10

Philip Kenneth Hockney

BORN 8 AUGUST 1933

Philip is the only sibling with two Christian names, sneaked in by my father moments before the minister baptised him. He passed a name to the minister noting, 'Philip Kenneth Hockney.' When Mum heard the minister say, 'I baptise thee Philip Kenneth Hockney,' she was upset. Dad wanted one son to bear his name. But the deed was done. Philip Kenneth Hockney was baptised. His position as second son provided instant companionship with Paul, his older brother, which continued throughout their long lives.

Philip was attracted to bodybuilding, development of muscles and physique. A cartoon advert for Charles Atlas regularly appearing in a bodybuilding magazine depicted a thin man on a beach in his shorts with a well-built, muscular man adjacent to him. The hint was that girls would fall for the 'he-man,' leaving the ten-stone weakling alone and unattractive. Charles Atlas offered a bodybuilding course. Philip used dumbbells and weights to transform himself into a 'Charles Atlas He-Man'.

When Philip left school, he considered engineering, taking a job at Hepworth and Grandage. Dad researched at the library the various opportunities for engineering. He suggested to Philip, 'If you want to be an engineer, be someone who tells others how to make things. Don't make them yourself.'

Following Dad's advice, Philip began applying for junior draughtsman's jobs, successfully winning a position offered by Yorkshire Engineering and Welding Company (YEWCO) in Idle, Bradford. The company became famous for dustbin lids that did not blow off, but their core business was manufacturing steel and aluminium road tanker products. Attending Bradford Technical College, Philip qualified with a Higher National Certificate in Mechanical Engineering. It took ten years to become a fully qualified draughtsman, and as Dad prophesied, Philip was now telling people how to make things.

When National Service call-up was served, Philip joined the army, drafted to the Royal Engineers Regiment. He revelled in the discipline, enthused by the six-week heavy drill initiation. As it was National Service, he was paid two pounds a week. On completing his training, Anthony Eden, Prime Minister of Britain, retaliated against Colonel Nasser of Egypt for closing the Suez Canal. Philip's battalion was posted to Suez but left for Cyprus before the bombing of Egypt began. Britain was negotiating Greek independence and

Archbishop Makarios was seeking independence for Cyprus too. Philip was posted to Limassol, and promoted to Lance Corporal, where he remained for the rest of his tenure.

The heat in Cyprus was intense, especially in the afternoon, so the sensible British ensured all physical work was conducted in the early morning up to lunchtime, leaving army sappers free to sunbake on the beach in the afternoon. Consequently, Philip built up a tan and appearance to rival film star Rossano Brazzi.

Mum received a phone message Philip was on his way home to be demobbed. No more would she have to rely on the blue airmail letters. He would be safely at home. She became quite emotional when the phone rang at three in the morning. It was Philip. He had overslept on the train, missing Leeds and was now in Skipton – next stop Carlisle. We didn't own a car, but Trevor Hall, Paul's friend, had one. A half-hour later, Paul and I sat in Trevor's car, speeding off to Skipton station.

I was excited to greet my brother at 4 a.m. The station was dimly lit. Looking around I could see only a foreign-looking man with fair hair, wearing a white jacket, and brown trousers. I did not recognise him as Philip my brother. Only when he called 'John!' did I realise who it must be. The Mediterranean sun had bronzed his skin and faded his hair. We drove home between a barrage of questions. He was tired and ready for proper sleep.

We followed Philip into the house. It was still dark, with Mum dressed and cooking at the stove. When she saw her son safe and home she burst into tears, hugging him close. What a homecoming – her beautiful son had returned, safe and sound. God be praised!

Philip wanted to see Bradford, his hometown, and I was more than happy to accompany this stranger, this Mediterranean gentleman, into Bradford city on the bus. Still wearing his white demob jacket, he had lost his Bradford appearance. When the bus

driver asked for fares, Philip asked in a broken voice, 'How much...
Bradford?'

The conductor held up four fingers, 'Fourpence,' he said.

Philip took coinage from his pocket and offered four half-crowns.

'No!' The conductor insisted, 'Four pence', rummaging round
in Philip's proffered hand of coinage to select the four pence. A
typical Philip joke.

With final demobilisation complete, Philip returned to
YEWCO. It took a little time to settle back into civvy street, but
he was soon back on the dance floor. He purchased a second-hand
Austin Ruby car with a seven horsepower 750cc engine and a crash
manual gearbox, for the princely sum of forty pounds. Whenever
four of us drove in the Yorkshire Dales, three of us had to get out
at a one-in-three hill and push. Uphill!

Back at study, Philip and his friend Jack Nicol were leaving
technical college with a fellow part-time student. Opposite, David
was seen walking down the art school steps. The student said:

'See the chap over there, he's a real twit.'

Philip asked him, 'Oh! You know him then?'

'Oh! No, I just know he's a twit,' the lad responded. 'Why? Do
you know him?' he asked.

'Yes,' said Philip, 'He's my brother.'

The lad ran off while Philip and Jack laughed.

I admired Philip. He was confident, handsome and knowledgeable.
I was happy to polish his shoes, press his suit with sharp trouser
creases and rolled lapels on his jacket, tucking a triangular handker-
chief in his top pocket. He looked smart when he went to a dance,
hair shining with Brylcreem and swept back. I thought he looked
like a film star. So, did many of the girls.

I like to think the smart suit and skilled dancing paid off when

Philip met Mary Ford, an Idle lass living on Idle Green. A village phenomenon, Idle boasts a club called The Idle Working Men's Club. People from overseas join just to hold a membership card they see as funny.

A few months later Mary and Philip became engaged, purchasing a tiny one-up-one-down stone cottage on Dibb Fold for the princely sum of ninety-five pounds. Mary was eighteen and came from an even larger family of brothers and sisters. The one-up-one-down cottage was very basic. The room downstairs had a floor of pavement flags and a sink in the corner, no bathroom and the toilet a few yards' walk outside round the back. Over the next year Philip and Mary spent every weekend renovating their small cottage, fitting it out with a proper kitchen and tiny lounge. Repainting throughout and carpeting for warmth, Mum made curtains, and they created a snug charming little house that was theirs. David was best man and I was a groomsman at their wedding.

For the birth of their first daughter, Beverley Susan, they needed to move to larger accommodation, purchasing a semi-detached house in Grasmere Road, Eccleshill, with distant views to the Airedale valley and the moors.

My sister Margaret, living in Australia, wrote to Philip telling him how much she was enjoying her life there. She had emigrated with her friend Pauline, working at a Bush Nursing Hospital in Bright, Victoria.

With Philip now being a fully qualified draughtsman, they considered the favourable opportunities for a growing family and emigrated to Australia, arriving after a six-week voyage on the Fairsky. With a few pounds of savings and no jobs they stayed in a migrant hostel. These were old army Nissan huts, partitioned with a single plywood sheet between one family unit and another, sweltering hot in summer and bitterly cold in winter.

Hostels were basic accommodation but allowed families to save. Cafeterias served simple, plain food, but as many immigrants were in the same situation, lifelong friendships were established in the hostels.

Philip looked up 'Road tanker manufacturers' in the local directory, unbelievably finding one close to the hostel at Auburn, Sydney. Walking in off the street, he was offered a job 'with no rise' for a year. Six months later he was called to the office. Concerned and apprehensive, Philip felt cautious about his future. The managing director smiled and sat him down to tell him how well he had fitted in, and that his work ethic deserved an extra three pounds a week. It was a pat on the back for the 'Ten Pound Pom'.

Philip enjoyed Australia's casual management style compared with England's. Everyone from the managing director down was on first name terms. It was friendly and pleasant, and they welcomed and rewarded new ideas. Aussies loved to get together at weekends. Mary and Philip were pleasantly surprised to be invited as a family to weekend luncheons at the director's house. It would never have happened in England.

The team of Philip and Mary would have taken any job to save for their own home. Deposits on houses at the time were 25% of purchase price. Though prices were much lower than present the deposit required was A$1400. Philip worked three jobs, with his goal being to move from the hostel as soon as practically possible. He held his main job as a draughtsman, a second job making fibreglass ski lift covers, and a home-based job assembling door hinges and locks for bush fire engines .

After a couple of years, Highgate Engineers had a take-over bid by Kaiser Corporation's subsidiary Comalco Aluminium, which produced plate aluminium, extrusions and aluminium cans. They sought an outlet for road tank manufacture. Highgate moved

from its cramped space in Highgate Street, Auburn, to a large new factory complex at Fairfield, with money allocated for investing in new equipment. The management team moved as 'goodwill,' with Philip appointed Chief Sales Engineer. Two years later, Philip began to realise the market potential and saw an opportunity to start his own business. He had established a good relationship with oil company engineers and was well liked. He had his own vision and concepts and wasn't frightened to share.

Meanwhile, their family expanded with two more daughters, Michelle and Melanie. They were born in Epping, as the family had moved out of the hostel, purchasing a house at 110 Ray Road, Epping, an outer northern suburb of Sydney.

It was here my wife Alwyn and I stayed when we first arrived in Australia in July 1965. It was good to see Philip and Mary and their kids. Beverley especially loved seeing us from England and having a real auntie and uncle around. The sadness of emigrating is when families leave parents, grandmothers, granddads, aunties and uncles miles away. Those meaningful relationships that I experienced can be lost forever.

Philip left Highgate Engineers to form a partnership HEWCO – Hockney Engineering and Welding Company. Comalco forbade Philip to manufacture tankers for two years. Naïve to Australian business practices at that time, Philip conceded. It was a blow, but it also became favourable to Philip's business at that time. When his clients at the petrol companies heard he was under contract **not** to build tankers for two years, they felt he had been badly done by corporate bullying. The companies organised all cost-plus work and leaks to Philip's business. It helped him survive. After two years the business partnership was dissolved, and Philip registered Hockney Engineering Pty Ltd, moving to rented premises in Smithfield.

There is no doubt that without Mary's partnership and devotion to keeping the home and looking after the kids, the business would never have prospered so quickly.

Philip left early in the morning and returned late at night. His day began overlooking production. In the afternoon design drawings were made, with marketing in the evening at Auburn Businessmen's Club where suppliers and customers met after work. He was networking and it paid off, as he gained deals with suppliers and won price deals with clients.

I recall the evening he rang me to tell me he now owned nothing! The bank held everything he possessed, and he owed them a million dollars! It wasn't long before he borrowed more. There were less than six road tanker manufacturers in Australia, but competition was keen. Philip realised he needed to buy land to expand and create a purpose-built factory where he could modernise manufacturing methods, improve cost-effectiveness for his operation, and therefore offer keener prices, and gain bigger profits.

The bank loved Philip. He was doing well, and they happily lent on the basis of his existing business practice and belief in his future plans. He purchased land at Smithfield and built his factory to include a swimming pool so his production staff could cool off at lunchtime or in the evening during the long, hot summer days. Philip was shrewd, remembering his own welding experience working inside the barrel of a tanker in hot, humid conditions. He reasoned if the men were refreshed, they would work better.

Whenever road tankers pass through suburbia or crowded cities there is an element of risk as they carry highly explosive liquids. If an accident does occur or a vehicle overturns, it could have disastrous consequences. Philip thought long and hard over many years how to make a road tanker that was safer.

With his team of draughtsmen and engineers he built a proto-type, naming it Thomas. Thomas, in Philip's interpretation, meant **T**anker **H**aving **O**ptimum **M**ass **A**nd **S**tability. In essence, the centre of gravity was lowered, allowing the height-to-width ratio to stabilise. Tested on a racetrack in Melbourne with industry clients attending, Thomas became an instant success. It was supported by tanker drivers, who felt pulling a Thomas tanker was as easy as pulling a small trailer. Philip was allowed to use the name Thomas by Thomas the Tank Engine's originator, as it had no association with the children's stories. Thomas was manufactured in Australia and exported to Mexico, Britain, Europe, and Indonesia.

I felt extremely proud of Philip and Mary's achievement. They deserved recognition. Philip was awarded an Order of Australia for his contribution to the road transport industry in Australia. His medal presented at a ceremony at Government House overlooking Sydney Harbour. Philip, a Ten Pound Pom, had made it! Mary as well.

A few years later Philip sold his business, moving to Harden some four hundred kilometres west of Sydney. He built a house next to a farm where his daughter Melanie and husband John lived

Photo of Tomas Tanker

Photo of 'Linden Hills house'- Harden NSW

and worked. My mother's saying, 'If you've nothing to do I'll soon find you something' might have been on Philip's mind. What was he going to do next?

He investigated the deer market, which offered the opportunity to sell venison and antlers for the Korean market, a highly sought delicacy. Installing high fencing around his paddocks to restrain frivolous deer, he built up a large herd. Mass mechanical production can be controlled and problems solved, but Philip realised farming was different from manufacturing. In farming there are skills needed to understand weather, fodder and water, but much is in God's hands. Weather played a significant part in having to nurture the herd which made the business unprofitable. The deer had to go.

One morning I received a call from Philip at my office at DH Gibson Shopfitting. He told me he had just purchased a general store in Harden he was going to convert into a supermarket. I was

Special Products Manager of a large family shopfitting business. I foolishly mentioned to Philip:

'There's a science to supermarket product placement, it's not just a matter of putting stuff on shelves.'

He already knew that, having signed up with a buying group who advised storeowners about planning and stock, as well as purchasing formulas.

Philip asked if I would assist his photographer daughter Michelle to create a Christmas grotto in his shop. It wasn't quite Busby's in Bradford, but no one had ever seen anything like it before in outback New South Wales. Gnomes and fairies, toadstools and tunnels helped create a magical atmosphere. Hundreds of people from Harden and the surrounding areas brought their kids to see Santa and bought something, because it was different! Grottos were normally only seen in big city stores.

Photo of grotto

Photo of Philip and Mary

Philip and Mary settled in to country life, enjoying the open spaces and fresh country air. He was now a noted citizen of Harden Shire, enrolling as a councillor in the local elections. Between his supermarket management and council work, Philip was delighted to provide something useful to the town, a lasting memorial of practical help to serve future citizens – a community health facility. There was at that time just one doctor in Harden. For any specialist services people had to drive twenty-five kilometres to Young, or seventy to Canberra. Philip, as mayor, proposed the council use funds left by a previous resident to build a medical centre housing doctors and appropriate specialists. He negotiated with Wollongong University's medical faculty, agreeing to help send trainees and specialists. My wife Helen and myself were invited to the opening, a tribute to the initiative of Philip and the Town Council of Harden.

A few years later Philip sold his supermarket to concentrate on a new major project he began in 2012 – to design and build the world's most progressive commercially built motorhome. At the time of writing he is finalising the working prototype.

Philip is known as Pop to his many grandchildren and great-grandchildren. Industrious, adventurous, inventive, his life leaves a legacy of achievements. He's done OK has our kid!

He never worried what the neighbours thought.

Margaret Hockney - Camera Lucida
Bridlington 1st May 1999, pencil on paper
Using a camera Lucida 10" x 7" / 25.4 x 17.8

11

Margaret Hockney

B: 18 JUNE1935

My mother was jubilant.

She knelt down and thanked God from the bottom of her heart when Margaret Hockney became her firstborn daughter on 18 June 1935 at St Luke's Hospital in Bradford.

Mother so wanted a girl to dress in pretty dresses and another female in the family.

Only when two younger brothers were born did Margaret find herself the only girl in the middle. Four brothers made a difference. Paul and Philip as the eldest were buddies, as were David and I, the youngest, leaving Margaret, a dear sister, much on her own.

Not that she didn't enjoy her brothers – she thought Paul and Philip the funniest, cleverest brothers ever. She loved listening to them and being in their company, not speaking – just 'being there'. David and I spent some time with her, going on walks and playing board games.

Perhaps it was hard for her to be noticed with four boys having their own personalities. She became a shy, quiet girl with her own single bedroom across the hall from my parents. Before she became deaf in later years, Margaret heard Mum and Dad's daily arguments about money. Her room just across the landing was the worst room, with no opportunity to escape. Their arguments troubled her as they did me. Margaret had a clever brain – especially working out puzzles and reading. Encouraged to use our local library, she read all of the *Secret Seven* books by Enid Blyton and had the magazine *Sunny Stories* delivered each week. She played the card game Patience in her room, alone, easily memorising card positions using her brain.

Mum considered Margaret as her 'help' – she was a girl after all, and that's what girls did, work in the home. There were other opportunities to work and achieve something worthwhile. Perhaps it was how Margaret could show off. She joined the Chapel Brownie pack, which offered opportunities to challenge herself. Margaret loved filling her arms with Proficiency badges. Every badge sewn on the sleeve of her uniform was a visual display of her achievement that no one could deny. She was pleased with herself and deserved to be.

There were times Margaret accompanied David and me on our weekly escapades to the theatre or cinema – that is, if Mum hadn't

Photo of Margaret in Mrs Todd's play

found some extra chore for her. She laughed as loud as any of us but was equally subject to Mum's wrath when we returned home.

Margaret hated being in the limelight. Any spotlight on her was soon shed if she could possibly avoid it, whilst we boys vied for lead parts or support acts in plays written by Norman and Norah Todd, the afternoon Sunday School superintendents. They wrote wonderful plays performed each year near Christmas. Margaret never wanted to be noticed; content to be a fairy or an elf in a chorus part as long it was never in the frontal position. It is odd, then, that her school behaviour replicates Jekyll and Hyde. When Margaret began her grammar school education at Belle Vue Girls' School, she of all people led a gang of girls. She was the leader! Her members followed Margaret into all sorts of schoolgirl mischief, with frequent detention punishment because of misbehaviour. It didn't sound like shy little Margaret at all. Normally quiet and

demure, at school she was now in charge. One term report was so bad she pushed it down a drain on her way home from school.

She kept to herself at home but enjoyed the frivolity and laughter of her brothers. There was never a competition, but for whatever reason at home Margaret remained her quiet shy self. No one thought she would say boo to a goose. It seems her behaviour at school clearly demonstrated she had potential to be a leader, given the opportunity. Years later she became a brownie pack leader.

Though she disliked school, she pulled herself together during her final year to pass the General Certificate of Education in English Language, English Literature and Mathematics.

For my eleventh birthday, Margaret took me for a portrait to Jerome's photo studio in Bradford. There were few photos of me as a child as film was scarce and expensive during war years. It was special to have my own photo portrait, though I am glad it wasn't in colour. My new suit was tweed, a bright ginger colour with short trousers. I didn't particularly like wearing it, but Margaret suggested it was unique and distinctive with the green tie. It was new at Whitsuntide, but I hadn't worn it much. Margaret suggested going to Grandma's after the photo was taken, where she thought I would be given a shilling in my top pocket. We went and I got a shilling.

One of Margaret's 'girlie' chores was to iron her brothers' shirts. She was ironing a collar when Mum, who had been watching her intensely, suddenly said, 'Never get married, Margaret.' There was no follow-up conversation, no reasoning, just a cold statement. Odd that the statement was never shared with us boys.

A situation Margaret and I found hard to understand happened on Sundays. The love and forgiveness preached by Mum to all the dear little children at Junior Church changed when she came home. Mum's earlier Christian message seemingly forgotten, she verbally chastised my father. We were aware of our parents'

financial predicaments and frequently reminded of their situation. All Mum's friends and relatives spoke very highly of her and were concerned about our 'poor mother'. We children were expected to listen, learn and believe, often reminded of proverbs and quotes:

The devil makes work for idle hands.
Put some elbow grease in it.

And the verse that really mixed up Margaret's feelings:

J-O-Y, jay oh why
That surely means Jesus first,
Yourself last, others in between.

How can an individual achieve anything of value if everyone else is first ?

During school holidays when Margaret and I rambled the countryside, we walked on the canal bank to Kirkstall Abbey House Museum. Never stopping our chatter, we watched butterflies, picked daisies and bluebells, and enviously admired barges slowly chug past as children played aboard their moving house. How we coveted their lot.

Our delight in rambling was gladdened exploring the ruins of the abbey. We imagined monks walking about, praying and chanting, cooking in their kitchen and, if we tried hard enough, saw ghostlike shadows. Our imagination brought our historical experience to life.

Leaving school, Margaret had no idea which vocational direction she wanted to take. Auntie Audrey temporarily organised a position for her with the Yorkshire Electricity Board. She became a machine operator, at least until she knew what career she found interesting. It was a monotonous, repetitive job, easy to learn the skill and once

learned, boring! During coffee break one morning. she heard one of the girls was leaving to become a nurse. Her co-workers were encouraging the girl to stay, reminding her she would have to work weekends and shift work, have no time for boyfriends or to attend dances. She would have to empty bedpans and sputum mugs – every obstacle they could think of they shared, enticing her to stay. Listening to all the negatives, Margaret realised them as wonderful possibilities. The girl did leave.

Arriving home, Margaret announced to Mum she wanted to become a nurse. 'Glory be to God,' my mother shouted, believing Margaret's decision to be from God himself. The very next day Mum rang Miss Copeland, the matron at St Luke's Hospital in Bradford. At seventeen, Margaret was too young to begin trainee nursing. The minimum age was eighteen. However, the matron found Margaret a place as a ward orderly, allowing her the opportunity to familiarise herself with hospital practice before she registered. Margaret made use of her time, getting to know people, and the location of specific buildings and wards. She willingly accepted any task given, including emptying and cleaning sputum mugs and bedpans.

On 18 June 1953 Margaret moved into the nurses' home adjoining St Luke's Hospital. She was free to enjoy her spare time as she wished, but study was expected out of nursing hours. It was a new-found freedom for Margaret with no forced chapel on Sundays.

Regardless of her difficult relationship with Mum, Margaret empathised with the financial difficulties at home, deciding to continue to pay Mum board money. She felt that as she received full board at St Luke's, she could manage to help at home, though she had left very little for her own entertainment. It was a kind gesture.

Margaret met Pauline Ling, another student nurse, becoming her lifelong friend. It was through Pauline that Margaret saw a purpose for her life. She set her mind to focus on all the things she

lackadaisically had put aside. Margaret dared herself to study hard, purely because she knew she could, passing her final exams. Friends are wonderful beings, and Pauline's determination to challenge Margaret extended study for another two years, concentrating on midwifery. Margaret's ability to absorb knowledge seemed extraordinary, and she passed every exam with flying colours and the ultimate prize: The Midwifery Cup.

Once qualified, Margaret returned home still nursing at St Luke's until she decided where she would work. Mum and Margaret's relationship was still not close, with Mum constantly challenging her about her work and associating it with God. It was too much for Margaret. She and Pauline scanned the *Nursing Mirror* magazine for district nurse training positions, available in Devon. They moved south, learning to ride motorbikes and eventually drive a car, necessary for accessing scheduled appointments.

They loved their years in Devon but were getting itchy feet. They applied for positions at the Victorian Bush Nursing Hospital in

Margaret receiving the Midwifery Cup

Australia, and were accepted for Cobden, a Bush Nursing Hospital a hundred miles west of Geelong. They flew from Heathrow to Melbourne, a journey I recall myself from when I travelled in 1965. The 36-hour flight on a Boeing 707 from London touched down in Frankfurt, Tehran, Delhi, Rangoon, Singapore, Jakarta, Darwin and Sydney as if it were a milk run. The flight became an exhausting journey, with meals served between flights, and refuelling at every stop. Body clocks were thrown totally out of whack, but they were allowed a forty-eight-hour rest period in Melbourne before starting work at Cobden.

Next, they started as relief staff in Bright, a beautiful village set in the heart of the Victorian Alps. There was an easy manner working in Australia, and the hierarchy was not as rigid as the National Health Service in the UK. From the countryside, they moved to the beach at Chelsea with its long, sandy beaches, often taking long walks.

Margaret was highly intelligent and good at her job, but there was a gnawing problem in the back of her mind. Mum continually asked what she was doing, whether she was attending church, did she pray? And she wrote that she thanked God Margaret was helping the sick and needy through Him.

I can understand Margaret's inner feelings at that time. She knew perfectly well her work was nothing to do with God or Jesus. Margaret also knew the world wasn't a perfect place. The emotional torment became too much to bear. The religious overtones of Mum's ending of letters with blessings and religious comments created a confrontational mental conflict. Margaret had a breakdown.

It took some months for her to recover, but Pauline stood by her through this difficult time, a wonderful friend. Eventually Margaret began work again at Chelsea. Regaining her strength, she followed Pauline to New Zealand, adoring the Mäori and their traditions

and happy personalities. She was invited to a Mäori hangi feast and presented with an authentic Mäori skirt as a sign of their friendship with her.

In 1964 Margaret sailed on the *Himalaya* to Tilbury in the UK. Pauline, who had returned earlier, drove her car along with Mum and Dad to meet her and back to David's flat in London, as he was in Zurich for a few days. She settled in England for a couple of years, working in a private hospital in Harrogate where Pauline joined her later that year.

Still with itchy feet and missing the casual life of Australia, they applied to nurse in Zambia; a country that had only recently gained its independence. Kenneth Kaunda was the inaugural president. It was a poor country, struggling to survive economically. They worked in the most primitive conditions, working against the climate as well as the lack of available medicine. The hospital catered for many diseases as well as maternity, as it was the only place for people to go. They worked with lepers, a terrible disease, but their patients seemingly accepted their lot, had few or no possessions, enjoying what little they had.

Margaret wanted to explore South Africa. She had experienced Australia and its outback and South Africa was similar, with dirt roads, snakes and animals that can kill. She bought an old Volkswagen to set off on the road trip of three thousand and sixty-six kilometres to Durban, with no idea where she would stay en route or where to access petrol. Pauline pleaded with her to fly, but Margaret insisted she could drive, and they meet in Durban. Without stops, it was a thirty-five-hour drive and Margaret was on her own. A dangerous road for African travellers, let alone a white nurse alone. The car kept stalling, lengthening her journey, though it seemed after stopping a while, the car would start again. She slept in the car at night, oblivious to any dangers that could beset her,

from wild animals to local tribesmen. She travelled south through Zambia, eventually arriving safely.

She took the car to the first garage she saw to have it checked. The mechanic looked at the car and looked at Margaret.

'You've come from *where*?' he asked.

'Lusaka', Margaret said.

Scratching and shaking his head he looked at Margaret and then the engine, he couldn't believe most of the wires had burned through; the mechanic thought she must have had a fire in the engine. The car was fixed whilst she met Pauline, exploring the sights of Durban. Their return journey gave no problems and was a far safer drive with Pauline by her side.

Back in England, Margaret began to notice the Hockney genetic deafness. She couldn't hear patients, even when standing at the end of their bed. She learned to conceal her deafness but was aware she might miss some important word. Our family are all conscious of what deafness means as we all have varying degrees of it, but Margaret had a responsibility to herself and her patients.

Pauline by this time had married and was working in Bedfordshire. She loved working with Margaret and helped her take a position district nursing where hearing was mostly one-to-one, so she felt she could manage. Margaret looked to settle down considering the purchase of her own house. She had seen one in Bedford that had bedrooms and two bathrooms, but British banks at that time refused a *single* person a mortgage for a two-bathroom house. Philip happened to be visiting England from Australia and was a real hero to Margaret, helping organise a family loan on her behalf. It was at this time Margaret became aware of Ken Wathey, a district nurse in Bedford. She met Ken through a group who dined regularly in the hospital dining room. During a conversation, Ken and Margaret discovered they both came from Yorkshire. Ken, in his free time,

was an artist and a 'Friend of the Royal Academy,' familiar with David Hockney's work. They gradually became friends, often travelling to Yorkshire together.

On a holiday at brother Paul's cottage in Flamborough, they realised how nice it would be to live around Yorkshire's east coast. They looked for two neighbouring houses, eventually finding one large house on Vernon Road in Bridlington that had adequate space for both of them, but living separately, and thus the friendship grew.

Margaret began considering alternative medicine, and looked at an acupuncture course that though interesting, was rather expensive. When brother Paul visited, Margaret discussed her interest in the course and much to her delight and appreciation he said, 'Why not?' He gave Margaret a cheque to cover the first weekend. She found it so interesting she followed up with an iridology course. How wonderful to read health conditions through the Iris.

The courses were short but very intensive. Margaret decided she needed more in-depth study, opting to become a medical herbalist. It was a four-year course with frequent exams on the way. It was still expensive, but she earned and learned. The study was not only interesting but set Margaret living a new organic style of healthy life.

She bought a basic computer with a word processor to create her essays. Part of the house in Vernon Road was set up as a clinic for Margaret to see her patients. One-on-one with good quality hearing aids in quiet surroundings allowed her to converse with and hear her clients.

By 1991 Mum required constant help. Paul and Jean had given so much of their time and energy over the years they badly needed respite. Helen and I were prepared to take Mum, but adverse circumstances in the UK forced us to return to Australia, leaving Margaret and Ken to take responsibility. For the plan to work efficiently, they needed a different house, as Mum would never

manage the many stairs at Vernon Road. David helped Margaret select a large ex-guesthouse near the seafront in Kingston Road. It had a ground floor self-contained flat with its own access. Perfect for Mum as she could have her own visitors but have on hand assistance when needed.

Ken and Margaret moved into Kingston Road so Mum could move as soon as possible, leaving the Vernon Road house empty and for sale. Hutton Terrace was sold, with Mum feeling deeply saddened after her fifty years of living there. So many memories, so many heartbreaks and so much joy!

The new house in Bridlington had two ground-floor entrances allowing Margaret a patient's entrance with a separate consulting room/office. David helped with some new Phonak hearing aids, fully digital, and with three settings making hearing clear and concise. He also bought me some in Australia. They were the best-ever hearing aids, with noise adjustment that worked.

Ken and Margaret's routine was like clockwork. They were both early risers. At 6 a.m. they left with the dog to walk to the paper shop, had a quick chat and returned along the promenade by 6.30am for a cup of tea and breakfast. Their routine followed the same procedure every day without fail– wind, rain, or shine. Margaret opened her surgery and Ken painted until lunchtime. When Mum moved from Bradford, she would join them for a hot lunch, and have time to share their news.

For Ken and Margaret, after their individual daytime activities, conversation was full of sharing their news events of the day, watching TV, reading or talking and an evening stroll down the promenade before sleeping. Life was good.

David visited Bridlington quite often, lured by its crisp air and golden sands, and easy access to the Yorkshire Wolds. And it was now where Mum lived. Each visit he would stay a bit longer,

drawing and painting the countryside as well as individual pictures of Mum, Ken and Margaret.

The day my mother died on 11th May 1999, Margaret received a new computer. She began to talk to the world. She didn't need hearing to use the internet. A Scrabble freak, she began playing games with people in the USA, UK and the world. She realised, perhaps having spent time with David, that she too was creative, taking photos of flowers, or scanning them on her scanner, then designing a vase for them. She began to exhibit her pictures, generously supported and guided by Ken. One year she submitted two pictures to the Royal Academy Summer Exhibition. None of the selectors knew her name – she was just a number until selection was confirmed.

Both Margaret's pictures were accepted, one of an Octopus squashed on her scanner (she spent hours cleaning off the stink and mess). She caused quite a stir when the press then noted her surname was Hockney. Was she a relation? And did David like her

Margaret's Scanographics: Cowslips in vase / Poppies.

Margaret with her hearing dog Sally

Margaret at Book Launch

work? The press, having interviewed her, asked David what he thought. Margaret says, "He's amused by it really. Perhaps a bit more than amused."

The Royal Academy Summer show helped Margaret publicise her work, which began to sell through local galleries in Bridlington. I loved the idea that Margaret was creating and making images people bought. She was clever, and why shouldn't she make some small income from her work?

Sadly, Ken became very ill and died. It was a deeply distressing time for Margaret, who had waited so long for a partner who accepted her for who she was, as she did Ken. David had spent hours talking art with Ken, frequently ringing Bridlington from Los Angeles just to talk art. He also liked the house where Margaret lived, close to the sea and promenade. He began frequent visits, realising the Yorkshire Wolds were unchanged and he had an urge to paint but needed a bigger studio. He had the whole roof lifted, with big windows installed to let in the light.

Margaret moved to a small bungalow just a few minutes' walk away, continuing to make her pictures. Her deafness worsened, allowing her to apply for a 'hearing dog.' Sally was especially trained to respond to sounds, specifically the front doorbell, telephone and other appropriate requirements. She is allowed on any public transport, inside cafes, hotels. Anywhere Margaret needs to go, Sally can go with her. I was in Yorkshire when David received an Honorary Doctorate from York University. Margaret and I went to York Minster to see him accept his award. Little Sally sat quietly at her feet.

When Paul and Jean moved away from Bridlington to be closer to his children in Bradford, Margaret decided to move as well. David by this time left Yorkshire moving back to Los Angeles. If Margaret moved to Ilkley, she would be near Paul and if to

Harrogate, close to her friend Pauline. She took a residential home in Hampsthwaite in the rural countryside overlooking pastures and distant moors. Pauline is just a short drive away and was a twenty-minute drive to Paul in Ilkley.

Margaret had agreed to help co-write this book, but then decided to write her own story. She published *My Mother is Not Your Mother* in 2017.

I have a great love and admiration for Margaret's stoicism from her early childhood. She has independently made a life that helped others regardless of whether God was involved or not. She continues to create, write and enjoy her lifelong friendship with Pauline; her deafness gradually deteriorates into her personal *Sounds of Silence*.

Margaret survived because she 'never worried what the neighbours thought.'

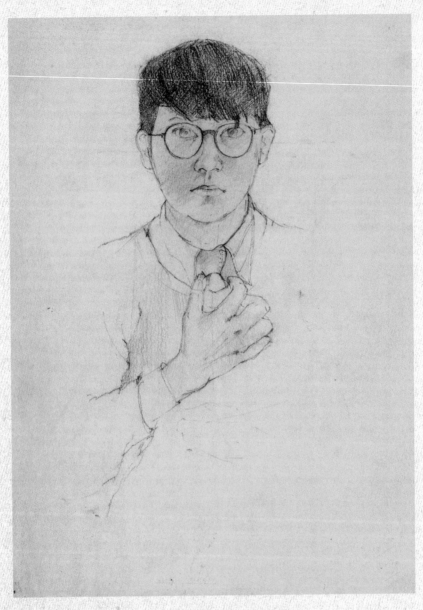

"Self Portrait" 1954
Pencil on paper
15 × 11"
© David Hockney
Photo Credit: Richard Schmidt
Collection The David Hockney Foundation

12

ART IS LIFE

David Hockney

B: 9 JULY 1937

Anthony Storr in his book *Solitude: A Return to the Self*, quoted:

Creative talent of a major kind is not widely bestowed. Those who possess it are often regarded with awe and envy because of their gifts, and the uniformity of a single artist.

I have often stood in awe not only of David's achievements, but also of his generosity in sharing new-found knowledge. I have never envied his achievement, or the wealth that it has bestowed on him. David pursues Art. He does not pursue wealth for wealth's sake, though this in no way diminishes the achievements of my siblings, who have made their own unique contributions within their lifetime. Because of David's success on a world scale and the qualified recognition of his works, he has become special.

We were all imaginative, as are many children, though David was always different; his confidence, his attitude to life and his passion to become an artist whatever that meant and whatever it cost, was in his soul. From an early age, he had a creative urge to draw. During wartime drawing paper was unaffordable, at least for our family. To satisfy his need to draw, he woke first, quietly creeping downstairs with a pencil. He drew figures, streets and houses, landscapes, and cartoons on the white edge of Dad's newspaper, Mum's magazine, or whatever comics arrived that day, anything imaginative in his mind at that time. For family members, there was gentle irritation their mint copy of the newspaper or comic had been interfered with.

David had no formal training in drawing, yet he was aware of proportion, perspective and scale. The newspaper, once read by its owner, was thrown away, or used to wrap cinders from the fire grate. Sometimes rolled and tied in a knot to use as firelighters–complete with David's sketches. Nevertheless, even in those early days, David woke early and worked, a policy he continues today.

No one had any perception this little seven-year-old boy was to become one of the greatest artists of his time. No one recognised his devotion, or first signs of genius, until he accessed his first drawing pad when he was nearly ten, and his desire to draw seriously became obvious. It was how he made marks without any formal

training. He was knowingly confident, yet in any other respect he was like most other kids of the time. A weekly chores list drawn by David and pinned inside the wash cupboard portrayed me with a miserable face. Everyone else was smiling, doing their bit, though he captured me correctly; I admit I never enjoyed chores yet rose early to do my newspaper round, often making the fire so it was warm when Mum came downstairs.

When David was ten years old, he won a pocket watch as second prize for designing a poster in *Eagle* comic. Ronald Searle, the cartoonist, won first place.

Mum was emphatic there was no competition in her family; she had no favourites, loving us all equally.

Not quite true, as was revealed after Mum's death in Christopher Sykes's *Hockney:The Biography* (2011) where a letter from her to David was published. As the youngest, I was often asked by Mum why I couldn't be more like Paul or Philip. I felt I had to live up to my older siblings.

I secretly entered a colour competition in the *Daily Express*, posting it myself (in case I didn't win), I received a Timex wrist-watch, with which I was naturally thrilled. It arrived one morning through the post. Mum's immediate and emphatic response was, *'There can only be one artist in this family.'*

I was eight and left for school rather downhearted but with a new watch on my wrist. I was never artistic like David, yet there are many families I know who have one or more successful artists in their midst. Indeed, Paul had tried earlier. Many years later I worked as a graphic designer and tutored at the University of Technology, Sydney, in Design Studies.

As sketchbooks became affordable, my mother began to keep David's as they became full. He wasn't too concerned about keeping them at that time, but later appreciated her retaining his

chronological efforts. Most kids draw with confidence, until they reach an age when how you draw matters and initially drawing is considered 'a phase.' For David it was his life, but we didn't know it yet! There were a few childhood instances when temperament got the better of him, but this was usually associated with deprivation of drawing to do something he considered mundane. As a member of the local Cubs and Scouts he relished contributing his humour and drawing ability, designing posters for jumble sales or Bob-a-Job week or the annual Gang Show.

It is now 77 years since I shared a spartanly furnished attic bedroom with David. A multi-coloured floral linoleum covering was cold to our feet in winter with no bedside rugs. Two single iron-frame hospital-type beds placed one against each wall, with a couple of grey army blankets kept us as warm as toast during winter months. A small single wardrobe and chest of drawers amply accommodated our few clothes for school, play and Sunday best. Hand-me-downs from Philip or Paul were normal for David and continued down to me.

Walls were cream-coloured distemper, patterned by Dad using a soft sponge dipped in contrasting brown paint. We thought him very clever. He painted sunrises on internal and external doors to brighten our day. Wartime blackout material fitted a sloping, push-out window aligned to the attic roof. During the long summer evenings light never penetrated our room and, importantly, none leaked out to warn enemy aircraft. Unless one has lived with wartime blackout regulations it is hard to imagine how black, black can be. Familiar areas and a sense of direction are totally void when on starless nights one cannot sense where one is standing. It's just a black emptiness. Very frightening. Our 'naughtiness' after lights out, was never more than a torchlight under bedclothes, sharing spooky stories, reading comics, pulling faces and playing childish

trivia, sometimes frightening ourselves into belief there were real 'bogeymen' behind a Chinese screen standing in the corner.

Bath night on Friday began in age order, starting with Mum first, then Dad, with siblings. Wartime regulations limited water to a depth of nine inches, with a one-inch top-up for each additional family member. As the last to bathe, David and I wondered why we should bother stepping into grey, murky water. For fun we had farting competitions to see how many bubbles surfaced. It was all harmless as long as Mum didn't catch us, and we didn't shit. It happened once and our competitions ceased.

Every night, hands and faces washed, hair neatly parted, we knelt down beside our bed, palms of hands together, eyes closed, to pray to God to keep our siblings. Parrot fashion we asked Mum, Dad and relatives be kept safe, naming everyone, and to keep us good boys. Then we hopped into bed.

Most nights we jumped into bed together, excitingly anticipating the bedtime stories that followed. If Mum told a story, it was usually biblical, or one of Tolstoy's, *Martin the Cobbler*, which she read with great tenderness. If Dad, he began, 'There was once a little boy called David, and a little boy called John.' Nudging each other and giggling, Dad retold our day's activities, bringing our story to life, imitating the noise of a train shushing steam, or the gear-changing bus. He taught us a simple verse about a little train going up and down a hill. As the train struggled to climb, it became harder to climb becoming slower and slower. The verse slows, '*I - think - I - can, I- think -I -can, I-think-I-can.*' At the summit, finally achieving the climb with a final push, the train gathered speed downhill saying, faster and faster, '*I knew I could, I knew I could, I knew I could.*' The rhyme was a gentle reminder for us always to try until we succeeded, no matter how hard. Dad's loving goodnight was complemented with 'chin pie', a rub of his stubble chin on our soft cheeks.

In 1945 when war ended, and blackouts were removed, our attic beamed with brightness. During long summer months when dusk lingers at 11 p.m. and early morning light filters through at 3 a.m, it wasn't always possible to sleep, unless we were very tired. Our small world began to bring colour. Buses repainted from battle-ship grey became bright blue for Bradford City Transport or pillar box red for West Yorkshire. Street lights shone at night and shops left window lights on after closing time. People's hearts lifted after living so long in darkness.

We made friends with two neighbours, Malcolm Pounds, who was David's age, and Dudley his brother, my age. Their father had a small farm at Greengates where we frequently played during school holidays. Our experience of playing around cows, pigs, hens and geese was new and enlightening. The farmyard, from dung beetle piles to cow sheds and pigsties, had distinctive aromas, but we soon acclimatised. We nicked raw molasses from a forty-four-gallon drum, licking our fingers clean and revelling in the taste. We took home 'Windfall Apples' that had fallen off trees for apple pie, and at Christmas the farm killed hens for Christmas fare. David and I were offered a shilling each for plucking feathers from the dead chickens strung up in an old barn. They were still warm. We were hesitant in case we hurt them, but Malcolm's father shouted:

'Nay lads tha won't be getting no shillin unless tha does better than that. They're dead! Thi can't feel owt.' *

The magic word was all we needed for a stronger pull. We got our shillings plus a chicken to take home for Christmas dinner. Mum was thrilled, as we usually ate tongue and white sauce, but we never plucked chickens again.

A family pet rabbit, even a guinea pig, became household pets

* Now lads, you won't be receiving a shilling unless you do better than that. They're dead, they can't feel anything.

until we got a dog, Stanley, named after Stan Laurel. We were forced to change the name to Paddy when a new neighbour Stanley moved next door. When we shouted the dog's name, Stanley came out too.

Rationing prevented us enjoying healthy diets, even after the war when rationing continued. Consequently, daily doses of cod liver oil, Virol (a malt extract) and slippery elm food helped balance nourishment. Though boils on the neck or arm were frequently poulticed, David grew a terrible five-core carbuncle on his leg. I can still hear his screams as Mum applied a hot kaolin poultice to draw the pus. Home remedies were often administered to save a shilling payment to the local doctor.

At the end of the terrace, a copse of trees separated Hall Road from meadows. We spent a lot of time nestled in the upper branches, sitting quietly observing caterpillars, birds, spiders and butterflies, or neighbours chatting over the garden fence. Climbing trees became a delightful pastime; though where we drove large nails in the trunk to assist our climbing, we often tore flesh on legs and hands during our quick descent. We explored streams for tadpoles and newts, keeping them in jars to study how they changed.

Mr Rogers, an elderly wool merchant, lived in Hall Road, a stone's throw from where we lived. He drove a Citroen Avant car similar to Maigret, the French detective. On Saturday mornings, if David and I stood in sight of his garage he took us for a ride to Harrogate whilst he took the spa waters. What a thrill to ride in a car and see how posh people lived. He locked us in whilst he bathed, using the time to play I-Spy or watch fine ladies smoking Sobranie cigarettes have morning tea at Betty's Café Tea Rooms. In return we ran any errands he needed.

David, attending Wellington Road Primary School, was taught 'comprehension' classes. Following the telling of a story, students were asked to interpret some part of the story with a drawing. David

was in his element. Proper paper and powder paints mixed with water gave him inspiration. It was obvious he had talent. Eager to draw at any time, he carried a pencil in his pocket whenever we went to chapel. Hymn books have a couple of blank pages in the front and back. David used the blank pages as an opportunity to draw on real paper, especially during a boring sermon or long prayer. He must have filled many a hymn book. Years later when he became famous the hymn books were scrutinised, but all the pages had already been removed. At eleven, David sat the Eleven Plus exam, an intelligence test to determine whether a student was eligible for grammar school. All children had to take the test, a determining factor for their academic future. If achieved, then opportunities for university or further education were possible. Failure meant the student was doomed to a secondary modern school. David passed with flying colours and, like Paul before him, was awarded a scholarship to the Bradford Grammar School, where he began in September 1947 after the summer holidays.

Explorations were part of our energy and learning wherever we could afford to be, rambling, cycling, hitchhiking or using public transport. Rain didn't stop us. If we had stayed at home every time it rained, we would never have experienced walking over the moors in mist, with boggy peat underfoot. It was a totally engrossing experience compared with a bright sunny day, both providing manna for the soul.

We were encouraged to use the local library, visit museums and art galleries, and explore historic sights and old churches, discover any subject which broadened our mind. *Arthur Mee's Children's Encyclopaedia* and *Lands and Peoples* rested in a rosewood bookcase in the front room. After washing our hands, a volume would be committed to our care, engrossing us in the stories and people on their pages.

We never stayed in bed. To stay in bed was a waste of life. As the morning sun cast its beam warming the linoleum floor, we jumped out of bed to be greeted with the whiff of fried beef dripping and bread. We had been discussing a hike to Otley Chevin, Kirkstall Abbey or Shipley Glen when Paul passed through the kitchen on his way to work, offering the use of his tandem. His kind offer made a significant difference to where we explored that day. The tandem was Paul's pride and joy, bought second-hand for himself and girlfriend, Jean. My own suggestion of a round trip was dismissed, whilst David, being the elder, took responsibility for our day's tour. He suggested riding to Harrogate, returning via Knaresborough and Spofforth Castle, a route I loved as it was a pleasant ride, not too difficult, and easily fitted into a day's pleasure. I agreed.

David assumed charge of the steering as he was eldest, and I the pillion. We wore light short-sleeved summer shirts, shorts and sandals. There were no fancy cycling togs or headgear then. Usually Mum supplied sandwiches of dates, dried banana, Nestlé milk or demerara sugar, anything to give us energy. Today, with no spare bread available, we were given two pence each for chips.

The road seemed to fly beneath us. We were fresh and eager and a worthy team in perfect rhythm, helping us reach Harrogate sooner than anticipated. Harrogate is always beautiful, but in summer the well-cut green strays, flower beds and lush green trees quickly passed by. I was hoping to stop and enjoy a ramble, but he who steers the tandem is in charge to go wherever he chooses. David decided to pilot his unwilling rider to Pateley Bridge, some additional eight or nine miles further. I preferred our original route. Although freewheeling the steep decline to Pateley Bridge, we thrilled at the warm wind rushing through our hair, boxing and buffeting our faces as we gathered momentum. We loved the sensation, sharing an exhilarating joy together as we turned into

Pateley village. Our nostrils sniffed the mouth-watering aroma of the local fish-and-chip shop. Parking our steed, we awaited with anticipation the taste of two pennyworth of chips with extra scraps, salt and lots of vinegar, a mouth-watering delight, left with just one penny each.

Sitting on the bridge wall, dangling our legs and enjoying the view, we revelled in the flavour of cooked hot chips in beef dripping. We quietly observed the pristine water dance over pebbles in the River Nidd. Before we departed, cupping our hands into fresh clean water, we took a sip. It tasted sweet and fresh. David dipped his head under the surface, quickly withdrawing and wiping his face on his shirt tail.

'That's better', he said. We stood momentarily, our legs straddling the bike. David casually suggested we return via Grassington and Skipton instead of the route we came. I was happy to go along with his suggestion as the mileage is less and the road between Skipton and Shipley is relatively flat. Leaving Pateley Bridge, we pedalled the undulating countryside through the soothing green, lush valley, which I noted began to change. There was a reservoir on our right, which shouldn't be there. I reasoned by now we should be in the limestone country of Wharfedale and shouted my concern to David. He remained silent. The only actions I took were to pedal and enjoy the countryside. I began to feel peckish; after all, one bag of chips between us was of no substance when using up so much energy.

The tarmacadam road suddenly came to a halt. I was confronted with a stile and a path leading to the moor and a distant peak I knew was Great Whernside. David confirmed he knew perfectly well where we were but chose not to share his detailed knowledge with me. I think he saw the ride as a wonderful adventure, which it was, but we still had to get home. Before tackling the stile, we

rode back a short distance to the village of Ramsgill. With the usual Hockney effrontery, we knocked on a cottage door (or rather David did whilst I stood behind). A ruddy, shiny-faced woman answered, dressed in a long ankle-length skirt and a large white apron. David asked if she could sell us 'two penny-worth of bread, please'. She smiled a big, broad smile, shook her head side to side as if she didn't know what the world was coming to and considered us a bit daft. She returned with a freshly made loaf straight from the oven. We exchanged it for the two pence and thanked her politely. She waved goodbye, and as soon as we were out of her sight we tore the crusty corners, devouring our half each.

I am trusting, but dubious of David's judgement as we negotiated the tandem over the stile and began to ride the unmade footpath in front of Great Whernside, one of the three great peaks of Yorkshire. It stands sweeping, bold and beautiful against the blue sky, dominating the bleak yet endearing landscape.

Riding the pathway presented a problem. We frequently had to dismount because of the deteriorating condition of the track as well as a suspected slow puncture. We realised we were not good Scouts, coming out without a repair outfit. Otherwise we would have 'Been Prepared.' Of course, our original plan was to ride through residential countryside. This day was exciting, but by now I was beginning to feel aching legs and rather despondent about the yet-to-be-made journey home. Time too was catching up on us as dusk began to cast its long shadows over the wild landscape. We had no idea how far we had yet to travel to a road but pushed on until a dry-stone wall and stile bore a signpost to Kettlewell.

My suspicion was confirmed. We had ridden miles off our intended trajectory. At last we would soon be in habitation. The country we travelled is some of the most majestic and beautiful in West Yorkshire. Any other time I would have been totally

enraptured with its views, but today my physical strength overrode my spiritual. I suppose that is the difference between David and me. He nonchalantly accepts what has happened. I hadn't and he had caused the problem.

I was tired as we descended into Kettlewell village and concerned about my capability to ride back to Bradford. From my reckoning it was thirty-five miles. The tandem had a hub braking system. Riding slowly down a one-in-three hill with constant application of the brakes caused them to overheat and smoke. David decided that we should dismount and walk down the remaining distance to the village. The dusk of late evening had now overtaken us. Darkness had arrived. Fortunately, the tandem's dynamo lights worked. My parents had always taught us if we were in trouble to call a policeman, or reverse charges on a telephone. Policemen were regarded as helpful within our community, probably because they plodded their beats and knew the local community personally. Our last two pence gone and knowing it would be early morning before we got home, we decided to reverse charge a call to Mum. David made the call, with Mum relieved we were safe. All was fine as far as Mum was concerned.

'Don't worry,' she told us, 'Trust in the Lord.'

I secretly wished the Lord would help push us home. The coolness of the night and concentration on the task seemed to create a renewed energy, our harmonious pedalling interrupted only when we had to pump up the tyre. It turned out it wasn't a puncture, it was a leaking valve. Two exhausted little boys slowly exerted the last uphill, pedalling to Eccleshill village at the end of an eventful day.

It was 2 a.m. when we opened the door and crashed to bed. We had pedalled over ninety miles. For all the drama of our tandem ride and the aching muscles, our day in Yorkshire was never forgotten.

David was eleven and I was nine.

Many years later Christopher Isherwood called David 'Mr Whiz Tours', as he always organised quick tours, taking in as much as he could in the shortest possible time. Our trip to Great Whernside must have been a practice run.

Even at eleven years old David's only agenda was art. It was his only reason for living; an issue he was soon to deal with as he began his first term at school. David began at the prestigious Bradford Grammar School, where Paul had spent five years and was now leaving in July to take up accountancy instead of his preferred art. The rest of the school holidays were spent with David and Mum preparing for his start at grammar school. It was a different situation when Paul had begun five years earlier. The family had now enlarged to five children, making money tight. David was given a second-hand blazer rather than new. Not that he minded, accepting it without complaint, though he was confronted with the wealth of boys and their spending money compared to his scholarship. Most students were from financially viable backgrounds, looking at sport and academics as part of a culture, as their fathers had before them. Sport was never on David's agenda, which he was soon to discover.

He did make friends with other boys from wealthier homes. Jeremy Crowther visited, driven by his father, always bringing Dinky toys as gifts. We played on the front room floor with London buses and taxis, cars and trucks. School students were encouraged to have a pen pal from overseas countries. David wrote to a boy in the US, receiving gifts that embarrassed us as the same value could never be returned. A large box of bubble gum arrived. It tasted like Germolene smelled and blew bubbles the size of a face. He shared them at chapel, until Mum confiscated them for blowing bubbles. At Christmas a large box arrived containing an electronic robot. It bleeped, and its eyes lit up as it moved, making electronic noises.

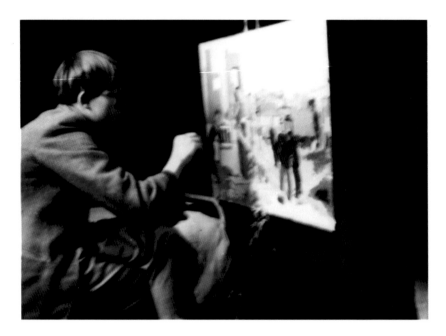

David Hockney painting at home

Much to David's disbelief, he learned the art period was just one-and-a-half hours a week, and only in the first year. Art was perceived by the school as recreational rather than academic and for David that was devastating. It was this moment that he formed his own plan. Only *he* was responsible for his future. David vowed not to waste one single art lesson. He was already having to waste time on sports and running. He allegedly won a cross-country race, much to the surprise of other well-trained competitors, but was disqualified when a master travelling on a bus spotted him riding a bicycle part of the way. He wasn't ashamed. Art was far more important. He saw his opposition to sport as a means of having more time to draw, in or out of a lesson.

Deciding to fail academic subjects so art would be a part of each year's curriculum, David consciously planned failure, to stay in the lower form. The Education Board was not amused, but neither was

David. His stubbornness was considered foolish, especially when he applied for transfer to Bradford Art College but was refused, with the added authoritative comment he was 'wasting valuable opportunities.' Still, David's passion was unfulfilled. In English Language he was given an essay as homework. Instead, he handed in a self-portrait collage he created from magazines and newspapers. His English master thought it wonderful.

An outlet for his work came from various inter-school organisations and clubs, all of who vied for David's skill in creating amusing and attention-getting posters. He was pleased because his work was being exhibited, as he saw it. People looked at his posters. Some of the work was crafted in scraperboard, a black finish board scraped with a fine knife or point to uncover a white relief. His work made him a popular student, as did his anti-establishment stance. Only in his final year did David begin intense study of English, History and subjects that would stand him in good stead for his Regional College of Art application. He achieved his goal quite easily, but had always hoped the school would have made an exception for his art, so he could still be academic and create art. However, their curriculum would not recognise Art as an academic subject. Still, David felt pleased, he had followed his own plan to stay down and continue with art. At the final speech day, accepting his fifth art prize, the whole school cheered him with a standing ovation.

Grammar school complete, my parents expected David to seek suitable work. After composing a portfolio, he went to Leeds as Mum instructed, applying, as Paul had done, to advertising companies. Each agency considered David's work impressive for his age and ability, and offered a position provided he attended art school part time. However, there was no way he wanted to work in an advertising company. He desperately yearned to go to art school.

He was at his crossroads. Possibly this was the only time David told an outright lie to our parents. He told them the agencies had said he must go to art school but omitted to add the job offer. My parents, though considerate of David's capabilities, were reluctant to allow him to go to college, as every other sibling had gone to work and because Paul had wanted to be an artist but instead took up accountancy.

David must have put forward a persuasive argument. He agreed to work during any holidays to pay his way towards the family income, provided that he attended the Regional College of Art. Mum and Dad agreed provided the City of Bradford award a grant. Fortunately, David's application was successful. He now knew when the first term began, he would commence study at the Regional College of Art. Bradford Council's help to David was acknowledged when he later gave works of his art to the City Art Gallery, Cartwright Hall. Meanwhile, he began working as a farm labourer in Wetwang, East Yorkshire, demonstrating a willingness to Mum to earn money. He even sent a rabbit through the post, thinking it would be a good stew for the family. It was never received. It was 1953.

When David returned to Yorkshire forty-two years later in 1995, Wetwang and the Yorkshire Wolds were unchanged. His love affair with the Yorkshire Wolds became history.

During his early years David's understanding of who an artist was, caused him some confusion. He describes his own thoughts in his book *David Hockney by David Hockney*:

> *I thought an artist was the man who painted signs and bill-boards, the person who designed greeting cards and calendars. I thought anyone who paints pictures does so in the evenings or weekends after work.*

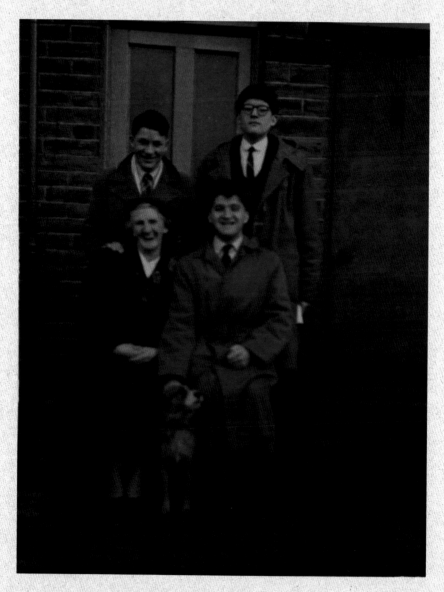

John, David, Paul and Mum, 1954

My parents also couldn't have understood how or when an artist painted, otherwise, despite their reticence towards art as a career, they would have guided him. David had to work it out for himself.

Within us there existed a great love of Yorkshire. So too with Paul, who never left the county to live anywhere else. 'Enough blue sky to make a sailor a pair of pants,' Mum said. She often referred to local sayings: 'Red at night is shepherds delight' meant the next day would be fine.

Today we were taking potluck. David, myself and friend Philip Naylor planned a walk to Almscliffe Crag; perhaps one of our last walks before David began Art School. The view at the top of Almscliffe Crag was breathtaking. On a clear day to the east, York Minster and the Vale of York could be seen. The Yorkshire Dales to the west.

Mum prepared our favourite sandwiches of beef dripping with lots of dark jelly and salt. Instead of a carrying a vacuum flask of tea, we thought as good Scouts we should use a primus stove gathering fresh water from a running stream. Catching the Harrogate bus, we alighted at Leathley, just past Pool village. There was a quicker route to Almscliffe Crag, but the road from Leathley wound through the countryside to Stainburn and we wanted to walk. The road, typical of West Yorkshire, had thicket fencing or dry-stone walls. Away from the industrial city the smells of country life sharpen the nostrils, especially after muck spreading. It was certainly fresh the day we took our walk. Hedgehogs shuffled confidently across the narrow roads; swifts and swallows swept over the meadows, whilst cows lazily lay down chewing their cud.

As we walked, our conversations ranged from jokes, Scouts, and the more philosophical questions of life and the universe. When we had passed through Stainburn village, a stream trickled by the wayside. The clear water appeared perfectly fit for drinking and

making tea, and the road verge was wide and well grassed, perfect to relax among foxgloves, buttercups and daisies. The primus soon had the billycan on the boil, loading it with handfuls of Typhoo tea (David later painted a packet when he was at the Royal College.) Stirring the water whilst it was boiling, we brewed the tea for a fuller flavour, but it was only when we added milk we saw a slight oily scum laying on the surface. None of us were too keen to drink with an unknown body floating around. It may be quite harmless, but we were hesitant to try. No one wanted to take the chance… just in case!

We were deciding to throw it out when a robust old woman came walking towards us. She was alone. It was difficult to see whether she was plump or not, as she appeared to be wearing a number of coats over her person. Her head and ears were covered with a woollen hat tied under her chin. She carried bags in each hand, seemingly fairly heavy as she shuffled from side to side, balancing their weight as she walked. As she drew closer it was apparent her skin was leathery and tough, and she sported a wispy grey beard on her chin.

'Good morning,' she shouted, as if we were hard of hearing.

'Good morning,' we all called back.

'Don't suppose you have a spare cuppa going do you lads?'

'Yes! There's plenty if you'd like one,' said David smiling, and remaining silent of our discovery.

She put her bags down. We noticed they were bursting out with clothes.

She settled herself comfortably, and David offered her an enamel cup of the piping hot brew, saying, 'Careful, it's a bit hot.'

She slurped a sip.

'Oh!' she said, 'I was just ready for a nice cuppa. In fact, if there's anything I like better than a cup o' tea, it's two cups o' tea.'

We laughed at her joke. I remembered to keep it for myself. She often burst out laughing for no other reason than I think she

was enjoying herself. The lady was very likeable, chatty and quite unique. We had never come across anyone like her before. How she could drink her tea so hot amazed us, but she smacked her lips, asking for another. As she reached her arm to dip her cup in the tea, we smelled the whiff of her body. She was on the nose, mustn't have bathed for weeks.

'So where are you three going?' after another slurp.

'Almscliffe Crag,' we replied in unison.

'Oh! You're climbers.'

'Not really, we like walking and thought this a nice place to visit,' I said.

'I love it this time of year,' she said. 'Plenty of nooks and crannies to keep warm.'

'You mean, sleep out?' David asked.

'That I do, best place to be, the highways and by-ways. Had enough of living in the fast world.'

This lady was becoming very interesting to us. Her fingers were short and fat, a gold ring squashed onto her third finger. It was hard to tell her age, but she did have some grey hair sneaking from under her hat, she certainly wasn't young, but then she didn't seem old in her manner. Her eyes were bright and alive, blue as the sky, and sharp, no cataracts there.

'Wouldn't you prefer a warm bed at night? What happens when it's cold or snowy?' Philip asked.

'There's plenty of warm places if you know where to go. Animals don't get cold like we do. I've slept with a cow or two and even pigs, and barns with hay are lovely to sleep in.'

We realised she was a homeless lady – a tramp. Not one of us had ever met one or seen one before.

Homeless men were referred to as 'Chip Harry,' we assumed she must be a 'Chip Harriet.'

By the third cup of tea she became even more interesting. David gave her one of our sandwiches. She took it, opened it to see what was inside, shut it and took a big bite. The sandwich was still being digested whilst she spoke, spraying crumbs over our clothes. She began to share her story helping replace the stained-glass windows in York Minster after the fire. Bits of sandwich continued to spray out as she spoke.

'I worked on the stained glass,' she said. 'It's slow, hard work, the same method monks used hundreds of years ago. They're beautiful. For God I made them.'

She was quiet for a moment, as if in another place. We kept watching her, a bit overawed by her presence.

I thought, 'What if she was my mother, would I be happy her wandering the countryside alone ?'

Philip asked, 'Why do you prefer this life?'

Chip Harriet shrugged, thinking a moment.

'I have no worries, no bills, no problems,' she said, smiling. 'No car repairs, no traffic to sit in, no house to insure, no politics to worry about.'

We all considered her words.

'You'd be amazed at the kindness of people I find everywhere,' she continued smiling.

'Thank you, gentlemen,' she said, 'That was a really nice cuppa tea, and the dripping sandwich.'

Philip helped her up.

'Thank you,' she said, picking up her bags. She smiled, nodded and left.

As we sat on the top of Almscliffe Crag contemplating our lush green view, our minds and our thoughts reflected Chip Harriet. The conversation home centred discussion of the qualities of life and Chip Harriet, another story stored to memory.

Bradford Regional College of Art

The Regional College of Art opened from 9 a.m. until 4 p.m. for day students; 6 p.m. to 9 p.m. for evening class activities. Day students were permitted to attend night classes when life models were used. David took advantage of utilising a twelve-hour day to work. He thrived on it. He dressed 'arty', wanting to be individual, arriving the first day wearing a khaki duffle coat and a long red scarf knitted by him, complete with bowler hat. Someone remarked, 'Who the hell is this, a Russian peasant?' He was in fact dressing like his idol Stanley Spencer but was nicknamed Boris that day.

There is no doubt David's work ethic could never be criticised, but his studio cleaning must have lacked. My father wrote to *The Studio Ltd*, a weekly in New York, asking how David should clean brushes. On 17th July 1957 he received an informative response from the Managing Editor G.S.Whittet:

Dear Sir,

Thank you for your letter of 12th July. We feel sure that the tuition your son has been receiving has no doubt impressed upon him the methods of cleaning his brushes and palette. Naturally brushes should be treated with care and washed in petrol and good soap solution. With regard to the palette, it is not so necessary to clean it and some artists allow their pigments to accumulate to quite a considerable thickness.

We cannot advise you on the choice between canvas and hardboard as it depends on the artist's selection and affordability. Our own feeling is that if your son is so talented he would probably resent any parental interference with this side of materials.

Yours Faithfully
G.S Whittet
Managing Editor - The Studio.

When my father quoted *'Never worry what the neighbours think'* all of us at some point in our lives heeded his wisdom, but David took his advice to heart. Fearless in his pursuit of artistic endeavour, David's personality and work ethic attracted a group of like-minded students who became firm friends: Norman Stevens, David Oxtoby, John Loker and Michael Vaughan. They were known as the Bradford Mafia, rebelling against the establishment and rules considered harsh. Yet they worked hard, creating their own individual styles. A gift of old canvases offered to the college painting class was like gold to the students, but due to some works containing lead paint, the Head of Painting wanted them destroyed. Real canvas was unaffordable for most students and hardboard was a cheap substitute. David sat on the bonnet of the Head of Painting's car, refusing to move until the decision was reversed. David won!

Hitchhiking in Yorkshire, I was picked up by a talkative driver. He was most amicable, with conversation covering a host of topics. We got on well, and he offered to drop me back at Leeds rail station in the afternoon. We met as arranged (sometimes people don't turn up – he did) and chatted about whatever took our fancy. He began telling me about his daughter attending the Regional College of Art in Bradford. Before I could share my brother attended the art school too, he told me how some chap called Boris was a real twit. Apparently, a nice twit, but nonetheless a twit. When I eventually had the opportunity, I told him he was talking about my brother, David. His apologies continued for a further fifteen miles until he compensated for his remarks by driving me home to Eccleshill, still apologising as we said goodbye. Mmmm, I thought, David is becoming quite handy!

With Paul and Philip away from home, I moved into the front attic with its panoramic view, allowing David to use the back attic as his bedroom-cum-studio. He dearly wanted to paint my father's

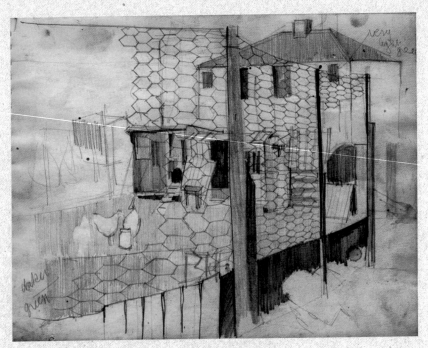

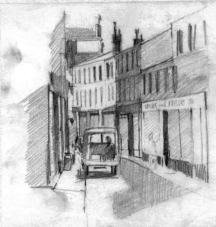

Above:
"Bradford School of Art I" 1953
Pencil on paper (sketchbook)
Page 27
7½ × 10"
© David Hockney

Left:
"Bradford School of Art I" 1953
Pencil on paper (sketchbook)
Page 35
7½ × 10"
© David Hockney

Right:
"Bradford School of
Art I" 1953
Pencil on paper
(sketchbook)
Page 40
7½ × 10"
© David Hockney

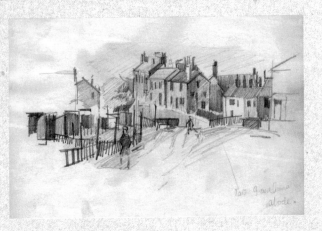

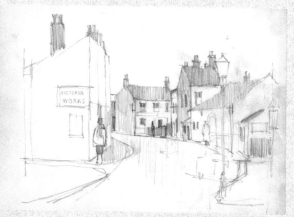

Left:
"Bradford School of
Art 1" 1953
Pencil on paper
(sketchbook)
Page 40
7½ × 10"
© David Hockney

Right:
"Bradford School of Art 1" 1953
Pencil on paper (sketchbook)
Page 45
7½ × 10"
© David Hockney

Below:
"Bradford School of Art 1" 1953
Pencil on paper (sketchbook)
Page 52
7½ × 10"
© David Hockney

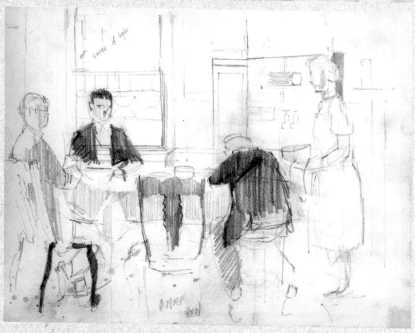

David Hockney at eighteen

portrait along with other works he submitted to the Yorkshire artist's exhibition in Leeds. As David set up his easel, Dad set up a mirror, positioning it to observe David paint when he sat. If David selected a colour, Dad would say, 'I don't think that's right, not for the cheeks,' but David continued, assuring him it was how they were taught at art school. *My Father* sold the first day of the exhibition for ten pounds. David never expected to sell anything, ringing my father to get his permission.

'Of course, sell it David,' said my father, 'You can always paint another.'

David sold it, but some years later bought it back at an undisclosed price, and now it hangs on his bedroom wall in Los Angeles.

Provincial art schools in the early fifties based their teaching style on Walter Sickert. It was a requirement that students paint en plein but carrying brushes, canvases and an easel was impracticable. As my father restored second-hand prams, David found the perfect vehicle for transporting his equipment. He even had a cover and umbrella in case it rained. Many Eccleshill locals remember him pushing his pram around the village. He knew British artist Stanley Spencer also used a pram to carry his canvas and paints.

He was often laughed at, but was oblivious to comments, nonchalantly pushing his pram, wearing his bowler hat, long red scarf and duffle coat, spats over his shoes. My brother Paul refused to walk with him, whilst I loved his dress.

Between leaving the Regional College of Art and commencing at the Royal College in London, David received papers for National Service. He registered as a conscientious objector, his main opinion being that the current government under Anthony Eden waged a colonial war in Egypt, which he considered wrong and wanted no part of. His argument to the Board was unanimously accepted. In lieu, he spent two years at St Luke's Hospital, Bradford and a

year at St Helen's Hospital in Hastings, Sussex. He made use of his spare time drawing patients, decorating the ward for Christmas and Easter, and painting.

Royal College of Art

His service complete, the day came for David to leave home for London and the Royal College of Art. From September 1959 he never lived in Bradford again. He owed his home City, but it was too provincial, too restrictive for who he was, and who he intended to become.

The grant of two pounds a week, payable each term meant David had to be frugal. My parents had no extra cash, so he was limited to finding lodgings, feeding and clothing himself, and buying appropriate art supplies. He initially registered for etching tuition because materials were free. For accommodation he found what I considered an oversized dog kennel in an Earl's Court garden. The bare necessities offered a single bed, a chest of drawers, and a one-bar radiator with a meter that took shillings – a typical artist's garret. He had arrived in Bohemia! David made a sign, placed on the top of his chest of drawers so when he awoke, he couldn't help but see it. The sign said, '**Get up and work**'. He did! And still does.

He continued the same work ethic he had started in Bradford. It was warmer in winter at college, by arriving early and leaving late he didn't have to feed his home meter with shillings. Whenever my mother came to London, he swapped a room in the house with a student, so she wouldn't see how he was living. He once collected plastic tulips given free with packets of soap powder, sticking them in the ground outside his hut to brighten his day. Tulips are one of his favourite flowers.

It was a difficult period, but he survived. Ron Kitaj, an American mature student, saw him drawing a skeleton and paid him five pounds for it – a small fortune for David, more than Dad earned a week. They became lifelong friends. It was Ron who introduced David to literature and poetry to make art.

To save money, David tried living off Oxo cubes in hot water; then he became a vegetarian but became ill from lack of protein. I once found him at home in Bradford when Mum was out, looking quite ill, so called the doctor, who insisted David begin to eat meat as he lacked protein. He reluctantly accepted the doctor's advice and got well. About the same time, he made the etching *Myself and My Heroes* – of Walt Whitman, Gandhi, and himself. He also etched an elephant trampling on insects, suggesting the elephant bore no *intent* to kill the ants, it only killed insects accidentally because its foot was so huge. It was his vegetarian period.

David proclaimed his homosexuality in 1962, long before the word 'gay' was transformed to modern usage. I arrived home one day to find my mother in a reflective mood. She quietly told me that David had told her he was a homosexual. I pondered for a second, rang David to tell him he was still the brother I loved, and that I accepted him as he was. I am unsure whether he felt comfortable with my support, but some extended family members felt embarrased because he made a public statement. As I began to understand what he had told me, I recalled homosexuality was still a punishable offence. However, there were no authoritarian accusations to David personally. The law was under discussion but not yet repealed, and with friends like Quentin Crisp, Cecil Beaton and others, David's life was moving quickly.

He has no fear standing up for what he thinks is right, as our father did before him.

A condition of completing studies for a Diploma at the college, was to submit a life drawing and an Art History essay, David was told that he would fail unless he did so. Cheekily, he painted a wonderful torso of the male figure emblazoned with the words, *'Painting for a Diploma'*, the genitalia conveniently covered.

As David pointed out to the bureaucracy:

'What use is a Diploma to me? Surely, people who look at my work determine whether they like it or not. The diploma is irrelevant.'

Unconcerned whether he received a Diploma or not, David made his own in the print department using the RCA logo, and gave them to other failed students. However, when the examinations board met in June, rector Robin Darwin announced he was giving Hockney the rare distinction of a gold medal. Darwin was aghast that David's General Studies marks indicated he had failed his Diploma; he immediately altered the mark, saying the arithmetic was wrong.

When David was told he was to be awarded a gold medal, a friend suggested he wear a gold lamé jacket they had seen in the boutique men's shop Cecil Gee's. He had become blond because he had learned in the US 'blondes have more fun'. On presentation day, when it was announced David Hockney had won the gold medal, he walked to the podium with his gold lamé jacket and blond hair. The standing ovation became deafening, continuing for a good five minutes.

David was commissioned to create *A Rake's Progress*, a series of etchings with David as the Rake. He went to New York, completing sixteen of the originally required thirty in the portfolio. Not only did David create the plates, he had to print them himself. There was a difference to printing a few at college; to print whole sets was a hard but not impossible job. It was tedious unless you chose to be

a printer, and then one understood the many skills involved. David found it difficult but accomplished the initial sets. The publisher Petersburg Press, operated by Paul Cornwell Jones, published large leather-bound volumes, and some mini books affordable to those whose budget didn't include the ultimate set.

David had become an artist, recognised as someone to watch. He had exhibited in the Young Contemporaries exhibition, exposing recognition on the London art scene. He had met John Kasmin, who offered to be his agent, before David left college. Peter Webb, in his book *Portrait of David Hockney*, tells of Kasmin inviting the Marquis of Dufferin to David's garden shed, agreeing to open a gallery under Kasmin's name and sell Hockney's work. David was promised a minimum of six hundred pounds a year. As my father only earned 300 pounds, it gave David the start he had always wanted.

I often wondered what Mr Coleclough, the Principal of Bradford Regional College of Art, thought of David's success. It was Mr Coleclough who had emphatically announced only a person of means could be a professional artist. Teaching would offer the ability to paint at weekends or evenings. Concluding only an artist of means could really be an artist! One had to be wealthy or from a family that would support you.

Times had obviously changed. David Hockney was on his way.

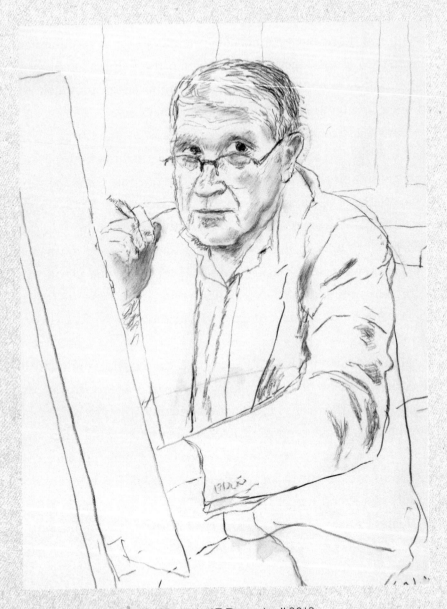

"Self Portrait, 17 December" 2012
Charcoal on paper
30¼ x 22⅝"
© David Hockney
Photo Credit: Richard Schmidt
Collection The David Hockney Foundation

13

DEVOTION COSTS

David Hockney

David is not a mean person. Quite the contrary, he is most generous, but super-careful of his use of his time. Yesterday has gone, tomorrow unknown, so *now* is the only time there is to make choices. It applies to everything he does. Time is important.

"To laugh at something every day," he says, keeps him going. "We have to have humour in our lives". He does not suffer fools.

Devotion can be costly. I have seen it in David. His cost is that only a *selfish* person can be so devoted. I use the word 'selfish' not as a derogatory term, rather for David to achieve what he needs to explore and pursue at any given time, it is necessary for him to nurture every minute in that pursuit. Nothing else matters – only his art matters. **Now** is the only time there is, for David.

I have often wondered how, when we slept and played together, brother David planned to reach for his stars. Only David knew his ambitious inner self.

His has been an absorbing, independent, successful, but I believe somewhat lonely life. There are people who have been important to him. Many of his friends have died over the years. Names I know and have met are Nick Wilder, Ossie Clark, Christopher Isherwood, Henry Geldzahler, Mo McDermott, Norman Stevens and Jonathan Silver and my sister's partner, Ken Wathey. All and many more were part of his life. He chatted with them, shared ideas with them, and loved them.

Today, David probably has the best staff he has ever engaged – knowledgeable, and workaholics when they need to be, discovering through him their own skills and knowledge.

In the late seventies and early eighties, I know David was sometimes lonely when he asked me to go to Los Angeles at Christmas. "I wished my arms stretched to Los Angeles, you need a hug", I would say. Devotion costs. It can be a lonely life, but if it were different, David Hockney could not be who he is; not be the person who is unselfish in passing on his knowledge and his discoveries, because there is more knowledge to seek, to learn; always more to explore.

On my seventy-fourth birthday he sent me an email.

Dear John

I might as well confess I have come from a very, very, rich family Not having much money did not get in the way of our riches. We did not have a failure of imagination. There were poor people around, some of them very poor indeed, but we generally noticed it was failure of imagination. What can be done about this?

I sometimes pondered, open their eyes more I thought to myself. The unbelievable beauty around us could be pointed out.

Children seemed to notice it more. They were richer.

Some of the poorest people were always trying to tell others how poor they were. They came up with what I personally thought crackpot ideas about the total misery of the world.

Their very poor eyesight was often not noticed, the blind seemed to lead the blind, and this made me sad at times. They got some sort of enjoyment fighting and smashing things up and would get encouragement from some other sad people who made them bigger sticks and catapults. Some of the poor lived in a bigger house, not so good really, more stairs to climb, further to walk to the fireplace, even daft bigger tables where they had to shout to say anything as each one was so far away.

In the end I wasn't sure these people could be helped other than perhaps some spectacles, or a large bottle of eye cleaner might do it.

I confess to not bothering too much but then thought of making a false window. I could with a brush make some signs on it to see if they might take notice, if they didn't, why bother?

I confess on the whole that's been my motto. I've tried to ignore the shouters. I find it's better.

And, you can stay richer. They tended to make the air too hot, not so good for breathing. They even went on and on about burning

leaves, how bad they could be for you, but I noticed when they were
just smouldering the smoke was very nice indeed, better than
the hot air they made which sometimes almost choked me. I have
found my motto to be quite useful. Perhaps it could help some of
the poor, but if their eyesight is bad I'm not sure what one can do.
I ponder it at times, especially sitting near the smouldering leaves.
I find it helps.

Avoid the shouters.

Laugh a lot it clears the lungs.

Love David H

Renting a flat in Powis Terrace, Notting Hill, David eventually purchased the whole building, modernising it to include a separate studio. In the basement lived Mo McDermott, who had attended Manchester Art School where Celia Birtwell and Ozzie Clark had studied. It was Mo who introduced David to Celia and Ossie. The Swinging Sixties became full of life, of enterprise. Art, fashion, music, became creative talents, amidst the objections to war and armaments. Life became bohemian in London. In the provinces like Bradford there was change, but never like London. Energy, young people's energy, was everywhere.

The city burst with bohemia. Paul, my brother, helped David acquire a one-man show at the Lane Gallery in Bradford owned by Paul's friend, Eric Busby. The Busbys had large department stores in Bradford and Harrogate. The exhibition was a sell-out and the name Hockney began to be recognised as that of a new and upcoming artist.

In 1969 David must have been invited for dinner with Dickie Buckle, a lifelong devotee of ballet. Cecil Beaton must have been there too as my mother, reading Beaton's diaries 1963-1974 (*The*

Parting Years Diaries 1963-1974), came across this piece she wrote in her own diary:

After dinner at Dickie Buckles, David talked of the coming of the Golden Age. He had read many philosophers and has thought a great deal. In the next forty years all will change. The computer will do away with work: Everyone will be an artist. No need to worry, all the leisure in the world, everything will be beautiful.

There will be no private property or need to own anything. Everyone will be ecstatically happy. It was marvellous to see this white skinned, champagne topped, dark glassed young man in pale pistachio green, with bronze boots, orange- yellow alternate socks holding forth with such vehemence. Midnight chimed without realising that it was bedtime. David goes to sleep only when he is tired and wakes only when he has rested : never a question of a daily routine.

A few years later David was in his element. The picture he had attempted to complete three times was at last going to be exhibited publicly for the first time. He had struggled to paint *My Parents*. Until this third and last picture, he was never satisfied it truly represented who they were. I had driven Mum and Dad to London on a bright sunny morning. David was eager to begin their painting. His studio was on the top floor where he had placed a two-metre square canvas on an easel, allowing him to observe a drawer and shelf unit, on which stood a mirror and a vase of flowers. Underneath the drawers was an open shelf with a pile of books lying on their side. Chairs placed at each end of the unit were ready for Mum and Dad to sit. In another area of the studio was an unfinished painting of Henry Geldzahler looking at a screen of pictures.

They took their places, both sitting upright. David asked them to relax a few minutes whilst he set up his palette. At that moment, my father pulled his chair forward at an angle and took a book from the bottom shelf. When David glanced up, he saw their pose.

Mum waiting patiently as she was told. My father busying himself reading. This separation is how they are. Mum waiting for Dad to finish, but he never does as he is always busy.

David asked them to retain the pose whilst he painted them in their chosen positions. When each of we siblings saw the picture, we agreed it was honest. His rendition captured their situation wonderfully – their likeness of course, but it was also full of love and empathy. It is a truthful painting even though there is separation; the connection is what is happening in the picture, being themselves! Mum sat waiting for Dad to finish, but he never did, not until he died.

In 1977 David was given a one-room space to present his work at the Hayward Gallery. There were other artists who shared the exhibition, who I recall created either minimalist or installation art. I was able to attend the opening during one of my rare visits to London.

The painting of *My Parents* made its debut at this exhibition, with Mum and Dad attending. It was a proud moment. They stood each side of the picture whilst David squatted on the floor in front of his painting. My father painted from time to time, copying from a photo or a magazine. He had recently made a very good likeness of his hero, Sir Bertrand Russell, a man of philosophy and a stalwart for world peace. David hung my father's picture in his exhibition as something he felt was inclusive and made what he saw as a peaceful statement.

One room had some bricks and another four or five canvases on the wall with a ballpoint pen line drawn one inch around the perimeter of each canvas, another two inches around the perimeter and another three inches. I could never understand minimalist work, which in this case meant apparently years of progress. I still don't see it.

Fyfe Robertson, a noted and respected BBC journalist of the day, walked around the exhibits with David. When he arrived at David's room, he likened it to arriving at an oasis in the desert. The rest he called Phony Art or 'Phart'.

David in front of 'My Parents', Hayward Gallery, 1975

This statement was later to bring Fyfe Robertson to tears, as he was ruthlessly condemned by the art establishment. However, David supported Fyfe Robertson's comments, writing in *Art Monthly*:

> *People want meaning in life. That's a desperate need, and images can help… Unfortunately, there is within modern art contempt for people. You can read it in criticism now: the idea that ordinary people are ignorant, art isn't for them, you need a visually sophisticated group etc. This is all hogwash as far as I am concerned. That's why the Arts Council is devoted to certain kinds of art; they see it as a continuous struggle. They'll accuse Fyfe Robertson of philistinism, and shelter behind that – which I think is cheap. I think he has to be answered: there's a real case there.*
>
> *I do want to make a picture that has meaning for a lot of people. I think the idea of making pictures for twenty-five people in the art world is crazy and ridiculous. It should be stopped; in some way it should be pointed out that it can't go on.*

The publicity helped promote the exhibition, albeit for people to decide for themselves, but it was never well attended.

In 1999 the Australian National Gallery purchased David's *A Bigger Grand Canyon*. I happened to be in Canberra the same week for a storytelling conference.

We met up at the gallery. It is a huge painting, made up of over fifty-eight canvases, giving the viewer an authentic experience of colour and depth. Unless one steps back the picture cannot be viewed as a whole. Brian Kennedy, the Gallery Director, had approved the purchase and the gallery's international curator, Jane Kinsman was ecstatic; the purchase had been made for international art. A large exhibition of prints by Ken Tyler, David's printer from

New York, expanded the exhibition. At the grand opening with my wife, Helen and brother, Philip and his family, we were thrilled to see a major work of David's in Australia. It was given pride of place opposite Jackson Pollock's *Blue Poles* until Brian Kennedy left and the replacement director banished the painting to the moving staircase from the car park.

David stayed with Peter Goulds in Canberra and I arranged to pick him up from Sydney airport on Friday evening at five to have dinner together. Qantas let him down badly with cancellations, so bad he could have driven to Sydney before his eventual arrival of a 30 minute flight at 9 p.m. By that time David didn't feel like dinner. I suggested we eat a late supper at the Imperial Peking restaurant at The Rocks Wharf. It was a pleasant October evening. The view over to the Opera House set a magical tone. Having David's approval to order, I asked for the house speciality, Queensland mud crab in ginger sauce. Often, I have people who say, 'Oh! You're the brother who gave David the second-best meal he has ever tasted.' It was not over-filling, a delectable mouth-watering delicacy of crab and ginger. He couldn't believe the bill was so cheap compared with Los Angeles or Paris. I dropped David off at his hotel. The best meal he ate was in Paris, so not bad for Sydney.

David was flying back to Los Angeles on Sunday, leaving Saturday night free, but Helen had promised I would play guitar at some work function she had organised. I was irritable I would not see David on Saturday night, and kept saying so. We drove off to the function, still grumbling I was missing seeing David. We parked, and walked towards the door. Helen went ahead, I followed.

I was gobsmacked! A lump in my throat. Here in this room gathered my family, Philip and David, Peter Goulds, friends from Melbourne and Brisbane and Canberra to celebrate my sixtieth surprise birthday. Philip sat me down, gave me a beer, then

presented a *This Is Your Life*. He had made recordings of friends from England: Philip Naylor and Jim Cartman, Jeff and Marion Thelwell, and John Coultous and wife Janet, Mike Powell, my old guitar skiffle buddy, all spoke on the tape. Also, there were Ann and David Bottomley, and Mike and Linda Daldry, except they were not recordings, they were live, here in the room. Helen had saved for three years to give me this party, and I had verbally chastised her over the last hour. She forgave me, understanding she couldn't tell me, or it would never have been a surprise.

Philip had somehow organised flights with my UK friends.

On Sunday morning David drew a portrait of Helen and myself using Camera Lucida before we drove him to the airport.

On Wednesday June 21st 2000 David was offered the Freedom of the City of Bradford. Allan Hillary, a current councillor, gave the Freedom of City address. Allan had attended the same Sunday School and Youth Club so had known David in his early teenage years.

Allan said:

Lord Mayor, distinguished guests, fellow Council members.

I have been given the privilege of expressing support for granting David Hockney the Freedom of the City. I have been aware of David's exceptional talents and his deep loyalty to Bradford which he has sustained since his formative years in Eccleshill during the 1950's and 60's.

It was at Stony Lane Methodist Church, Eccleshill, where David and his family had close links that many of his contemporaries and adults first became aware of his exceptional artistic talent.

David became a star at Stony Lane Youth Club gang shows, when he would draw caricatures in charcoal – people in the audience would shout out famous names: Churchill, Atlee, Lloyd George , Montgomery. David, with just a few strokes, would bring the character alive to the great delight of the people present – I and other Club leaders threw away dozens of drawings during those years.

To me David has always possessed a single mindedness and confidence in his own ability. He certainly caused a stir when he left Bradford Grammar School at 16 years old, to commence formal art study at the Bradford Regional College Of Art in 1953. This was a period when David was seen drawing a series of complex trolley bus wires at Bolton Junction whilst lying on the ground on his back. David happily conversed with the observing people who asked, 'What on earth are you doing?'

To me David Hockney has commanded greater popular acclaim than any other British artist this century. He had acquired a national reputation by the time he left the Royal College of Art in London, with a gold medal for his year in 1962. With his very rich and extensive talent he has continued to explore many different art forms including modern technology, opera theatre stage sets and photography.

The extent of his versatility seems endless with no desire to sit back on his past achievements. For the past twelve months he has been experimenting with optic technology. Currently he is exhibiting at the National Gallery, London. His recently completed portraits of twelve National Gallery attendants is a first – having taken only one day preparation on each portrait, being a particular stunning achievement.

David Hockney has never forgotten his roots and has become a famous Bradford son in his own lifetime.

When one thinks of Art, one thinks of David Hockney and when one thinks of David Hockney they think of Bradford.

To me, David Hockney – Companion Of Honour, Order Of Merit, R.A and numerous honorary doctorate degrees can stand proudly alongside Frederick Delius and J B Priestley. What a trilogy of talent representing three art forms by three Bradford sons.

Granting David Hockney the Freedom of the City in the Year Of The Artist, seems particularly fitting.

In January 2012 I had an opportunity to speak to Edith Devaney, curator of David's *A Bigger Picture* exhibition at the Royal Academy.

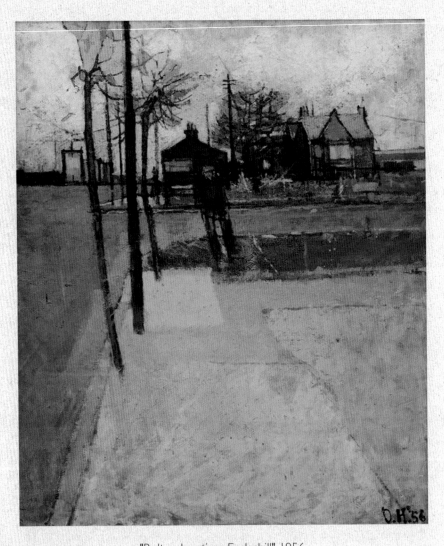

"Bolton Junction, Eccleshill" 1956
Oil on board
48 x 40"
© David Hockney
Photo Credit: Prudence Cuming Associates
Collection Bradford Museums & Galleries, Bradford, U.K.

I was overwhelmed by the size of the exhibition and its curation. I asked Edith if I could interview her with the intent of discovering how an exhibition like David's is planned. Where, how and when was an idea formulated?

Edith agreed to discuss the curation with me.

It began in 2007 when David had painted the largest ever painting created en plein air, *Bigger Trees Near Warter*. Warter is a small village in the Yorkshire Wolds. I happened to be in London at the time and experienced the moment.

David had asked the Royal Academy if he could hang the picture on the key wall in the largest of the galleries, indeed he determined the size of the work to fit this particular wall. This was the first time David had seen the work in its entirety, as he had no space big enough in his existing studio to view the picture as a whole. At the close of the Summer Exhibition Edith agreed to clear a room of all other works except for David's large picture which was constructed of 50 multiple canvases, an overall measurement of 460cm x 1220cm. Some scale photo facsimiles of the work were then placed on the two adjacent long walls.

If you can imagine standing in a single gallery in the centre of the room, your eyes take in not only what is in front of them but sense the work of nature around you as well. Pure landscape, pure nature that so excited Edith, and all of us who were there at the time. It was this moment, with David's masterpiece en plein air painting totally embracing the viewer, that activated Edith's concept that was to change their lives over the next few years. Her vision was ambitious, but she needed to persuade other parties at the Royal Academy to release galleries for one David Hockney exhibition, suggested for January 2012.

Edith used the moment, sharing her passionate excitement with Norman Rosenthal the then Director of Exhibitions. Norman

tentatively agreed to consider an exhibition, so they went to see David the following day at Pembroke Studios.

'One never commissions an exhibition', said Edith, 'But here we were putting the idea to David'. Normally, Norman is the person who talks a lot but for some reason, on this occasion Edith took the stage. She was excited, passionate, and enthusiastic with her unique vision of how this exhibition could be curated. It took three efforts to persuade the Exhibitions Committee to agree to release the other galleries, allowing David to create a huge body of new work.

David spent two days looking at the Royal Academy galleries, assessing the spaces, the light, visualising the concept in his own mind. He soon accepted what was to become the biggest painting project of his lifetime, spurred on by the passion of Edith Devaney and his own vision.

'I'll do it,' he said, 'As long as you will curate it, Edith.'

Edith knew if David gets the space – he will create the drama.

The concept was agreed, but now the work began. They needed sponsorship commitment.

Edith approached BNP Paribas putting forward her ideas. They too became excited, and she won their financial support. The Royal Academy could have carried the exhibition without financial sponsorship, but that would limit the supporting factors such as repainting walls and paying for film screens, designs and promotions.

In 2008 Edith went to Bridlington to talk to David, offering an outline of her progress and vision. David meanwhile had worked prolifically, virtually having enough work at that time to cover the needs of the exhibition, but even then, would have to cull some to fit. He was working on new ideas, filming moving collages of the Yorkshire landscape at walking pace, using nine cameras mounted to a jeep. The exact same view, at exactly the same measured piece

of road was filmed each season, so viewers experienced the distinct natural changes in seconds. It was new. It was thrilling, and it was nature. David was a great collaborator and open to ideas. He does love visionaries. It gave Edith great personal joy and excitement her own vision was being realised.

The curated selection had to be carefully considered to include some of his early 1950's landscapes around Bradford that gave the viewer a sense David had grappled with landscapes since he was a teenager. The exhibition followed his journey from that time.

When I arrived in UK for the exhibition in December 2011, I was travelling north after staying with friends in Wheathampstead and turned on the radio. An announcement declared David Hockney had been awarded the Order of Merit by the Queen.

How proud I was of our kid!

The night prior to the official opening in January was for David's friends and family. What a party! It was the first time we Hockney siblings and family were together in the one place for over 30 years.

The record attendances proved the success of the exhibition, and confirmed Edith's belief and vision back in 2008. I could not comprehend the body of work I was seeing. To realise every mark, every brushstroke had been imaginatively, skilfully positioned to provide so much pleasure.

Though it was cold and snowing outside, David Hockney's *Arrival Of Spring* gave a glowing warmth to those who visited the exhibition.

Eleven months later at Christmas 2012 I tried to speak to David to wish him a happy Christmas. I could not make out what he was saying, at first thinking he was either very tired or a bit drunk, but I knew he didn't drink. I sent an email to Margaret asking if he was well, only to be told he had a stroke in November, and she wasn't

to tell anyone. I was most concerned David was sick, so took a quick flight to the UK to see for myself. By the time I arrived in February, he had begun drawing with charcoal. It was a blessing. He has always said if he cannot use his hands to draw or paint, life is finished for him.

I sat in a wingback chair as he made a charcoal drawing of me. Margaret called in to see us both, and he made a picture of her too. It was good to see him speaking well, distinctly and sensibly. We drove over to the big Bridlington studio to see all the charcoal drawings he had made in the last month. No colour, as charcoal and grey perhaps fitted his mood?

I had booked a bus ticket back to London, but David insisted I join him in the car along with staffers John, and Dominic. The problem for me is that the confined space of a car when everyone else smokes isn't a healthy place. Nevertheless, I joined them on the journey, so we could talk. The following morning, I had to be at Heathrow early and Dominic woke to drive me to the terminal at 6 a.m. I asked Dominic how he enjoyed working for David. He loved it and looked forward to learning a lot more. He told me he had met so many important people and had visited places he would never have dreamed of had he not been part of David's staff. He looked forward to the future, to learn and to give.

Tragically, a week later Dominic was dead. It was a tremendous shock to David, me and everyone who knew him well in Bridlington. David withdrew from his world, totally devastated. He had lost so many of his friends over the years; some to AIDS, others to drugs, and Dominic's death became the only reason David left Bridlington, left Yorkshire, and left England for good.

Jean Pierre Gonçalves de Lima (JP), David's, assistant, sat in a chair in the Hollywood house soon after they arrived back to his Los Angeles studio. He too was distressed, sitting with his head

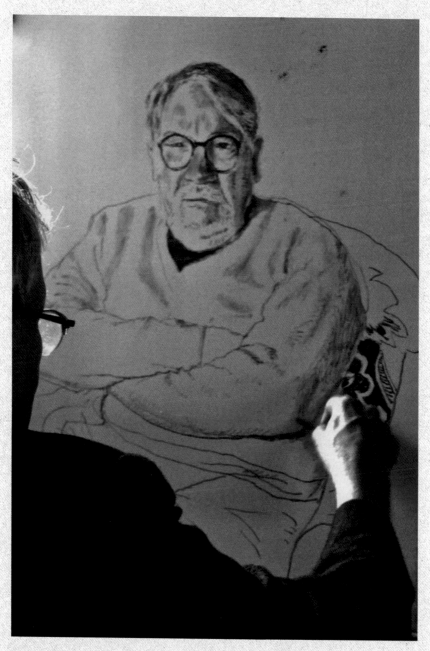

David Making a Charcoal Drawing of John, 2013

buried in his hands. David looked across at him, realising he repli-
cated Van Gogh's *Sorrowing Old Man*. The pose shared how they
both felt. JP's became the first portrait of a total of eighty-two
David painted when he returned to portraiture. The portraits
allowed David to spend time with many of his friends and family.
He reconnected with people, which became the deciding factor for
what David worked on over the next three years. His pain and grief
gradually eased through his love of his subjects and the time he
spent with each of them. It wasn't only David's time alone looking
at and painting people, it was the break for lunch, quiet, where he
could hear and talk without noise. Gradually David returned to life
and what he loves most – painting. Each portrait took about three
days.

In October 2013 I accepted an invite to *A Bigger Exhibition* at the
De Young Museum in San Francisco. My sister Margaret flew from
Bridlington with her friend Pauline. I had attended the opening at
the Royal Academy in London 2012 and was now seeing the same
exhibition but curated by Gregory Evans, David's faithful friend
and manager of his operation, with some additional charcoal works.

Never have I attended an opening of David's work as well staged,
flamboyant and theatrical as I saw that night at De Young. Usually
they are fairly staid affairs, with wine and dinner, inclusive of celeb-
rities and the artist's guests. But at De Young every employee wore
a blond wig, large black glasses, red braces and a bow tie, imitating
the blond Hockney of yesteryear. Huge polystyrene trees from the
Yorkshire paintings were placed in the entrance and directed people
to a replica *Sermon on the Mount* serving water one side and wine
the other. The triumph of the evening was the official opening,
when all the staff as replica Hockneys accumulated at the top of a
large stone staircase and 'razz ma jazzed' down the stairs in perfect
unison. Pure Hollywood, with David beaming from ear to ear.

The next day David drove back to Los Angeles with JP and others on his staff. I returned with Jonathan Wilkinson, David's technical assistant. Neither of us had travelled the coast road before, so chose the slow route and the opportunity to absorb spectacular views as the road undulated around pretty bays and towns. We stopped for a while to watch elephant seals dozing on a beach, snuggling against each other.

At dusk, we accepted David's suggestion to stay at the Madonna Hotel at St Louis Obispo. It is like no other accommodation I have visited in the world. It became a haven for Hollywood stars, with John Wayne a regular guest and investor. Every room is designed with a different kitsch theme. I was booked into the Fox and Hounds suite; a huge unit with leather couches and English wallpaper, featuring a gigantic stone fireplace and gas log fire. It was as big as my home in Australia. In the restaurant we sat in lolly-pink chairs trimmed with gold paint and brocade, finishing our meal with lolly-pink ice cream.

During our drive the next morning, Jonathan shared a story. It is obvious Jonathan has a great respect for David, not only as an artist or employer but someone who faces life and gets on with it.

Jonathan related a time he was sent to Marrakech for a photo shoot. He had a customised camera specifically built for the work he was commissioned for. The night before the shoot, the camera malfunctioned and he didn't have a spare due to its unique design. Jonathan began thinking about what David would do and remembered him saying you just 'get something.' He couldn't recall what that something was, but this was a similar situation. Rather than the expense and time of rescheduling his trip, he found a camera body in Casablanca and a lens in Marrakech. Though they were in fact incompatible, he managed to not only 'get something' but also got a photograph way beyond what he would have been used to

with his existing kit. It opened up something new for him.

When we arrived at the studio the next day, David was completing a painting of JP's nephew. I sat observing, when I suddenly realised, I should be writing down what I was seeing. I picked up my notebook and began.

I am sitting in David Hockney's studio watching the master at work. His assistant Jean Pierre constantly and silently moves around, photographing his every stroke.

A portrait of Kevin, JP's nephew from Paris is having the final shadow completed. Hockney stands back. 'That's it', he says, screwing his face and eyes for a momentary last glance. He pulls faces a lot as he peers at his work.

The painting is removed from the easel and placed on the wall beside two other recent portraits. David sits down, peering intently, appraising his work, observing every detailed stroke. He lights another cigarette. The whole of David's life has been about looking at people, and landscapes, every detail absorbed.

When designing operas, he would sit in the worst seats to make sure no one missed the visual experience.

Once the painting is complete the memory card from JP's camera quickly downloads all the photographs to a computer. Within minutes the painting is reproduced on a TV screen, showing every stroke in quick time. It's mind-blowing to see each recorded movement come to life. David smiles, turning to JP and quietly says, 'Very good.'

The purpose-built studio, with its windows designed to capture maximum natural light, is fitted with lighting suspended from the ceiling for night work or viewing. The walls fill with new pictures placed for observation, whilst on the back panel of a long counter hundreds of notes and reminders are displayed. The lino floor is splattered with multi-coloured paint droppings and brown stains from stubbed cigarettes. Paint-spattered armchairs and a sofa offer comfortable rest in between intense work sessions.

Meanwhile, JP replaces a blank canvas on the easel, as a different chair is positioned in readiness for the next portrait. Hockney works prolifically, his next subject already planned in his mind. Jonathan Wilkinson climbs into the chair, positioned on a raised platform with a blue velvet curtain as background. He prepares to sit in a comfortable position. When the sitter is positioned to David's liking, markers trace around the feet so the sitter will sit in exactly the same position again after rest periods. JP has repositioned his digital camera on a tripod. He rests a moment.

Hockney looks at Wilkinson, to the canvas, to Wilkinson, his eyes screwed up as he focuses on his subject. His hand holds a piece of charcoal to place the first marks, confidently, knowingly, in perfect perspective that allow the head, torso, legs and feet to fit perfectly proportioned on the canvas. Only experience and skill provide the necessary knowledge of where to place those marks. All David's portraits are full body rather than head and shoulders. He wants it that way.

He coughs quite heavily, undeterred, lighting another cigarette, and continues making marks.

It is silent as he works, no music or talking whilst painting is in progress. Nothing that distracts from his work.

David stops drawing to instruct JP about the palette he requires. They quickly organise. Everything is at hand. Mixing colour is photographed and recorded by JP in preparation to recommence the portrait. There is no stopping until David's command to do so.

Hockney is ready for the first application of colour. He is using a new acrylic paint that has a four-day drying time. JP lowers the easel, allowing Hockney to paint at eye height with his subject.

Standing on his feet for hours at a time does not seem to affect the 76-year-old. It is what he wants to do – what is essential to his being. If he cannot paint or draw – life will end. There will be no reason for existence, no point living. His art is everything – his devotion.

The only sound in the studio is the minute sound of JP's digital camera

capturing every stroke. They stop momentarily – a new colour needs to be included in the palette. It is completed within seconds. Hockney turns back to the canvas and JP to the camera.

'White, I need white'.

It is immediately there, and back again to the canvas.

I watch David, his eyes on his work – back to Jonathan – back to the canvas as he concentrates on the skin tones of Jonathan's face. His face contorts from time to time as he screws his eyes closed looking, always looking.

I wonder whether the click of the camera disturbs him or whether he can hear it at all. His genetic deafness will get worse, not better. Noise disturbs deaf people. I am aware myself because my own deafness is difficult in crowded or noisy rooms. I was introduced to JP's nephew Kevin but couldn't hear his name in the gallery surroundings where echo increases noise. I was embarrassed to ask again. It is a problem, a genetic family trait.

My gaze momentarily looks at three recent portraits on the studio wall. I notice, though the curtain backdrop is the same used in every picture, the colour background for each portrait differs. The stage floor is carpeted with a scruffy grey plain carpet, yet two portraits visibly have bold stripes on their floor surface. The real colour and texture of carpet and curtain is abandoned for one created by David that he sees as complementing the portrait with the colour of clothing the sitter wears. David's selection appears brighter. Artistic licence?

His hand never stops – nor do his eyes, they work in harmony together; eyes, brain, hands create. All the time I write, Hockney has worked on the canvas, now over two hours since he completed Kevin's picture. His passion, movement and observation have never stopped for one second.

At present he concentrates only on the task in hand – in his world – his excitement – his creation. My own hand tires writing. I think I will find it harder to continue than David. He seemingly tires only when he stops

the cycle of observing, looking, painting and drawing. His mobile phone rings. He has a special attachment that directs incoming voices direct to his hearing aids. He interrupts to speak as he works, but then the cycle is broken. He rests.

There is a total physicality when David creates a portrait: standing, looking, drawing, mixing, movement of arms, legs, hands, fingers and feet. Every part harmonises his process of making marks.

A quick cup of tea and the short break is over, yet even during those few minutes Hockney's brain works ceaselessly. An elongated iPhone picture he took having lunch at the Prince Hotel in San Francisco, he now compares to Vermeer's painting of *The Soldier and the Girl.* David points out how small Pauline is to Margaret my sister who is closer – how Pauline is pushed away as the lens records and distorts the five guests at the table. An observation that affirms David's theory of use of the lens in *Secret Knowledge.*

It is for me always a privilege being here, observing. We share an intimacy between us though David concentrates only on his work and subject. I have always felt inclusion, especially in California. It is different in England. Here he seems more relaxed, and so do his assistants. Perhaps the frequent Californian sun offers better light, and perhaps a better temperament!

David continues work on the head and face, shadow of cheeks and mouth, and the dark area of eyes that reveal the personal features of Jonathan's face.

JP clicks the lens open twelve times in the last minute, but sometimes it is many more. The number of photos taken to record a picture must be hundreds as the process the artist follows is documented.

What value or record for history will these images provide for the future? Imagine if we could have observed how Picasso, Matisse, Monet made their marks, to observe the old masters creating their

work. Perhaps if I look close enough at David's process, I can imitate his method, but unless my own looking uses the hand, the eye, and the heart to interpret, it will never be the same as the master.

JP concentrates again on the canvas through the camera. He decides when to click the lens, choosing what he records. Many shots may be discarded but the nucleus will finally be a faithful record of each picture David paints or draws.

For the artist, to scrutinise his own work in process is of signifi-cant value, otherwise what would be the purpose?

All the portraits at this time are full body, not head and shoul-ders. He did paint many head only portraits sometime in early 2000. From memory he finished them in about one hour each. They were on A4 canvases painted in oils.

Now feet and hands become an integral part of his portrait as a whole. I recall when he was looking at *Secret Knowledge* there were many portraits in full dress or regalia. Very few were head and shoulders.

I have two days before I return to Australia. David wanted to paint my portrait. I take my place in the chair. He looks at me and dislikes the Masai Barefoot Technology (MBT) shoes I am wearing. They have a radius sole to assist walking with a natural gait. My sister wears them too. David thinks they make my feet look as if I have a club foot. He lends me his Saville Row bespoke shoes for the duration of the portrait, whilst he wears old, grotty slippers.

I choose a yellow jumper with a red striped shirt, green socks and my borrowed shoes that are the most comfortable I have ever worn. I think the colours I have chosen will be a good balance for my portrait and the blue background will contrast with the yellow.

The first day I sit nearly four hours before he rests. We continue the next day but are still not finished. The day I am leaving I sit another two hours to complete the portrait. I love it, but then

I usually love what David paints or draws. At least this time he is painting me after I have enjoyed proper rest. I admit on some drawings I look a bit miserable but having flown from Sydney taking fifteen hours plus the time to and from the airport and to be greeted with, 'Sit there I'll draw you' is not a good time as my body need rest.

My portrait is number six, taking its place on the wall in numerical order.

A month later I receive a reduced-size laser copy of my portrait, placing on my wall with my Hockney collection.

In the UK and US, David is a popular figure, not only because of his art but his views on social and political issues, especially his favourite topic of smoking with which he is frequently in the media.

David is admired by the famous and un-famous. He has dined at the White House, Buckingham Palace, and Kensington Palace, has met the Emperor of Japan, and leading world politicians and aristocracy. He has been honoured by the Queen with the Order of Merit and Companion of Honour, and by his contemporaries with honorary degrees. His work is collected in art galleries and private collections around the world.

Accepted as a great thinker and an artist, David continually thirsts for knowledge, and in so doing becomes the teacher. He moves on, looking and using whichever genre suits his current pursuit. He shares what knowledge he discovers, willingly, because tomorrow he searches anew.

On his second visit to New York in 1964 he applied for a driving licence and was given a test immediately. He failed, asking when he could take another test. In England it would have been a month to wait. He was told in about an hour. He returned and passed, bought a second-hand Ford Falcon convertible, filled it with petrol and began his drive to California.

He loved the sunshine, swimming pools, minimal clothing and warm, balmy days. The exact opposite to Bradford's dark and over cast gloom. The light and brightness of California made colours vibrate. Crisp and clean; David was ecstatic.

The people he met and were introduced to were exciting and helpful. Many are friends today. The first time I visited David in Los Angeles he was settled in his house in Montcalm Avenue. My mother and my sister-in-law's mother were visiting at the same time.

On Christmas Day, David took us to the director and actor John Schlesinger's for Christmas lunch. The hospitality was overwhelming and embarrassing, when presents from under the tree were given to each of us. We never expected anything, but this was the warmth and presence of people in the film industry. We shared New Year with actor-director Tony Richardson and his daughter, Natasha. Tony had just one year before directed Mick Jagger as Ned Kelly. Some Australians seemed incensed that Jagger was given the role, setting fire to wardrobes and sets whilst on location in Bungendore.

We enjoyed tea with Christopher Isherwood and Don Bachardy; two friends who loved David's work and whom David painted and drew from time to time. I was browsing Christopher's bookshelves and came across a title '*How to Know God,*' he had co-translated with Swami Prabhavananda. Intrigued by the title, I took it from the shelf, to look at it. Christopher took the book and signed it to me as a gift. With Mum, myself and Mrs Rushworth accompanying David wherever he went, he was so proud to introduce us. We felt like royalty.

We were treated to tea at film director George Cukor's home, meeting people who were George's friends and famous names in Hollywood. I noticed George collected pictures by Monet and Matisse.

In January 1982 David was finalising his design for a performance of *Parade*, a triple bill at the Lincoln Centre in New York. My mother, brother Paul with his wife Jean and daughter Lisa were there. We stayed at The Hilton on Sixth Avenue, each morning strolling around the corner for a cheap three-bucks breakfast.

David took me to watch how the scenic backdrops were being painted. The studio was on the top floor of an old New York warehouse, and we took a lift to the upper floor. As we walked out into a huge open space, four artists worked on scenic backdrops. Each artist held A4 sheets of paper in one hand and a long brush in the other, painting on large, upscaled canvases spread on the floor. David marvelled:

'Just look how they can paint to scale by eye, just using the drawing I made.'

The artists used large brushes that looked not unlike soft sweeping brushes, converting David's scale design to the backdrop. The Met has a proscenium some twelve times larger than Glyndebourne, so the scale of any design was huge in comparison to the operas David had previously designed.

Back to the Met, to see how the Bo-Peep costumes were faring. David coordinated the costume designs with Ian Falconer, who was working for him at the time but left to create an illustrated children's book about a pig called Olivia. It became a worldwide bestseller!

The costumes for Bo-Peep in Ravel's opera *L'enfant et les sortilèges* were for the chorus, as they physically step from a wallpapered room to the stage. Picasso created a design for *Parade* in the 1930s; now David was adding his artistic impetus to a dance by Sartie, a French farce opera by Poulenc.

The opening night became a sell-out. Jackie Kennedy sat in a box seat. The whole evening was a visual and musical delight. I

had watched David using a model in his LA studio, testing lighting against bright red and blue. What we saw on stage that night made the audience gasp. Multiple curtain calls and tumultuous applause complemented rave reviews the next day.

Following his success, David treated us to *HMS Pinafore* starring Linda Ronstadt and Kevin Kline on Broadway. Paul, my brother, an enthusiastic participant in Gilbert and Sullivan operettas, played amateur parts at home. To watch this professional Broadway production was a memorable treat.

There was insufficient room for me to fit in a cab back to the Hilton with Mum and the family. David suggested we walk together.

'It's only two blocks and I can walk one block with you.'

We chatted about the enjoyment of the matinee and the success of *Parade* the previous night. Then David left me to walk the half block to the Hilton's swivel side door. When I pushed, the door was locked. A sign declared it was closed at six each evening. It was now six-thirty, and I was unaware of the fur-coated figure that stood behind me. I turned to find a woman holding a small gun in her hand, asking for my wallet and camera. I was dumbstruck, and terrified. White-faced, I stood perfectly still, passing my wallet, camera and small bag, watching her run to the opposite side of the road, and run off. Shivering and in shock, I ran the half block to the reception desk, explaining that I had been robbed. Their response was, 'Don't worry sir, you're alive!' Ten minutes later reception called me to tell me there was a block on my Amex card. Unfortunately, I had just changed three hundred US dollars in cash.

Reporting the theft at the local police station, I passed bashed-up police cars, and saw handcuffed people sitting on benches chewing gum. It was just like the movies, except this was real. There was no way I would recover any money or goods, the duty sergeant told me. I signed the declaration and he 'filed' it on a spike along with

a hundred or so others. He repeated, 'You're alive, sir!' At least I could claim insurance once the theft was reported.

The next night, cautious and frightened, I made myself walk alone. I was not allowing the incident to make me fearful in the future. I was OK. It was only one block. Having a drink in a bar with Gene Kelly's brother (or so he said), a conversation started with small talk but finished with living in the shadow of famous brothers. The next morning, David kindly gave me some cash, suggesting I return to LA and take Mo and his wife Lisa on a trip to the Grand Canyon.

I loved Mo and Lisa. Mo had introduced David to Ossie Clark and Celia Birtwell in London in the early 60's. He married Lisa Lombardi an artist in the 70's. They were happy to join me when I told them the news. Mo had been in drug rehab in the UK and the US. At present he was free, funny and creative, making marvellous tree cut-outs and hyacinths. He gave me a vase of hyacinths. After rehab in England he lived with my brother Paul and wife Jean to help stabilise. Six months later Mo returned to LA.

David loaned us a Chrysler wagon with lots of space, and windows for visual pleasure. Leaving Los Angeles over the mountains, we drove to Pear Blossom Highway, the last subject David photographed before he moved on from photography. Continuing through the desert we arrived in Las Vegas. Living in Australia, I was accustomed to long-distance driving, and we continued to St George in Utah for a first night stop. From then on it was slow, casual and easy, a virtual crawl as we meandered through Canyon country to Bryce. Being winter, snow had fallen. I knew how to drive through snow, having passed my test in the UK in 1957 with snow and ice everywhere, a hill start, on ice included!

We booked into Bryce Canyon Lodge, enjoying dinner and a few drinks. Up early after fresh falls of snow, the crimson-coloured

hoodoos sprinkled with snow were breathtaking to see. They were eerie, ghostlike, like supernatural sculptures. The air, crisp and cutting, with clear blue sky added reflective light onto snow caps. We made snowballs, a snowman and a snowwoman with tits. It was fun; an unforgettable experience.

Slowly driving down the canyon en route to Zion National Park became a totally different experience. From the canyon floor we gazed upwards, captivated by the rich red monoliths standing like giant sentinels watching over the valley.

Back through St George to Las Vegas: from the natural to the exploitive! Flashing lights, poker machines and heavy gambling. A man-made ugliness compared to the natural beauty we had seen. Poker machines as far as the eye could see. We checked in to the hotel. It wasn't Sinatra's joint, something rather humble but still Las Vegas. We walked on to Caesars Palace, posed with the statues and did silly things. The trip was happy, gay and fun, thanks to David.

The return to Los Angeles across the desert was uneventful, following Route 68 through Nevada to California. Only when we arrived into Los Angeles did Mo want to stop. He left the vehicle, returning five minutes later with a small bottle. I became suspicious, asking him what it was, realising Mo had just recovered in rehab. He said, 'Smell it if you like.'

I did – it was thinners, a solvent used as a paint thinner. I asked how much he had paid for it. He said, 'Twenty-five dollars.'

I said, 'You're mad Mo. You could buy a gallon of the stuff at the hardware store for that.'

I threw it out of the window. He never spoke to me again. A year later he died, the drugs too much for his body to take. The tragedy of drugs stays with me, and I thought of the hard work Paul, my brother and his wife Jean had successfully achieved with Mo after a year. I realised later I never should have been so judgemental. It

was Mo's life, but we had such a great time together and David had been very generous giving us all the opportunity of some pleasure and joy. We did love that. Those moments will remain as memories.

When I completed my father's archives in 1993, I returned to Australia via Los Angeles, and created five books, one for each of our siblings, selecting letters and photographs I had discovered. Gregory Evans, David's manager, was returning to New York so he accompanied me to Glasgow. I took him to the Glasgow College of the Arts to see Charles Rennie Macintosh's works. The next day Gregory went to New York and me to LA.

We selected letters, photos and pieces of interest we thought our siblings would enjoy. In his usual nonchalant way, David told me we were invited to Roddy McDowell's for dinner. I was always excited meeting David's friends, and from when we arrived, I found Roddy to be a perfect host. Sitting around a large round table with Maggie Smith, Dennis Hopper and Hal Hartley, Roddy was kind and friendly and very interested in what my father had achieved in his life. Conversation shifted from one subject to another until someone asked why I was there in LA. I told them what an exhilarating experience it had been sorting the papers and letters Dad had accumulated over his lifetime and what I had discovered about both our parents prompted a serious question addressed to both David and me.

'You mean you liked your parents?'

An odd question, I thought, though I naively hadn't thought about it because our parents had given their lives to us. The conversation changed to the topic of trust.

When Roddy died, he left his one hundred ashtrays to David.

Maggie Smith came to Sydney to play the Alan Bennett monologues. I went to see her and left a note inviting her to our home if she had free time. I received a card from her, recalling the

night at Roddy McDowell's with great affection, and she told me she had a photograph of us on her dressing table. I was thrilled she had remembered, but she was playing in Perth and didn't have the time to see us.

Following my father's death, Mum was invited to LA for Christmas. My sister Margaret and her partner Ken joined us. Angela, my stepdaughter, accompanied me from Australia, as Helen was working at Christmas and New Year. Angela and I stayed at the Malibu house as Christmas Day was to be held there. Tony Bennett and his daughter Antonia joined us. The house seems to be a non-threatening environment for those friends of David who are stars, and they are mutually honourable. Tony told me when he last came to Australia on the Hilton circuit, he was tired of staying in hotel rooms. He is a watercolour artist and loves painting. On a radio interview with Margaret Throsby in Sydney, he mentioned his love of drawing and painting and the boredom of staying in hotels. A man from the Northern Beaches rang to invite him to paint near his home. They have retained their friend-ship over thirty years or so. Tony drew a portrait of me, a very good likeness sketched with a ballpoint pen on blue card. To me, there is a wonderful camaraderie when we meet famous people in situations that are free of pressure or personal interference. People are people. Billy Wilder, the film director, called; Jack Larson who played Jimmy Olsen in the original *Superman* movies and lots of friends kept the day a long party.

In 1989 Helen and I attended an evening at Salts Mill in Bradford, the night David was sending live faxes direct from LA using two printers to two printers at Salts Mill. There were over a hundred and forty A4 sheets, making up one huge print entitled *Tennis*. The whole event was filmed by Yorkshire TV, who had cameras and crew in LA at David's studio and two cameras at Salts Mill filming

the assembly of the faxes. It was this publicity that drew large public attention to Salts Mill and Saltaire.

Sadly, Jonathan Silver became ill with cancer. His health deteriorated. David flew back to Bridlington where my sister lived with her partner Ken Wathey. Distressed by Jonathan's declining health, David painted a picture, *Sunflowers for Jonathan*. When he showed the picture to his friend who was so ill, David asked him,

'Tell me, what would you like me to paint, Jonathan?'

'Yorkshire', Jonathan replied. 'You've neglected it for so long.'

1997 was the beginning of David's sojourn in his native Yorkshire. Though Jonathan sadly died, David continued looking at the countryside he had abandoned for two decades. He began to see the Wolds with a new vision and, using watercolours for the first time since college, he brought Yorkshire to life. It was obvious he had a great passion for the beauty that surrounded him.

Unlike California, Yorkshire has four distinct seasons and David learned to know them intimately. How long the hawthorn blossom lasted. When the best time was to paint the morning or evening light. David spent hours sketching the differing plants of the hedgerows, so he would know them intimately.

It was here in Bridlington that JP, who had been hired in London, came into his own. My sister Margaret lent JP a digital camera to make himself useful. I have tried photographing David, but he was disturbed by the click of the lens so would not allow anyone to photograph him working. As there is virtually no sound with a digital camera, JP was able to take pictures of brushstrokes, or David mixing a colour. Nothing was shared until Margaret and JP worked out from the memory card how to download and watch how a picture was made.

David was thrilled, immediately recognising the advantage. From then on, JP photographed every work David made and

became a constant companion. Every frame was downloaded to the computer and replayed through a TV screen. From that day, every work has been recorded.

Due to my sister's deafness, she discovered using a computer was a boon for her communication. Margaret's new computer system, including flatbed scanner, printer and digital camera arrived on her doorstep. It opened up a whole new world to her. She could communicate with family or friends anywhere. It didn't matter that hearing was a problem. Margaret adopted technology as her way of communicating, and SMS on an iPhone became part of her world.

It was Margaret that discovered the app 'Brushes', demonstrating to David how it could be of use to him as a new medium. Initially he played his iPhone as a mouth organ or played the piano (there are apps for musical instruments). He began to play around with the Brushes app, drawing flowers and items in his room. Every day we received new iPhone drawings to our emails. A short time later he graduated to the iPad. His drawings improved the more he used the app, and he got software to enable enormous prints. His subject matter was around him, in his room, a view from the window, a vase of flowers, the kitchen sink, a pair of shoes. He was never short of a subject to develop his skills.

A surprise wooden box arrived on my doorstep in the Blue Mountains of Australia. I had no idea it was coming, but knew it was from David's studio. My emotions were mixed when I opened it. Made for each sibling was a half-original size of *My Parents*.

It's what I mean about the kindness and generosity of David to his family. *My Parents* takes pride of place among many other of David's etchings and drawings I have on my walls. I feel close to my parents still, even though they are long gone. A painting tells more than a photograph. We know the message David conveyed when he painted it and I can look at and enjoy it every day.

The Wagner Drive

I always thought of David as an artist using paint, pencil, photography, lithography and etching as his main genres.

One fine blessed day, David called us to be ready at exactly 4.15 p.m. My wife Helen and I were staying at David's beach house in Malibu. The house was purchased from a dear old lady who had built it in the late 1930s. There is a small lift from the garage to sea level, accommodating one person. David said it was used by Charles Laughton when filming *Witness for the Prosecution*. A lot of people wanted to buy the house, offering more money, but they would have torn it down and built a modern home. The lady wanted it to remain loved, as it was. David adored it, bought it and never changed it. He began using the fax as a new art medium from the Malibu house. At four thirteen on the dot David arrived, hurrying us up the steps to his red Mercedes sports car. I was opening the passenger door for Helen to sit in the front when David said, 'Oh! No, let Helen sit in the back.'

A CD of a Sousa march began to play as we pulled into the stream of traffic heading north. It was loud, blasting through a boot full of speakers, seemingly in harmony with the moving traffic. Sousa was perfect. Here we were in the US of A. Still utterly oblivious where David was driving us, or his intention, we enjoyed Sousa with the movement of traffic for a few miles. It was so America, so enjoyable, so thrilling.

Suddenly, we turned right off the highway onto a very minor road. The car stopped. David smiled but never spoke as he changed the CD. He looked at his watch, lit a fag. We began to move at a slow twelve miles an hour. I recognised Wagner as the car began to gently sway into a bend. It was gradual, soothing, seemingly in harmony with the environment. I felt David was using the car in a ballet with the landscape. The slow movement grew to an

experience, gently climbing, stealing glimpses of distant views. As Wagner's *Parsifal* began to ascend, the car climbed up with every corner, every glimpse of distant mountains combining a sense of sight and sound as pure pleasure. We were at one with the music and environment. Wagner's music energy increased as we danced naturally around bends, rising higher and higher. David glanced at his watch, smiled, and as the music burst into a crescendo, there in front of us at that exact moment were glorious blue mountains and the setting sun. I was breathless, didn't want to breathe in case it disturbed that moment of pure joy.

One felt like weeping with pleasure it was so magnificent. I have never forgotten that experience; never will as long as I live. The coordination of music, car, sunset all harmonising to a beautiful masterpiece.

The Wagner Drive was a precious gift to the few David chose to share his Wagner experience with. I marvelled at his creation and the time he must have spent to make the drive possible. I am sure others who were taken on the unique journey feel the same.

It was an art experience, but it seems too crude to say that. David's Wagner Drive was a combination of his prowess as an artist, his patience, and his love of music and beautiful landscape.

It happened then. 'Now is the only time there is.'

Helen was a bit ragged when we returned. She said it wasn't the wind so much as the boot full of super speakers she was sat on.

I know why David wanted me to sit in the front. Sorry Helen!

Seventy and After

On 9 July 2007 David celebrated his seventieth birthday, arranged by John his partner. It was held in the grand ballroom of his friend Sir Tatton Sykes, at Sledmere House, Sledmere. David painted

Sledmere village in the early days back in Yorkshire when Jonathan Silver was still alive.

Paul, Philip, Margaret and I attended. I was staying at David's house in Bridlington. John, along with David's staff, had gone to Sledmere in the afternoon to finalise details for the evening. David felt tired and had a lie-down. I was reading when the doorbell rang. A small blonde lady stood before me. I recognised her face but couldn't place from where. She spoke in an American accent, asking if David was at home. I told her he was sleeping.

'Oh!' she said, 'He asked us to drive over from the Lake District to see him on our way to London.'

'That's an effort,' I said, 'I'll have to wake him, who can I say is calling?'

'Bette Midler.'

How remiss of me not to recognise her, though I never expected Bette Midler to knock on the door of a house in Bridlington! With David, who knows?

I hurriedly made tea whilst Bette, her husband and children went upstairs to the studio with David. There is something rather awesome about meeting stars and famous people who chat as old friends. There are no airs and graces. I suppose they feel safe. Then, it is they who seek the company of David.

An hour later they left for London, and David rested again. For guests who preferred not to drive to Sledmere Hall, a double-decker bus had been hired to pick up guests in Bridlington and return them after the party. The party began on the bus, presents given and opened by David, and old-time songs sung in a happy, relaxed and joyful atmosphere. Like children, we all pushed the bell a few times. The party was fairly formal at first, champagne and drinks before dinner was served. A large birthday cake, decorated with an edible version of David's famous painting of Sledmere village with

Happy 70th Birthday David

its winding road and red brick houses, stood on a cake stand at the entrance.

Speeches were light-hearted, culminating with siblings including David singing my father's favourite songs, *Little Billy Williams* and *Why Don't Santa Bring Something to Me?*

The night was one to remember. David designed personal invitations and a menu. The dinner, designed and created by Celia Birtwell's son, Albert, was a culinary masterpiece. He imported his own staff from London specially to honour David. The night finished with fireworks from the terrace that would have been proud on Sydney Harbour on New Year's Eve. Boarding the bus home the revelry continued, its occupants filled with good food and wine.

There is always inclusion on these occasions. David leaves no one out. Anyone employed was invited, including cleaners. Everyone made to feel important, part of his team – that's David.

In January 2012 David's big exhibition '*A Bigger Picture*' opened at the Royal Academy. It was the only time *all* the Hockney family, including nephews and nieces, were together. A luncheon organised at Langham's Bistro off Piccadilly was private for family only. We will never all be together again.

On a visit to David's in 2015 he insisted on taking us out for dinner. We were allocated a table for four. No one could hear across the table, including my wife and Bing McGilvray, a friend and guest, who are not deaf. David had made a real effort on our behalf to take us somewhere pleasant, but it was pointless being there as we couldn't hear each other at all. It reminded me of an occasion when I was with David and other family members at a restaurant with very poor service. We waited and waited to place an order. David got terribly bored. Spreading his pink serviette on the table in front of him, he began to draw us sitting around the table, including his dogs Stanley and Boodgie. His drawing attracted the

waiter's attention, so consequently we were able to place our order and eat our meal. The owner asked if he could keep the napkin but David refused, taking it home and printing us a copy on his laser copier. I have the picture as a reminder of that time.

Helen and I went to New York in December 2015, then to David for Christmas and New Year. He is a consummate reader and gave me two books he was reading at the time, *The English and their History* by Robert Tombs and *The Brontës* by Juliet Barker. I gave David *1914: The Year the World Ended* by Paul Ham, an Australian writer whose book on the subject reveals an alternative viewpoint.

Though seemingly tired, David found energy to paint Helen and me in a double portrait – the first time he has painted simultaneously on two separate canvases.

I chose a two-piece blue pinstripe suit, a pale blue shirt with a red bow tie, and a red pocket handkerchief. My shoes were normal style, polished black, though still had the radius sole. This time David hadn't noticed, or he accepted them.

For the double portrait, two chairs are set up facing each other. JP is not here to use the digital camera, photographing David's marks on this painting; he is in Paris spending Christmas with his mother who is unwell. Bing controls the camera.

I watch David's intenseness as he begins. His face shows a severity as he concentrates his outlines first of Helen's profile, then my own. Helen wears a brown velvet top and tan colour velvet skirt, which later became a challenge for David's technique. Helen offered to change, but David insisted he must deal with the problem. He achieved the mix perfectly. I was overjoyed to view the finished paintings. David was pleased too. Mine was different from my previous painting. I like both, though posing with my head turned sideways for the duration of the sit was rather uncomfortable. Helen wasn't happy with her portrait, but it is how David

sees it. The two portraits took over four days to complete, with four sittings of about four hours each. Sixteen hours in all for two portraits. His work ethic never ceases to amaze me.

I am quite happy just 'being there' in his presence, listening to his conversation on art, books and current affairs. I have never been in David's company or that of his friends when I have not enjoyed learning something of value.

In mid-March 2016, I received another large wooden crate. It contained a digital photographic painting David gave Helen and I as a Christmas gift, one of his latest series, *Four Blue Chairs*, dealing with reverse perspective and differing vanishing points. I am always thrilled to receive his gifts and to be able to enjoy looking at his work every day. My friends enjoy it too. It has been a conversation piece since it arrived.

David's fame has touched all his family in varying degrees, mostly my parents whose simple life revolved around their home in Bradford. David paid for their visit to the Oberammergau plays. They sailed to Australia and flew to France many times to see David's exhibitions. Mum wore her Coco Chanel two-piece suit to Buckingham Palace when David received his Order of Merit from the Queen. She was given pearls from the Emperor of Japan, but they were too heavy for her ageing, thin frame to wear. She felt blessed with all that happened to her.

After Dad died in 1977, Mum continued travelling the world in first-class comfort paid for by David, along with support from my brother Philip in Australia. The famous have visited her humble house, as she described it. Vincent Price, actor and avid collector of art, had tea with her, as did a host of David's friends: Kasmin, Henry Geldzahler, Ozzie and Celia Clark, Gregory Evans, Mo McDermott, Norman and Jean Stevens. She was always thrilled and proud whenever any of us took people home.

As well as humour, smoking keeps David enjoying life. When Helen and I shared Christmas 2015 with him in LA, he repeated the phrase he often uses, 'I smoke for pleasure,' then broke into a long, wheezy cough. He will always smoke, quoting Picasso, Churchill, Monet. Most of his close friends and employees smoke. It is about their personal enjoyment.

David continues to engage in his lifetime love of painting and drawing. Learning and living. He has come a long way from the small attic we shared in our home at Eccleshill. No matter where he is, one thing is certain, he will be drawing or painting until his final day. Smoking as well!

I do agree there are bossy people who want to interfere and tell us when and how to enjoy ourselves. I used to smoke as well; all the Hockney siblings smoked, but I gave it up. It was my choice.

The same 'bossiness' David refers to about smoking also demands I wear a helmet on my bicycle. It stops the pleasure of the wind in my face blowing through my hair as I speed downhill, and to me an ecstatic moment of joy, and it's free. Costs nothing! In Australia, some local councils have cut off low-hanging branches of trees in case kids want to climb them. Layers of sponge rubber are laid in playgrounds so if kids fall they won't hurt themselves. I still have scars on my legs from falling from a tree or bike. We learned from falls, and enjoyed climbing trees, sitting in the canopy with caterpillars, butterflies and birds. It was secret, and quiet.

David had some badges made: 'End Bossiness Soon'. I should wear one again.

Today, at eighty-two, David is not as spritely as he was in the halcyon days of the sixties, seventies and eighties. But his ability and stamina never waver. He is working in Normandy capturing the four seasons in new work yet to be seen publicly. It will be new, interesting and very David Hockney.

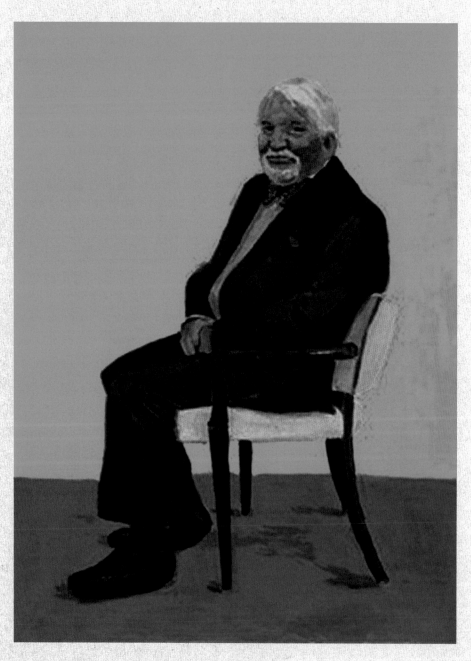

John Hockney – 1st, 2nd, 3rd, 4th, 5th January 2016
Acrylic on canvas, 121.9 x 91.4cm

14

John Hockney – Stage by Stage – Part One

BORN 23 OCTOBER 1939

David always knew he wanted to be an artist. Margaret became a nurse because her hours were anti-social, suiting her personality at the time and her own company.

Philip became an engineer when Dad suggested he work in a job telling people how to make things. Paul wanted a creative job but took to accountancy, and I wandered in and out, searching for a true vocation. Only David *really* knew from a child what he wanted to do and did it.

I'm not disappointed in what I have done, and happy in what I do now. 'Stage by stage' represents two parts of my life. First, the stages of life seeking my place, and second, my life has frequently been from a stage. I have no misgivings standing up in front of people to sing, entertain, make people laugh, and sometimes cry. I only discovered my *real* forte in life in 1995, fifty-six years after my birth. Everything else led to that moment because only then did I have the confidence, and never worried what the neighbours thought.

When my family moved to the village of Eccleshill from Steadman Terrace in 1943, I followed my brother and sister to school, only to be sent home as too young, at three-and-a-half years old. Enthused by my desire to learn, the headmistress, Mrs Bates lent me a book before sending me on my way. The book, published by Ring of Roses, consisted of no more than four or six pages with an illustration at the top and large print underneath. Each few days I looked at the words with Mum, learning them off by heart. When I returned and read the book to Mrs Bates with perfect pronunciation, I was given another to read and learn. By the time I started primary school when I was five, I had already read all the Ring of Roses series. Mrs Bates's kindness and initiative gave me a head start in reading and literature that has stayed with me all my life.

The first hint a specific pronunciation was lacking was when I couldn't say my Rs. No matter how I tried, the 'R' came out as a 'W'. My brothers stood in front of the fireplace singing 'The Wed Wivver Valley'. Taunting me, I wore 'Chewub' vests, making me all the more determined to pronounce my Rs correctly. My pronunciation success came from a brilliant Sunday school teacher, Miss Whittingham, whilst taking an afternoon walk through Thackley woods after buying me a Robinson's ice cream. Ice cream blocks

were wrapped in paper then sandwiched in between two wafers. There must have been a lot of untidy ice cream eaters, as wrappers were left scattered on the path as we approached the woods. My teacher suggested a game. Every time I picked up a wrapper I had to say, 'Rrrrrrobinsons'. At first, I couldn't get the hang of it, phrasing 'Rrrrr-Wobinsons' ices. But after picking up numerous wrappers, I proudly uttered 'Rrrrobinsons' ices. I was ecstatic, running home to join my brothers to sing 'The Rrred Rrriver Valley', ending the teasing, at least on that issue!

School for me began at Hutton Infants School when I was four years old, but not for long. The first morning I was given a teaspoon of cod liver oil followed by a concentrate of orange. Instead of swallowing it, I kept it in my mouth to spit out later. The next day I played truant, avoiding repetition of having the nasty stuff in my mouth. Playing on a disused tip near school, a neighbour saw me and took me home.

Mum took me back kicking and screaming – a delinquent in the making.

My father firmly promised the school I would be given cod liver oil in tablet form every morning. Years later I am allergic to certain oils, especially in oily fish. At infants school I made life-long friendships that exist today.

In August 1944 I began primary school at Eccleshill Congregational Church, used as an annexe to Wellington Road Primary School. David and Margaret attended the main school under the watchful eye of Mr and Mrs Bates, who were Headmaster and Assistant Head. The couple loved teaching, rewarding attentive students with stars stamped into their exercise books, but were quite ruthless with the cane if behaviour or learning didn't meet their standard. Classes were large, sometimes over forty kids, all trying their best.

221

As I never seemed to excel to top of the class, I felt I lacked compared with my older siblings. Viewing my school reports after Mum died, I noted I was actually pretty good. I was eleventh from a class of thirty-three, but reviewing my reports, noted I was only five-and-a-half marks behind first place, because marks were given in half points. My form place had never been discussed – except adversely.

Like my older siblings before me, I passed my Eleven Plus exam for grammar School. Carlton school to me was often a brutal, archaic place, with punishments inflicted by bored teachers who wanted to retire before the WW2, but were forced to remain when younger men went to war. Teaching methods were antiquated, along with punishments. Lines were thrown at students for the slightest misdemeanour, though industriously by tying three pens together with tape I could write a thousand lines three hundred and thirty-three times, plus one. Who was going to count?

There was a social mix of lads in my form who came from split or poor families. Harold, who had been away for a couple of days, brought a note to our form master who on reading it declared, *'You wrote this yourself.'* Harold had. Without further enquiry as to why, the master demanded him to bend over. The form master was going to cane him when Jeffries, a well-built lad of Indian descent, picked up a chair threatening the master if he didn't put his cane down. Jeffries, six feet tall, told the master he should have known Harold had only his father, who was blind, and his mother had died. The master sulked out of the room for the rest of the lesson. Following the incident, he made an effort to discover family circumstances.

I always tried to be an attentive pupil. I loved English, Science, Geography and History but struggled with Mathematics. Arithmetic was fine, but algebra or complex maths was difficult. Dad taught me late one night to use a formula for calculating answers he had

learned as an accountant. Confident I had mastered the workings, my stand-in maths teacher accused me of copying, disbelieving my differing work method to arrive at the correct answer. He never even checked my working. He gave me six of the best. I didn't tell my parents, and never bothered with mathematics again. When a first-form boy came with a note to a particularly cynical master, he teased the boy, picked him up and wiped the blackboard with him. Chalk all over the back of his blazer – not nice.

Though I improved my form marks, I spent four years in C class. The headmaster casually told my mother during an interview that the school thought I was a good influence over the other boys in my class because of my Christian and stable family background. Mum was aghast they had kept me down for their own reasons. So was I, the years could never be replaced.

I loved the stage and played parts in school and Sunday school plays or youth club Gang Shows whenever I could. In my fourth-year school report, my form master wrote:

'When John Hockney realises the classroom is not a stage, then he might start serious work.'

Today schools would have encouraged theatrics. I played a monkey in André Obey's *Noah*, though there was no standing ovation!

Before I started at grammar school, Mum bought some material to make my blazer, carefully embroidering the torch badge for Blue House. I thought it wonderful; with great pride for my first day until I noticed the tailored cut of blazers worn by other classmates. It was obvious my uniform was a homemade job. Fortunately, it was not compulsory to wear a blazer, as a large proportion of parents couldn't afford the outlay. The rule was never fully enforced.

I had no interest in soccer or cricket – both boring games! I refused to play cricket unless a tennis ball was used and was soon

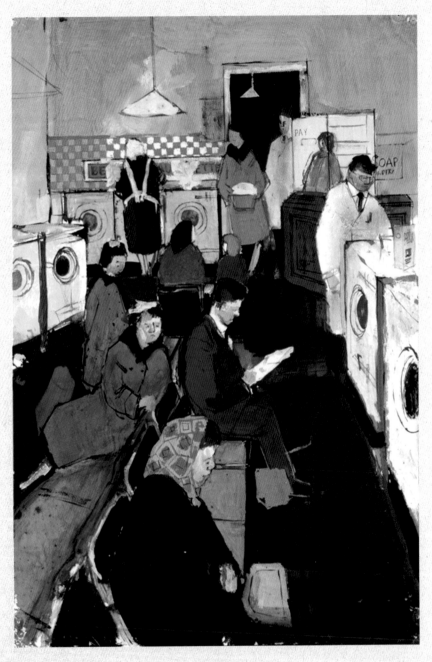

"The Launderette" Circa 1955
Gouache on paper
22 ¼ × 14 ¾"
© David Hockney

dismissed from soccer when the ball was kicked through the goalpost whilst I was keenly watching the mating habits of two robin redbreasts. When the sports master noted my swimming capability, I was immediately nominated for the swimming team. 'He swims like a fish,' the sports master said.

Although of tender years, I was made Blue House swimming captain. I rushed home to tell Mum my exciting news and I needed a new pair of trunks. The ones I wore had been used by Paul, Philip and David so by now tiny holes had appeared in the backside with noticeable pinkish flesh showing through. I asked Mum if I could have a new pair for the pending inter-grammar school swimming carnival. She looked at me with teary eyes and said:

'I'm sorry love, I can't afford any, but I can make some.'

I had no reason whatsoever to question my mother's experience with a sewing machine. She made our shirts and trousers so was confident to leave it in her capable hands. When the day came, I rushed home from school, had tea, and picked up my bundle of swimmers and towel ready for my anticipated win. Seats were already being filled as I arrived at Windsor Baths. The air was electric; here was my big night, I was totally confident of winning. I began to undress, but on opening my towel my face turned to horror. Here, lying on my open towel, were a pair of battleship grey wool swimmers, obviously hand knitted. I tried them on. Within seconds the burst of comments from my team barraged my ears.

'Wearing the tea cosy, Hockney?' one asked.

The longer I stood there, the more I was teased by my team and the sports master. I cursed my mother! As captain, I was given the news that Evans our diving expert was sick and wasn't coming, forcing me to take his place. My efforts to find substitute divers for that event were dismissed by the sports master who between bursts of controlled laughter said it was my duty as captain to dive. I'm

sure he knew what was going to happen. I hadn't considered the consequences, having to organise the team.

The spectators were silent; you could hear a pin drop as my toes wrapped round the edge of the diving board. All eyes on me. I lowered my knees, pushing up with my feet. I could hear the roar of the crowd as I went under, and my trunks stayed on top. Taking a big breath, I struggled under the water whilst my hand retrieved the heavy wool trunks. I pulled them on, swam slowly to the steps. As I pulled myself up, holding the chrome bars, my saturated trunks stayed down. My nude embarrassment had the crowd in uproar. I pulled them up, this time holding the trunks with a free hand and running towards the changing rooms, leaving the crowd in uncontrollable laughter. The sports master was holding his stomach as if in pain; tears ran down his cheeks as he gasped for air. I looked at him in anger, telling him I would never swim again.

As the laughter and teasing subsided, I was offered trunks by other teammates if I would swim again. They knew I would win. I did; as I believe everyone in that hall barracked for me, and I won a metre in front of my nearest rival. When I calmed down, I realised Mum had made what she could out of necessity, and love. My forgiveness didn't help when walking in town I saw strangers giggled pointing to me. 'It's him', they whispered. It was no laughing matter. I was twelve years old.

Leaving school, my friends Mike Powell and his brother Tet formed a skiffle band. I was learning guitar, but wasn't confident enough to play with the band. I had a strong voice from singing hymns every week at chapel. Mike played guitar and a kazoo he inserted into a small funnel, creating a trumpet sound. In our cellar we had an old wind-up gramophone with a horn-shaped sound box made of zinc. By dismantling the gramophone, the sound box would be a super instrument to play in the group. I carefully removed it,

decorating it and signwriting the name 'OKOPHONE' on each side. With a kazoo inserted, it created a rich, deep sound not unlike a trombone. I was back on stage.

Mike and I practised some neat harmonies. Mostly we played gigs at youth club dances and church functions, but sometimes my enthusiasm to remain on stage created a few problems. At a function at Eccleshill Congregational Hall we were playing to an enthusiastic audience, when the organiser told us to finish our gig. We still had a few songs to complete our repertoire, but he pulled the curtain on us. Continuing to play, we jumped from the stage to the dance floor – much to the pleasure of the dancing audience. Unfortunately, as I jumped my instrument caught one of the Christmas trimmings which in turn brought the whole ceilings decorations down on the dancers. We were banned from ever playing at Eccleshill Congregational Chapel rooms again, and our names were given to Sergeant Watson the local constabulary. Mike wrote a piece imitating a local reporter with a headline:

Band Banned by Church Circuit –
Fans riot as group refuses to go

From our Music Correspondent Melvyn Spriggs (imitating Melvyn Bragg)
Angry 'Jazz fans' attempted to break down a solid oak door at Eccleshill Congregational Church yesterday as their heartthrob 'Hocque' Hockney and his sidekick band the Delta City Six Group were banned from playing the lucrative Methodist circuit in Bradford's twilight jazz land circuit. A fracas ensued as security guard and part-time sideman Norman Button objected to the mass hysteria being generated by the hyped-up musicians, high on vimto, ordering the big hook wrenching Hocque from the stage, catching him in the middle of his Dark Town Strutters Ball. In a frantic attempt to finish the number, the singer, idol of the screaming Brownie pack, lunged from the balcony of the period concert room,

demolishing the Christmas decorations as well as the eighteenth-century plasterwork ceiling. Tough talking Norman Button commented, 'Hocque Hockney is a rat for doing this. The vicar is livid'. Strong words for an ex-Paratrooper-cook, now manager of the local fruit shop and decorated Brownie Akela. With that the Delta Boys and their leader were ejected from the building and their names taken by the verger. Last night their agent, Elston Dupré was unavailable for comment.

(It's a long time since Eccleshill has witnessed such depravity… good riddance we say) – Editor.

Mike reminded me of the many times we received fish bonuses from the fish-and-chip shop at the top of Eccleshill. Waiting in the queue late at night we sang hymns and madrigals in perfect harmony. The fish lady always got emotional and teary eyed, adding an extra half a fish cake to our order. David made a lithograph of the fish shop when he was at Bradford Art College.

My French master from Carlton Grammar School, Alex Eaton, formed the Topic Folk Song Club. It met every Friday above Laycock's Café in Bradford welcoming new singers. Alex was a communist, quite disliked by school management because of his political beliefs. He was also a member of the Peace Pledge Union and knew my father. He had tried teaching us conversational French by singing songs until the headmaster stopped him, threatening the sack if he didn't stick to the school syllabus. The conversational French I remember most was through the songs Alex taught. At the Topic Folk Song Club I was encouraged to learn guitar – or at least three chord tricks, as they were known. Every week they had an open mike session, so learners were encouraged to present. Workers songs were the most popular. The audience and Alex were very patient. The club still operates and held a sixtieth birthday celebration in 2017, the oldest folk club in Britain. Without the

club and enthused encouragement, I wouldn't have played guitar. My voice was strong from singing at chapel and Sunday School and could easily harmonise.

In1955 I left Carlton Grammar School to join Montague Burton Ltd, a men's multiple tailoring group, where I learned various cloth weaves, patterns and how to measure customers. A year later I transferred to the display division as a displayman. I loved the creativity and half-day closing mid-week when the store became my stage and fellow displaymen became my audience. They pretended to shoot me as I slowly fell down flights of stairs, just like the movies, a slow death. Sometimes, I performed mimes. It was this same exuberant bravado that eventually got me a date with a girl window-dressing Boots the Chemist, exactly opposite the Burton's store in Kirkgate, Bradford.

It was summer, long and hot with the dreamy twilight England enjoyed each year. My girlfriend was leaving for two weeks holiday with her parents. We had seen each other every day since we met, and I wasn't sure how I would manage not seeing her for fourteen whole days.

The relationship had begun with casual smiles at one another across the street, then peek-a-boo waves, until my bravado offered a kiss blown through the window and onto her lips. It was pure vaudeville, she with fluttering eyelids and me, a Yorkshire Valentino using the window as my stage to woo this fair young damsel. When I thought she was watching, I posed as a dummy, putting a price ticket on myself; selecting a pose whilst standing very still. Window shoppers gazing at the merchandise quickly moved away when I winked at them. Not good business for Burtons, but she loved this play-acting. It led to my getting a date with her. She was sixteen and I was seventeen, that seemingly glorious age of abandonment of anything serious for total indulgent pleasure. It was 1957; espresso

coffee bars, skiffle and drainpipe trousers were all the rage. Life was carefree, and we lived it to the full.

She went on her holiday and I was left alone. The hours ticked slowly by, and it was only Monday. Tuesday was even slower, and by Wednesday, I decided to travel south and surprise her. My employer agreed for the following week off and planned to leave on Friday afternoon. Courting a girl was a bit of an expensive pastime in those days. I had very little left of my two pound ten shillings after I had given Mum board and lodgings of one pound ten, so I decided to hitch hike – a distance of some two hundred and sixty miles. I left Bradford early Friday afternoon, catching a short bus ride to the Great North Road south, the best position to hitch a lift to the south of England. There were no others hitching, and lucky to pick up a comfortable truck going to north London. The trip itself was uneventful. Though the driver was friendly and wanted company, conversation was limited to weather, traffic, and his marital problems. He dropped me off at Hatfield tube station in north London.

Changing tube lines, I made for the Brighton Road, hoping it wouldn't be too long before I picked up a lift. I had been waiting half an hour and it was virtually dark when a private car with a couple of students travelling down to the south coast for the weekend helped me reach my destination by early morning.

At one in the morning, it was too late to register for the youth hostel, which closed at ten. Luckily, I found an empty shelter on the promenade. The shelters, with sloping slate roofs and ornate wooden pillars, are a legacy from Victorian England. They open on two sides with U-shaped benches, one side facing the sea and the other facing the flowered gardens and grand terraces of private hotels and bed and breakfasts.

I lay down on the bench facing the sea, enjoying the gentle

lapping of waves lulling me to sleep. Soon the bench felt rock hard and the cold snap with mist and sea air caused me to move to the warmer side of the shelter. Getting comfortable wasn't easy, I wasn't dressed for a cold night, and yet it was summer. I recalled sea mists were a natural part of a summer's night; I had to find somewhere warmer and comfortable. Walking along the promenade, I saw what appeared to be a café and it was open. A good pot of hot tea should see me through till morning.

The café was well patronised but unpretentious. Worn and scratched red laminated tables accommodated a single gentleman to each. Bentwood chairs painted a variety of colours provided the only cheer to the spartan establishment. Lino flooring was grubby and well-worn between the door and counter. A flashy new jukebox stood temporarily silent in a corner, and a hand-scribbled menu was the only decoration on the wall. The man behind the counter was balding and unshaven, a dirty apron tied around his chest. A half-smoked cigarette drooped from the side of his mouth and he coughed as he wiped washed pots, putting them on a shelf behind the counter.

My eyes wandered down the menu's scribble, and I realised in the warmth and cosiness how hungry I was. The menu was extensive, provided you liked chips and beans with everything. Spam, eggs, sausage and bacon, all served with a piping hot pint mug of tea and thinly sliced bread with a minute scraping of butter, all for two shillings. Spam, eggs, beans and chips was a feast for a king. I turned from the counter with my plate and mug of hot tea, looking at the men sitting in silence wearing blank, glassy expressions. I had to decide where to sit. My eyes scanning the room rested at a table occupied by a distinguished-looking older gent, a fashionable chap, wearing a grey tweed jacket and black polo neck shirt. His thick swept-black hair was tinged grey at the sides, and he wore a

neatly trimmed greying goatee beard. His cheeks and nose shone as if polished, and he stood out from the other lesser attired patrons, so I asked if I could join him. He nodded, silently motioning for me to sit down.

I must have looked quite dishevelled, and the speed with which I devoured my feast might have raised an eyebrow, but I decided to take my time with my pint of tea, so it would last an hour or so.

The gentleman asked if I would select some music on the jukebox. There was a distinct foreign accent to his speech and I wondered who he might be. Where was he from? Perhaps he was a count, or a wealthy artist. I slurped my tea – it happens when it's too hot – and looked towards him, still with my lips around my mug, nodding in affirmation. He pushed a shilling towards me. The jukebox played five selections for a shilling. I cannot recall what I chose, but it would have been hits I liked; skiffle, traditional jazz or the Beatles. I returned to my seat and he smiled again and thanked me. I picked up my tea and continued quietly slurping.

Our conversation ensued with the usual chit-chat about weather. There was the odd comment about how he liked the selection of music, and then he asked where I was staying. I told him until I could check in at the youth hostel I was taking advantage of the café being open. He looked at me straight in the eyes and still smiling, asked if he could offer me a comfortable settee at his flat.

The thought of a soft settee in a warm room was most welcome and I readily agreed, following the kindly stranger to the door and into the street. He wanted to stop off at a hotel on the way to pick up something. I wondered what it could be, and which hotel would be open at this time of the morning. We walked up the promenade, past exquisite grand Georgian terraces to a wide stone staircase leading to two huge black doors. Each had a decorative brass knob and handles, and windows with the name 'Savoy' etched onto an

opaque background. My gentleman rang the night bell and the concierge opened the door. There were quiet whispers between the two and money changed hands in exchange for what was obviously a bottle wrapped in a brown paper bag.

I was quite in awe of all this grandeur, never having had the opportunity to enter a hotel or even venture inside to see. I was still only seventeen. Alcohol had not passed my lips. The gentleman smiled at me and directed me down the steps and onto the promenade.

A short distance further, he stopped at a huge semi-detached white house. It was four storeys high with steps down to basement rooms and steps upwards to the front door. Huge high windows faced the sea like glass sentinels. As he put the key in the door, he told me that on a clear day you could see France from his first-floor window. That's odd, I thought, even with Dover being the shortest distance from France, one can only just see the opposite coast and Brighton is much further than twenty-two miles across the channel. Though I did hope later, when it became day-light I might catch a glimpse of the other side. Wouldn't that be a thrill? Dawn was breaking, and a delicious pink hue began to gently permeate the darkened night sky.

When my gentleman opened the door, I gasped. This was no flat as I had imagined. This was a palace. The white and black marble entrance hall opened to a winding staircase leading to other floors. My feet sunk into the rich red-carpeted landing. The walls were adorned with huge portraits set in gold gilt-edged frames. The woodwork and doors were painted a pristine white gloss. He unlocked the landing door in front of us, switching on the light as we entered. The room was huge. To the right were four high windows with interior wooden shutters. He closed the door behind us and locked it. I looked across to see the pinkish hue of dawn expanding towards us from the horizon. Mine host moved across

the room and began to close the shutters. Very considerate, I thought; the light might keep me awake.

I drooled when I saw the settee. I had never seen one as big. It would be heaven to put my head down for a few hours and enjoy this luxury. When he had secured the last shutter, the interior light cast shadows across the room. He leaned over the chair and switched on a lamp, then another. The lamps were ornamental statuesque naked ladies, standing on tiptoe with arms upstretched towards the ceiling. The lampshades were dark, allowing light to escape only from below and above, allowing a softness of light to the room.

The gentleman suggested I make myself comfortable whilst he would change and get us some refreshment. I couldn't believe this luxury. Looking around the room I noticed a table with a photo of a French château, a big house in the gothic style. On another was my gentleman with a lady and children. Family, I thought. On the long rosewood table in front of the settee was a photo of students in uniforms. They wore boaters, and jackets with broad vertical stripes, the style I would associate with Eton or a high-standing public school. I was studying the picture when he entered the room carrying two glasses and a bottle of whisky. The purchase from the Savoy no doubt. He had changed into a dark blue paisley-patterned silk dressing gown and was wearing a light blue silk cravat. Very swish, I thought, beginning to enjoy this taste of fine luxury.

He told me he couldn't sleep without a nightcap, and invited me to share one with him, but having never touched alcohol, I politely declined. He tried to insist, but I remained firm. It was guilt rather than my adventurous spirit. Being a teenage Rechabite, and winning a gold medal for a temperance essay, how could I indulge?

The comfort of relaxing in the softness of this settee began to make me drowsy. I just wanted to sleep, though manners suggest I

be polite and remain awake. He sat opposite me filling his glass to the brim.

'I shouldn't really drink this,' he said.

'Then why on earth do you?' I asked tauntingly.

He ignored my question. 'When I was at school,' he said, pointing to the photograph on the rosewood table, 'I had a fag!'

'A cigarette?' I asked.

'No!' he answered gruffly, 'A fag was a boy in a lower form that did your bidding. A cigarette, no', he said, shaking his head and looking at me as if I was stupid.

I recollected Tom Brown's schooldays associating it with that type of private school. He continued, 'If I was naughty, I'd get the fag to cane me.'

'Really!' I said with a frown, suddenly realising something was not right here. Hair began to bristle on my neck, a sure sign something was amiss. Trying to smile, I made some remark that it wasn't worth getting a caning for. But now I was very uneasy.

He continued to pursue the same line of discussion. His dressing gown by now had opened slightly and a portion of his naked thigh was in my view.

'Look, I'm taking another drink. I'm being naughty', he said.

'I don't care if you're being naughty,' I said quietly, wanting so much to put my head onto a cushion and sleep!

'If I do it again, you have to punish me,' he demanded.

His voice was becoming assertive, and I looked straight at him. I now knew this was no joke.

My mind was in a whirl. I was tired, not thinking straight. I suddenly realised no one knew where I was. My parents expected me to be away for a week. My girlfriend and her family had no idea I was in here. How was I to deal with this situation?

I had to try to think rationally. He stood up and went out of

the room. I looked over to the outer door, but the key had been removed from the inside. I was scared, virtually in panic. My pulse accelerated. I felt hot and clammy. What could I do? I had to think of something. He returned to the room with a long thin bamboo cane. He had discarded the dressing gown and cravat and was near naked sporting a pair of well-contoured striped silk underpants. My God!

He sat down in front of me again. Any other time and I would have thought this situation comical, but he was not a comedian, nor was it a comic show. This was real. I couldn't understand a nutcase who apparently enjoyed pain. I pondered for a moment, unsure whether that was all he wanted. What if he wanted to do it to me? I couldn't even cope with two of the best from the headmaster, let alone a torture instrument like this. My psyche was telling me, *go along with it and you'll be safe*. All I wanted was to get out.

He had been sitting back against the chair opposite me; now he leaned forward and poured himself another golden drink.

'I'm being naughty again', he insisted.

I began to realise I had no idea who he was, what his name was, or whether this really was his flat. Perhaps he rented it and would be gone tomorrow.

'You bloody bastard', I thought, 'I'll teach you'.

'Yes! You have been naughty', I said, surprised to hear my angry voice towards this pervert who was taking advantage of a naive stupid youth.

He instantly positioned himself across the rosewood table, pushing the school photo to one side. His eyes were pleading with me to administer the punishment.

Picking up the cane, I swung my arm back. I heard the swish in the air before the cane hit its mark on the covered buttocks of this imbecile. I was angry, very angry and very scared, but kept on

applying his desire for punishment with a gusto that surprised even myself, yet I was ashamed and perplexed at what I was doing.

He started crying, saying 'Thank you, thank you.'

I stopped.

I was drained, physically and emotionally, confronted by a part of life of which I had no knowledge. Why hadn't someone prepared me for this?

He got up. I still didn't know what was going to happen. Did he want sex?

Thank God he didn't.

'You'd better go now,' he said. 'You won't tell anybody, will you?'

I nodded my head from side to side, not wanting to speak. He went to the door, took a key from a cabinet and unlocked it. He held the door open for me to pass through and without saying a word or stopping to look back, I passed his near-naked frame. As I went down the stairs, he repeated, 'Don't tell anyone'. A chill passed over my body and I shivered. I unlatched the outside door and drank in the clean, fresh air of another day. Alive and untouched, I was shaken and felt betrayed by my trust in the kindness he had offered. I went straight to the bus station and boarded the first bus to London. I didn't want to see my girlfriend, not now. I felt obscene.

Watching the English countryside flash by, and thankful I was alive, I had time to reflect. Why was I not aware of this danger? Why had my parents or older brothers not told me what to expect? I assumed they also didn't know.

Being raised in a strict Methodist home created an illusion of always giving and returning love and kindness to our fellow man. My parents felt those who strayed from the paths of righteousness should be pitied and helped, rather than punished. But what did that mean? How did the innocent or naive victims survive or deal with their experience?

All of my social life had centred on chapel. Billy Graham the American evangelist was visiting UK and the north of England. I attended a meeting and like others was drawn by the soft music and emotional words, but the following morning life never seemed quite as rosy as the emotional confrontation with Christ the night before. Nevertheless, my life had been firmly guided by Christian values and regular weekly attendances at chapel. I suppose I felt with all this Christian love and charity in my heart, nothing could harm me.

I contemplated how my parents' social lives were limited, totally excluding the broader life of a larger world society. My upbringing in our provincial village of Eccleshill did not provide the worldly education appropriate to other aspects of social inter-course. Instead, I absorbed the same platitudes of the kindly but insular chapel folk, leading their daily lives without inquiring or understanding anything more than their small, tight world. That moment I resolved to seek out the knowledge necessary to equip me for any of life's confrontations.

As the bus sped closer and closer to Yorkshire, my mind tumbled. How could I blame my parents? They had only done what they thought to be right, within their own life experiences, and with love and compassion. If I tried to discuss this experience with them, I doubt they would understand, and mother would blame me. Even discussing normal, healthy sex was taboo. What I had learned was from toilet walls and a few mucky schoolboy magazines – how could I share this with them?

I appreciated how molested children who cannot share their experience until many years later, if ever, must feel, because in some way they feel the fault lies with them, just as I did.

I arrived home in Bradford, immediately visiting the village library to borrow books on anything I could find that would throw

some light on my experience.

I was aware sadism and homosexuality existed, but we were never encouraged at home or school to discuss such subjects. They were sinful or wicked. I found some books high up on the back-top shelves, where adult material was held but rarely loaned. I carefully assessed which books might help. Someone had borrowed a book two years previously, my other two selections had never been on loan. The librarian looked at me as I pushed my selection over the counter. Viewing the subject matter, the librarian suggested I shouldn't be reading this material. I told him I was over sixteen and wanted the books for research. He thumped the stamp hard, making such a noise people looked up from their reading.

My mother was surprised I returned so soon; I made an excuse about difficulty hitchhiking. I went to my attic room and put the books under the bed. I needed the company of friends for some sanity. Sharing the rest of the day with them, I made no mention of my experience. Returning home, Mum had 'found' my books. She was always suspicious of me. The books, she told me were 'not very nice', not the sort of subjects I should be reading about. If I would put my trust in God, my life would be filled with purity instead of disgusting or dirty thoughts. She wanted me to pray with her, but I wouldn't, so with a heavy sigh and a nodding head at my wilful attitude, she told me *she* would pray for me. Mother often prayed for me. But this time I made my own progress. Never again did I want to deal with a confrontational experience without having some ability to understand the consequences.

I felt let down by God, who didn't answer my questions. Nor did my mother.

Though there were other incidents in my life, I became aware. My decision to learn allowed me to always be in control.

The relationship with my window-dresser girlfriend lapsed.

Also, displaying clothing with limited artistic expression eventually became boring. I needed a change, taking a display position with Woodhouse, a furniture retailer in Darley Street. The work required a certain flair for creating room settings, which were changed quite frequently when seasonal promotions were advertised. The model rooms featured furniture with complementary accessories – pictures, cushions, indoor plants, to present familiar home settings. Much like IKEA do now, but this was the 1950s. I enjoyed my work, often working late Saturday night installing swop-over displays when a new promotion began at 9am on Mondays. The staff were friendly, fun and kind to be with. A real team pulling together.

One Saturday evening at ten to six, ten minutes before closing, a man in a suit walked in and asked my name. Smiling, I told him, John Hockney. He flipped through some envelopes, passing me a week's wages in lieu and told me to leave immediately. I was out of a job. I tried to ask why, but he rejected any discussion. I was shocked and tearful; I was a good employee, never a day off, worked overtime for nothing, why was this happening? The man continued issuing envelopes to other staff, including the manager, who had given ten years of his life to the place.

My parents couldn't understand it, questioning whether I had done something wrong. On Monday I went to another furniture shop in John Street, Jayes, and asked them for a job. I was employed, starting the next day. Two days later the manager asked why I had been dismissed from Woodhouse. I told him the truth, I didn't have a clue. I had worked hard.

He told me he couldn't employ me anymore, I had to leave, Jayes being owned by the same company. When I told my father, what happened he was incensed, and began to research who owned the businesses. He discovered virtually all furniture stores in Britain

were owned by Sir Isaac Wolfson, who held a monopoly on High Street stores through his Great Universal Stores empire, owning Jayes, Woodhouse, Smarts, and Jackson's.

Dad immediately wrote to our local Member of Parliament, receiving a response that a bill was being discussed in parliament for a 'Contract of Employment,' whereby any worker could not be dismissed without proper reason. A year later the bill was passed. Too late for me, but for others under the hold of monopolies it was at least a win. I was still despondent, knowing I always gave a hundred per cent effort. My brother Paul chatted to his friends at Busby's offering me a sales position in their department store. Busby's were incredibly kind and, being a family business, was staffed with loyal people. I was grateful, but for me it was a job that didn't excite.

A new jazz club opened in Bradford, in a cellar once owned by Tetley's Brewery. An arched roof, not unlike that of some of the old monasteries, added an atmosphere to what was to be known as the Students Club. On Thursday nights our skiffle group the Delta City Six were offered a free venue for rehearsal with a built-in audience. Other bands, Mike Sagar and the Crestas, played rock 'n' roll, setting a different tone and bringing a different audience. The main aim for the club was to promote jazz. I already sat in with Benny Netherwood's band at the Market Tavern on Monday nights, singing with the band and entertaining during the interval. The Students Club offered another opportunity. The floor was flagstone, and the roof and walls painted white. Candles in bottles were supplied to write a slogan or name using the candle's flame as a pen. Some art students painted murals on the walls in exchange for free entry. The entire atmosphere was very bohemian.

Mum and Dad monotonously tried to sway me away from 'sinful' places. I asked them to come and see for themselves, but

they refused. They thought it sinful because it opened until one on Sunday mornings, and they had read in the local newspaper hundreds of empty beer bottles had been found. Some investigative reporter for the local *Telegraph and Argus* thought a good story was forthcoming. The reality was it had been owned by Tetley's Brewery. The bottles hadn't yet been moved. Mum and Dad's problem, was they didn't believe me?

At the same time, I became resident compere at the Students Club, hosting major jazz bands. Humphrey Littleton, Acker Bilk, Ken Colyer, Merseyssippi Jazz band with Clinton Ford were just a few. The Earl of Harewood became an honorary member. Sessions began on Saturdays at 8 p.m. with local and feature bands from 10 p.m. to 1 a.m.

This period was the beginning of my confrontations with Mum. She could not accept I was listening to and participating with music in a warm and friendly atmosphere. Every week I walked home, arriving about 2am, a confrontation inevitable.

'Is that you John?'

My mother's voice called through the darkness from her bedroom. I was perched, hardly breathing, halfway up the dark stairs, my feet firmly wedged to each side of the staircase. I had practised climbing, feet pushing to the side to minimise a faint creak on one of the centre stairs. By striding over it, I should have made no sound at all. I had tried every way to lessen this disturbing noise. This was the best so far, but for a mother of sixty-two she had incredibly good hearing, unlike Dad who was stone deaf!

'Yes Mum', I responded.

'Come and give me a kiss goodnight. What time is it? I don't know what you get up to at these silly hours of a morning?'

I un-wedge my feet, and reluctantly enter her darkened room. She leans over to switch on her light as I stoop to kiss her forehead.

Mum moves her face to my lips. There is no kiss. She sniffs deeply.

'You've been drinking again.'

'Yes Mum!' I say wearily, sad that once again we re-enact this same weekly charade. 'I only had a couple of beers, and as you don't drink, I understand it probably does smell awful, but I am over twenty-one and there's nothing wrong having a drink or two with friends.'

'Yes, there is,' she says, 'It's a total waste of money. If you saved more, you could use it for something useful.'

Her advice was useless! Being her perceived wayward son hurt. She often asked, 'Why can't you be more like Paul or Philip?'

I silently mouth her phrase, 'Why can't you be more like Paul or Philip?' My inner voice responds, 'If only you knew, you wouldn't be saying that. Anyway, I'm me, and I'm OK!'

It was a stressful and unhappy situation for both of us. A sort of power game every time I returned late. Mum lay awake wanting a kiss. I attempted to make no noise at all, in the hope she was hard asleep. Her request was not because she wanted a kiss. She wanted to check if I had imbibed. I was being honest. I never hid the fact, but Mum had this uncanny flair for making me feel very guilty, and the confrontations quite wearisome.

I recall when I was twelve and had won a writing competition with the Independent Order of Rechabites about the perils of demon drink. On our way home, Mum and I walked past the Royal Oak Pub in Eccleshill. Wonderful happy sounds of mirth, singing and laughter emanated from its walls, but Mum shook her head saying, 'They're all sinners, all sinners.'

I thought to myself, 'They sound a lot happier than our lot in Chapel!'

'Goodnight', I whisper, moving to the door.

'Goodnight', she responds – in her recognisable tone of despair.

This same weekly scenario was farcical, and no help for our relationship, but what to do? The next morning, Mum had already left for chapel. Lying in bed, my eyes focus on the window. My room is now what used to be my sister's, across the landing from my parents on the first floor. I preferred to enjoy sleep in the front attic, but Mum wanted me in this small room, so she didn't have to climb another flight of stairs to make the bed or clean up. She had a point.

I adored the top attic room with its sweeping views across the Airedale Valley. Often, I gazed at the expansive vista in front of me, treasuring the lush, rich green of fields and scattered copses of trees across the distant hills. The changing seasons painted a kaleidoscope of colour for my view. Winter, with its short dark days cast a purple-grey darkness on tree trunks and branches, starkly contrasting with crisp white snow. The freshness of spring, with buds and blossoms bursting to accompanying birds returning from their migration south, and the lushness of summer, with heavy-laden branches drooping with emerald green leaves. And gorgeous, glorious autumn, when crispy red and golden leaves released by whispering winds were tossed lightly to earth, forming a patchwork carpet of rich, earthy colours.

I never tired of that attic room or its view.

I again focus on the bedroom window, calculating it is only one floor above ground level. An idea begins to formulate. Throwing back the covers, I leap to my feet, hasten to the window, and release the latch. After some exertion the window moves slightly from its previous locked position. Even the sash cords are brittle, coated lazily with previous colours of paint over the twenty-odd years Mum and Dad have lived in the house. Lifting and shutting a few times, the window eases. Block soap rubbed hard against each sash helps the window rise and fall whisper quiet. If I leave the latch off and insert a sliver of a Senior Service cigarette packet between the

window and sill, it shouldn't be too hard to shin up the drainpipe and in through the window. I get excited!

It's a simple exercise that may help pacify relations between my mother and I. The excitement and anticipation carry me through the week in high spirits.

The following Saturday, a beautiful moonlight night embraced me when I climbed the steps from the smoke-hazed jazz cellar. The radiused cellar ceiling arches were originally designed to hold barrels of Tetley's liquid spirit, rather than the invisible spirit my mother wished I would follow.

The Students Club had no licence for alcohol, and with pubs closing legally at ten-thirty, even if there was some alcohol on my breath, it would be at least four hours old by the time I got home. Sucking a packet of Fisherman's Friends mints never fooled Mum's ability to sniff the smallest indulgence. So why bother? It wasted good mints. It takes fifty minutes to walk to Eccleshill village from the city. A brisk walker can make it in less. I enjoyed strolling in the moonlight. It contrasted peacefully with the loud thumping beat of traditional jazz. As I turn into Hutton Terrace and through the gate at number 18, I hesitated, pondering if my scheme will work. There was no opportunity to practise. It works, or it doesn't.

'Of course, it will John, you know it will, just do it,' I assure myself.

I was fit, climbing up the drainpipe with ease, cocking my left leg over the stone windowsill whilst my right pushes for balance against the drainpipe. With some slight exertion I then use my left hand to push the tips of my fingers under the window. Without any pressure the window slowly rises. It makes not a sound!

Pulling myself through, I gently ease myself to the floor, turn, and close the window behind me, carefully switching the latch back to the lock position. I stand, wait, very still, not moving, trying not to

breathe, waiting to hear if there is a voice that will ask me if it's me.

Silence.

I quietly undress, pull back the covers, and have a heavenly sleep. Peace at last.

Waking early the next morning I look forward to a breakfast with a hot pot of tea.

'What time did you get in last night John?' Mum asked with a puzzled expression.

'Oh! About half past...' I said, letting my words slur to a silent nothing.

'But I never heard you,' Mum replied quite bewildered.

I answered with renewed confidence, 'Well, you must have been asleep Mum. I didn't want to wake you.' I studied Mum's face, as her brow became a frown. I knew she was trying to figure out how on earth I had got past her bedroom door. But then, just maybe, she *had* dozed off. This time!

There was no way of telling. I inwardly smiled.

The window eased our regular staircase confrontation, until I left for new experiences and new lodgings. It also improved my fitness, though at times I did wonder how on earth I still managed to access by the window, instead of the door.

Some months after our last confrontation, I accepted a position with Willerby's Men's Outfitters, who sought displayman for their Oxford Street store in London. David was at the Royal College and I could share some digs at least temporarily with Drag Kirby, bass player with the Bob Wallis Storyville Jazz band. Originally from Hull in Yorkshire, the band had made it to the professional London scene.

My problem was I burned the candle at both ends, working from 9 a.m. to 5.30 p.m. then off with the band on their night gigs, eating at the Star restaurant in Soho early morning, so naturally little sleep. It

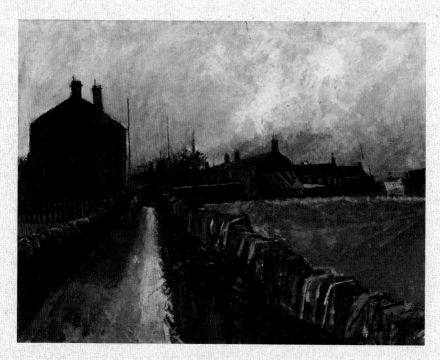

"Tunwell Lane" 1957
Oil on canvas
29 x 36"
© David Hockney

caught up with me, and had to make a decision. I took a job as a ward orderly at the local Plaistow hospital. Drag lived at Plaistow on the site of a Christmas cracker factory. Acker Bilk had lived there when he first came up to London with his brother Bernard. At Christmas, Drag went home to Hull whilst I stayed down in London. The hours suited me better than having to travel to Oxford Street each day. Leading up to Christmas was fun. I made most of the trimmings, as well as cartoons of the staff and patients drawn on long rolls of newsprint to cover the walls. We had lots of laughs from patients and visitors taking it all in good part.

Christmas Day was busy but fun at the hospital, though one patient became difficult. His appearance reminded me of the old silent movie comedian Ben Turpin. His eyes were crossed, and hair stuck out from his head. Just as we were serving Christmas lunch, he threw a tantrum, tossing his dinner on the floor. It was very sad to see his distress, but I was instructed to move him to a special room as he disturbed other patients in the ward.

Christmas day over, I returned to the flat only to discover I had left my keys. Climbing over the wall, there was one door inside the factory usually unlocked. Comfortably entrenched with feet up, listening to jazz with a cup of tea in hand, I heard a commotion and sirens outside. Police surrounded the whole factory. Someone had apparently seen me climbing over the wall, thought I was robbing the place and reported a break-in. I could easily support my authority to be there, and the issue was over. Ever since then when people read the little notes inside crackers, I always read, 'Help! I'm a prisoner in a Christmas cracker factory.'

At the start of my shift at the hospital next day, I was told the man who had the tantrum had died, and would I like to see him? The nursing sisters thought I would faint when I saw his body on the mortuary slab with his brain uncovered. He had died of a brain

haemorrhage. I was fascinated. Yesterday this man was alive, yet obviously unwell. Here he was, on the slab following an autopsy. The nurses were disappointed I coped yet sufficiently interested to look closely at his opened chest; his heart and lungs clear to see. The one issue I disliked was the smell. It's quite a repulsive distinctive stench, but I ignored it for the opportunity to view real human organs. Sewn up, and clothed his family noted how peaceful he looked. If only they knew.

My sojourn at Plaistow hospital lasted twelve weeks, sufficient to apply for training as a mental health nurse in Exeter. My sister Margaret lived there working as a Queen's Nurse, finding it a pleasant place surrounded by beautiful countryside. I considered having a qualification in health could be useful at any time in the future and for possible travel. I was still in limbo, clutching at straws, not really knowing what to do with my life.

When I arrived in Exeter, there was no formal accommodation for male nurses, being offered a room off one of the wards. In May 1960 I moved in and began training. There were three hospitals connected to the area, one at Wonford, one at Digby and one at Exeter. The first day of training, we visited each of the units as a familiarisation exercise, I became shocked to the core. In one ward at Digby hospital there were ninety-two senile mentally ill patients. The space between each bed was nine inches. There was one nursing sister and one trained nurse to supervise all of them. In the small kitchen off the ward, the enamel on the sink had worn off, harbouring a multitude of germs. On day one I became a rebel, commenting on the disgraceful condition of the mental health ward and questioning if the authorities were aware of the conditions. The ward sister, a cheery Scottish woman, answered:

'Of course, they know but they close their eyes to it.'

The accompanying tutor objected to my remarks.

'We are the ones who have to pick up the pieces,' she added, putting her arm around the nurse, 'Just the two of us!'

I admit Wonford was a far superior hospital, with newer and more spacious accommodation.

Next to my room on the ward was the padded cell where violent patients were given drugs and fitted with lockable suits. The floor and walls were padded, preventing the patient from causing any bodily harm. It was horrific and frightening for the patient locked inside. I tried it without the suit. A place one could easily go insane.

My accommodation was not really suitable, never able to escape from the workplace. As training progressed, I became friendly with a psychologist, who was also appalled at what he saw. He was responsible for administering ECG (electroconvulsive therapy), where earthed points are fitted to the head in front of the ears. Electric shocks cause the body to retract assisting with treating short-term mental illness. Most patients were heavily drugged. I honestly intended to proceed with the course, but I could not hold back from criticising the system. Were politicians aware of the archaic conditions mentally ill patients were living in? There was no way these poor souls would improve under these conditions. I pushed myself to study, complaining when issues I felt were morally wrong.

Eight weeks later, I was called to the chief male nurse's office to be told I was unsuitable for the course and required to leave within the hour. This time I felt I was being sacked for a good reason.

Returning home to Bradford, I can't say I was welcomed with open arms, but when I related what I had seen and why I had been dismissed, both Mum and Dad were extremely concerned. Dad wrote to our local MP asking what he knew about mental health institutions. It appeared there *were* politicians making moves to change the system. In 1961 the Health Minister laid out plans for

reorganisation and de-institutionalising of mental health hospitals. At least something positive was going happening.

I was never out of work for long. I won a display manager's job at M A Craven of York. The company was over a hundred and fifty years old and famous for their sugared almonds, Best English Mints and Mary Ann Toffee. Their main products were boiled sweets and my responsibility was designing packaging for product and promotional material for retailers and wholesalers. The recipes and process of manufacture hadn't changed in a hundred and fifty years. Plans to build a new plant on the outer areas of York had already begun. I took a pleasant flat overlooking the river Ouse in Peckitt Street. Mum made some traditionally designed curtains to suit the decor for me.

When the company moved to the new premises, diggers began demolishing the old building. Barely had work started when a digger broke an arm of its digging tool. Immediately all work ceased, and archaeologists were called to investigate. What the digger had hit was the top beam of a Viking Hall. The site became the biggest find in Europe and it now houses the Jorvik Viking Centre – well worth a visit.

My brief with Cravens included a travelling exhibition utilising a rail carriage that moved across Britain to major cities considered for an expanding market. The train carriage needed to be fitted out to display every product. The carriage would be moved overnight, ready for exhibition the next day in another city. The plans included sales staff travelling by car to the next city after the exhibition, sleeping, eating, and setting up by ten the next morning ready for the day's consultation. The itinerary had to coincide with rail links to meet our schedule, as well as not being too distant for exhibition staff, to safely travel between cities too exhausting. Like many of these projects, expectations and budgets didn't always add

up. There were certain factors that could not be changed; such as the cost of hiring and moving the carriage, accommodation and meals. This left the cost of fitting out the carriage drastically reduced, yet the train exhibition over a four-week period was a great success and increased retail and export sales. The company had never previously ventured into mobile promotion, but the effort and uniqueness paid off.

On weekends in York I met with friends Philip Naylor, Jim Cartman and John Coultous, who came over from Bradford. Friends Janet and Mike Powell, who lived in York, joined us too. Each week we imitated a foreign language. We all could speak 'Yorkshire' except Jim, who spoke five languages fluently. Jim was elected to order drinks at the bar of the Kings Arms pub pretending to be Russian. He imitated so well the barman totally believed we were all delegates from Russia visiting York Cooperative Society. It was extremely difficult to hold back our sniggers and laughter. Eventually we were rolling on the pavement outside. The pretence of impersonating foreign languages gave Mike and me an idea. We applied as a duo singing French songs at a music festival in Haworth.

We were billed as 'Elston Dupré (Elston is Mike's first name) and Hoque', a French singing duo. We thought singing *Plaisir d'Amour* and other songs like *Ma Normandie* would make the festival interesting, adding a French flavour. The night of the event we wore short cream raincoats and berets, standing at the bar, smoking Gauloise cigarettes. Some girls from our home town recognised us, shouting, 'They're not French! They're from Bradford'. Our disguise betrayed, we were kicked out without even performing.

The largest audience I ever compered was at the Bradford Gaumont Cinema, when the Students Club engaged the popular Acker Bilk Band to perform in concert. The cinema held three thousand two hundred people and was packed to capacity. I was

John with Crescent City Jazzband, Bodeca Nighclub, Manchester, circa 1962

hesitant how I was to introduce the band as an event to remember. I admit I had the jitters. Acker Bilk was the biggest name in British traditional jazz. I spoke to Acker, suggesting to introduce the band one by one, beginning with percussion and rhythm, trumpet, piano and trombone leading up to clarinet with Acker as the final focus.

I first had to capture this audience. My brother Paul and wife Jean were there, as well as many friends. Three thousand two hundred faces, was three thousand more than the usual crowd at the Students Club, where most people knew me well, my humour and idiosyncrasies. I walked on stage still without a plan to connect to the audience, so I tripped, just a light trip looking back at the floor as if I had really tripped over something. It was silly but the audience laughed! That was it, now relaxed, I held them. My nervousness fell away. The pre-patter and introduction won them over, and with the final '… *And here…. is…M i s t e r Acker Bilk!*' the audience went mad. Acker was thrilled, and the night a complete success.

Between jazz, folk and skiffle moments, my friend Philip Naylor and I would camp or hitchhike. Davy Crockett hats were popular

and Philip's mother, a furrier, had made one for each of us out of rabbit fur. Arranging to meet two friends, in Windermere in the Lake District, we were delayed hitching lifts. We arrived at 1am early morning at our prearranged shelter overlooking the lake. We found no one there, and tried to sleep but were very cold. Walking back through the town, we came across a telephone box and squeezed ourselves with sleeping bags inside. It was an old-fashioned phone box with a coin box having a button A and a button B. When making a call coins had to be inserted in a black box, once the call connected one had to press button A which took the money for the call. If the caller didn't respond, then button B would return money for the call. We had been there about an hour when I very slowly and nonchalantly I raised my hand to push button B. I hit the jackpot! Eighteen shillings in two-shilling pieces poured into the cash cup. It was not premeditated, just a simple action. Leaving the telephone box (and trying every other one in town with no success), we headed for Appletreewick through the lush green meadows of Yorkshire. It was Easter, and the weather was warm and sunny bright. Lambs gambolled in the fields. The eighteen shillings was soon exchanged for pints of mild at the Royal Oak.

I was still working for Cravens in York but was home for a visit. I saw Alwyn Schnacke running for the bus. Her tight skirt caught my attention, but unfortunately, restricted her last dash to reach the bus by a second. I knew Alwyn by sight at the Folk Club, so offered her a lift. She told me she was finishing with her boyfriend, who I knew well. Dropping her off near Peel Park, I thought she always looked smart and liked a laugh, suggesting if she was there when I came back from posting a letter in town, I'd give her a lift home.

We became a love affair, culminating with our marriage on 2 April 1965. There were a number of events that pointed to the writing on the wall, so to speak. The local Conservative club that

was booked for our reception rang two weeks before our wedding day advising they had double booked, and our booking was cancelled. It posed a problem for us, as my parents were teetotallers and Alwyn's were not. Using the club would have conveniently catered for those who indulged in alcohol and those who didn't. Thackley Methodist Chapel, our marriage venue, had a no-alcohol policy, but we were able to access the Church of England rooms at Greengates, just to enjoy a sherry. We had paid upfront for caterers to provide afternoon high tea. Two days prior to our happy day, my car engine blew up. My sister's friend Pauline loaned us her car to drive to the Lake District for a short honeymoon.

The day of our wedding arrived. My father offered to cover the wedding photography and had three cameras. The ceremony itself went off well. Dad posed us for what seemed like ages in various family groups before we drove to Greengates Parish Church Hall for our reception. As bride and groom, we were first to arrive, only to find the doors firmly locked and worst of all, no caterers. Guests began to follow as my friend Philip Naylor found the caretaker and opened up the empty hall. Mobile phones were way off being invented, so all we could do was wait. Terribly embarrassed with guests stood without any food or drink, and an hour went by before the caterers arrived.

The sherry was drunk to appropriate toasts as we escaped the buffoonery for the Lake District. With heads held high we dealt with the problems. Alwyn and I thought the day could have been filmed as a comedic farce. But it wasn't a film. It was real!

Arriving home after the honeymoon, we called at Mum and Dad's. I knew immediately there was a problem as soon as I asked Mum what the wedding photos were like. She became teary. Dad told us he was 'very vexed' as it turned out he hadn't put film in any of his cameras. As I say, sadly was the writing on the wall?

Helen Hockney – 1st, 2nd, 3rd, 4th, 5th January 2016
Acrylic on canvas, 121.9 x 91.4cm

15

John Hockney: Stage by Stage – Part Two

AFTER EMIGRATION

Prior to our wedding day we had applied to emigrate to Australia. Margaret, my sister, had lived there, and Philip with wife Mary and daughter Bev left the UK in 1962 now living in Sydney. However, we were turned down on medical grounds as Alwyn had previously been treated for tuberculosis. Due to our rejection by the land down under, I took a dream job at Bradford Regional College of Art as Keeper of Studies, considering my own long-term future commitment, and the fact David's fame was growing.

In July we were suddenly re-offered a place in Australia. It was a difficult decision as my work at the art college was highly regarded. I designed appropriate promotional material for visiting exhibitions from the Victoria and Albert Museum as well as planning student and tutor exhibitions, framing and hanging work in the gallery. I learned screen print and lithography and got paid for it. I was twenty-five years old and could return in two years.

Leaving Bradford by train with Mum and Dad, we called on David in London before we took the tube to Heathrow. David drew a pen-and-ink sketch of Alwyn and I sat on his sofa. Neither of us had ever flown previously. Ignorant of travel etiquette I wore a three-piece suit and carried a raincoat and umbrella. Alwyn wore a pleasant print dress gifted by David and made by Pauline Fordham, a designer in Carnaby Street in the sixties.

Seated in the Boeing 707 with a single aisle and two seats either side, we cruised down the runway for take-off. That first experience of thrusting power from the aircraft engines as we gained speed was a mix of thrill and fright. The journey to Sydney took thirty-six hours from London, stopping at Rome, Cairo, Calcutta, Rangoon, Hong Kong, Manila, Darwin and Sydney. Fed and watered each time we took off we all felt bloated by the time we reached Australia.

Sydney International Airport, was a collection of Nissan huts. Migrants were quickly processed through customs, though the terms of our 'Ten Pound Pom' scheme meant we forfeited our British passports for two years. Philip, Mary and Beverley were at the airport to meet us. It was a bright, sunny Saturday July morning with the sky blue and not a cloud in sight. It was winter, but for me, used to the contrary weather of England, quite warm.

Philip drove a Ford Zephyr, quite a flashy model, like an American car. We carried little luggage, just a change of clothes. Philip announced we would travel via Epping Highway.

A short while later I asked how far to the highway. He said, 'You're on it.'

It was a normal two-way road, not a highway as I had imagined. Arriving at Philips home around midday we were tired but appreciative of the first barbecue they prepared for us. It took days for the jet lag to wear off.

On Monday morning I started job hunting, interviews were far different from the formality of England. Bosses were happy to be called by their first names. There was a friendliness and casual approach to what never seemed a formal interview. I was happy to accept the position offered in display at David Jones Elizabeth Street Store, starting the next day.

A few weeks later, we found some accommodation of our own. Australians convert garages into what they call 'granny flats.' We moved into one in Eastwood with a bedroom, a lounge and combined dining room and a small kitchen, toilet and shower. Quite useful and pleasant near the railway station. The landlady, an Italian lady called Mrs Paloni, was kind and welcoming. We paid two pounds a week, though we waited six weeks for our belongings to arrive in two tea chests. It felt like Christmas, opening our own things. Records, books and pictures helping us feel we now had a home.

First impressions of Australia were questionable. Though workplaces were far more relaxed than the aristocratic hierarchy of Britain, the work situation in display differed greatly. The display industry for me offered less of a future, being relegated to hardware or the less worthy display tasks. The most exciting time came with the pre-opening of Grace Bros department store at Roselands. The first major shopping centre in Australia opened with great fanfare and success.

After it opened, I left display to work in industry, becoming a

'bonus basher', making telephonic cables for the new postal sorting office in Sydney.

As 'new chums', as we were referred to by Aussies, we went to see an Australian film called *Wake in Fright*. Viewing it with disbelief, I decided Australia was not for me, and wanted to return home. The film tells the story of a teacher who worked in the country outside Broken Hill. It is a violent film of man and beast, showing a face of Australian reality few wanted to admit existed. Donald Pleasance starred with Chips Rafferty, both great actors whose parts portrayed a cruelty and disregard for nature and man.

We didn't return to the UK at that time. We began, exploring the bush, discovering Australia for ourselves. We found a sense of togetherness in the communities we visited, provided you were white. Aboriginal settlements were usually a few miles out of town. Christians, believing they were good missionaries, were still removing children from their parents. A White Australia policy still existed but wasn't as partitioned as South Africa. Our travels helped to inform us first-hand as we learned about the countryside and the people; the more we travelled the more we met new friends, and the more we settled.

On Sunday alcohol was not served in hotels unless you were a member of a club. Otherwise one could drive more than thirty miles from Sydney's central post office to be classed as travellers. We could consume alcohol all day once we signed a traveller's book, then drive home. The law was eventually changed when breathalysing was introduced.

I joined Dexion, a British company, in their Speed Frame division. Speed Frame is a display framing system. I was established when twelve months later Brenton Fuller returned from Dexion UK to take over the company as Managing Director in Australia. I was asked to research the existing distributor reseller programme

and was given three months to complete the task. I had to establish existing buying patterns against products to help as a basis for a new distributor stockist network. I was given the task of setting up the new distribution system in New South Wales as a future model for other states Australia-wide.

The team at Dexion was exciting and enthusiastic. Brenton Fuller was young, challenging and impressed with my work. On a trip to UK, I manipulated a week at Head Office in London and to Dexion in Laubach, Germany, instructed in their promotional and advertising programmes. I returned full of new ideas, ready to apply them and move on. Time passed by, but I was impatient for the future. Nothing was happening. Philip, my brother, wanted to set up a sales division for imported goods for the transport industry. I joined him, both of us travelling to London for an international truck exhibition. We visited Yorkshire, having lunch at the Devonshire Arms at Bolton Abbey. A memorable day with all the family. David was making a name. Margaret was back at the National Health Service. Paul had become a local councillor on Bradford Council. My parents were content knowing their children were all doing well. It was the last time we were all together.

One surprising life-changing day I was practising guitar, fiddling with chords and songs when Alwyn suddenly began singing. I couldn't believe my ears. Mouth wide open, I had never heard her sing. I didn't know she could sing. Her voice was fantastic, clear and beautiful. Unique, in as much she sang with a Merseyside accent. Most singers lose their hard dialect accents, but Alwyn didn't. The Beatles didn't. Her voice was like a nightingale. Astonished, from that moment on, we began learning some songs as a duo – *Pearly Shells, Leaving on a Jet Plane, Plaisir d'Amour* and many of The Seekers songs to creating a repertoire. Alwyn had a natural shyness about her but enjoyed singing at friends' houses. I saw an

opportunity for us as a duo and pushed to get work in the clubs around Sydney. Most were Returned Soldiers or Sports Clubs but quite wealthy, with large auditoriums, professional sound systems and host bands. At Blacktown Workers Club, we finished our act to fairly good applause. Not the best, but fairly good as we were mostly singing folk songs and were told later folk didn't go down well in clubs.

A couple who enjoyed our performance greeted us after the show, inviting us back to their home for a coffee. They lived in a garage like ours, fitted with a bedroom, shower and small kitchen for a few dollars a week. We sang a couple of songs together instantly feeling a natural harmony. Barry and Leslie Ryder didn't actually become friends until much later, as we concentrated every spare moment practising our repertoire. The Seekers were big time in London, and we used a lot of their songs in our original presentations. About six months later we had an audition with a talent scout, Stan Herps. He felt we had an interesting sound and nurtured us, suggesting songs and directing our stance and movement. It was Stan who secured work in clubs, starting on Friday nights after work; we drove 100 miles to Newcastle staying in 'artist's digs' in Hamilton. Gradually,we won more bookings and requests from clubs. I began learning double bass, and Barry bought a new Maton guitar. We purchased an amplifier and microphones, providing some control of our own sound and our own equipment. Stan booked us in more clubs covering Canberra, Queanbeyan, the South Coast and eventually Sydney, our home base. We played our first TV show on *John Laws Tonight Show*, singing *Red Rubber Ball*, followed by *Don Lane Tonight Show*.

A Saturday night gig in Newcastle at The Leagues Club was well received during our first session. We had retired to the dressing room, when a waiter asked if anyone was called Hockney.

Newgate City Ramblers, (L-R) Alwyn, Lesley, John, Barry, 1969

I put my hand up, and he told me a chap called Roy thought he knew me. 'So what?' I didn't know any Roys. The guy was insistent, and my curiosity got the better of me. Here he was on a staircase in front of me. I had no idea who he was until he said, 'I'm Roy West. Rene's son.'

The last time I saw Roy he was nine and I was eleven, staying at his house in Bradford. Here he was, my second cousin, in Australia. He hadn't known I was in Australia and I had no idea he had come to the Antipodes. After the show we chatted. We invited him to stay with us in Sydney. It was a pleasure to have someone close to home who told lots of stories about me, mostly funny, that my mum had passed on to his auntie and his mum. Our relationship became a lifelong friendship.

The Newcastle shows included Sunday mornings at the Sulphide Workers Club. They were a pretty hard crowd, usually still bog-eyed from the night before, with guys taunting artists trying

to perform. A group of lads on the front row began flipping chewed paper at Alwyn, trying to get a piece in her mouth whilst she was singing. One stuck his feet on the stage, taunting her. I was about to interfere when Alwyn, still singing and smiling, moved forward and stood on his foot as hard as she could. From that moment they thought we were the greatest, sat up and took notice. Alwyn was in show business, that was certain.

We were offered a two-week cabaret deal in Adelaide, 1000km from Sydney so used holiday leave to drive across the Hay plains with my bass on top and running out of petrol. This was the real Australia we had never experienced before, where as far as you can see in any direction there is nothing! Apparently, there are cross-winds on the plains and with the bass on top it sucked the petrol consumption and was why we ran out. Luckily, a fellow traveller assisted with a can sufficient to reach Hay. We never made that mistake again. In Adelaide we stayed and played cabaret at the Enfield Hotel. Four TV programmes were booked, two with *Reg Lindsay's Country and Western Hour* and two *The Ernie Sigley Show*. The tour helped promote us and learned behaviour for TV appearances. We met Johnny Farnham on the Ernie Sigley set, and he invited us to a party after the show. He was English, a genuinely nice guy. His big hit then was *Sadie the Cleaning Lady*.

On our return to Sydney, Stan offered us a professional contract; we had sufficient forward bookings to become fully professional with bigger fees and TV offers. It was exactly ten months earlier we had met Barry and Leslie. It was fast track, but then every hour of spare time had been spent practising.

At Marrickville Returned Services Club (RSL), we performed to a fabulous receptive audience. After the show, Barry and Les wanted to have a talk with us. Their news was a bombshell. I had no idea they never wanted to be a professional group. They had other

plans, to move to Melbourne, have kids, and start their own curtain company. They anticipated my reaction, kicking the amplifier half way across the stage. We had never discussed our future, accepting performing was what we all supposedly loved. We eventually parted amicably but it was a disappointing blow to our future. A few weeks later Stan our agent had a severe heart attack and died. It was a tragic time for Stan's wife, and daughter, but they did kindly suggest another agent, Thurstan Cubban.

Alwyn and I cruised the talent quests looking for a couple who might want to form a quartet. Then we heard Dave, a Geordie twelve-string guitar player who came second to Alwyn and I at a talent quest in Ryde. Dave joined us, moving in to the spare bedroom, allowing practice every day. Our sound differed from the Newgate City Ramblers but was distinctive. Learning new songs to suit our different sound, we were soon back in action, reinvented as 'The Harbour Lights.'

We were back on stage, with good gigs, and a new agent. The future looked bright again, until Dave brought his new girlfriend to a gig at Katoomba RSL in the Blue Mountains. A disturbance occurred in middle of our performance. It was over!

Alwyn didn't have the heart for entertaining anymore. I couldn't blame her, but we had arrived at the steps of stardom. Had it all worked out, we were on the verge of making records and professional status. I was disappointed, but we had tried ,and enjoyed the success, whilst it lasted.

When Mum and Dad visited Australia in 1970, they watched a TV recording of the Newgate City Ramblers recorded on the Reg Lindsay Country and Western Hour. Dad tried to film it with his super 8 movie camera but picked up white lines and nothing else. It was eight months prior to the release of video cameras and video players on the Australian market.

When our group disbanded, I became unsettled. I thought it might be time to return to England, but Alwyn was concerned if we packed up and didn't get a job or a house, we would lose what we had worked for in Australia. We talked about it agreeing I would go ahead, and if within one month I didn't have a job or a liveable place, I would return, and say no more about it. Within a week I had a job with a car, and a furnished house in York rented from a doctor friend.

I had no idea at that time our relationship was flawed. Alwyn didn't return, eventually leaving Australia for a visit to UK. I had no idea anything was wrong between us, but obviously there was. Here I was in Yorkshire, and Alwyn in Sydney. Though six months later I eventually returned to Australia to pick up where we left off, our relationship never resolved. I eventually applied for divorce through the newly opened Family Law Court in Sydney. One year and one day after application, the decree nisi dated 23 October 1978, my thirty-ninth birthday, was released.

I thought all I had to do now was snuff it on the same day and all the dates would be connected. Divorce is hurtful and disappointing, questioning self, and the doubts of past difficulties. We were able to break up without too much animosity or angst. The words we spoke, 'For better for worse', came to mind. After thirteen years of a pretty good time it was over. We had foolishly never invested in property, devoting time to the group and singing, but it made the divorce split a lot easier to deal with. The most valuable items were David's pictures that he had given us over the years. We negotiated assessing values and because they were signed 'To John and Alwyn', we tried to split them the fairest way.

After our split I needed to find suitable permanent accommodation. I was appointed Manager of the City Showroom for a shopfitting company in York Street, Sydney: U-Rect-It Pty Ltd, a family

business. I had a company car but considered a flat close to the harbour and catching the ferry across to the office a wonderful way to start each day. I found a temporary bed and breakfast a stone's throw from Neutral Bay wharf. From outside it looked old English style, with a small garden at the front to sit out. A reception desk in the foyer was well-kept and clean, with fresh flowers in a vase on a nearby table. It had all the appearances of a well- appointed bed and breakfast. The room was still vacant but would be gone before lunch. My mind was fuddled not asking to see the room before I parted with money, as I paid my last two hundred dollars for two weeks with toast and tea for breakfast. I followed my host along a winding corridor, past some window views to stairs leading down a dark hallway. It began to smell damp as I followed him. He stopped at a door, opened it with a key, put his hand inside to switch on the light, leaving immediately.

I walked in, horrified! A single forty-five-watt bulb hung from the ceiling without a shade. A hospital-type iron-frame single bed pushed against a wall, unmade, with dirty sheets. A single wardrobe stood against the wall, with a broken mirror, and a set of three drawers. I sat on the bed with my head in my hands. *This is entirely my fault.* Cockroaches scuttled for dark as my foot squashed a couple stone dead. I felt sorry for myself at the lowest point of my life – I had paid my last money for a room I foolishly should have viewed beforehand. First impressions don't always count, and I was foolishly vulnerable.

This moment became my crossroads. I could only blame myself for my situation, no one else. I could not stay in this room. I was better than that. I asked for the return of my payment, but wouldn't give it. I really didn't expect him to, but it was a try. I had just thrown two hundred dollars away.

Walking out into the fresh cool air I felt alive and knew I had

taken charge of my life again. My brother Philip agreed I could lodge with them till I sorted permanent accommodation.

Within two weeks I moved into a small furnished bedsitter in Ben Boyd Road, Neutral Bay. There was a view looking across roofs to the harbour. Perfect for me.

Gradually, I began to live again, saving whatever I could. David invited me to LA for holidays and was generous with time and money. The trips were joyful occasions, meeting interesting people, sharing conversation and listening. I always returned full of expressive ideas, lots of confidence, and in time, the guilt of divorce began to wear off.

The City Showroom drew a different clientele from the usual shops. Advertising agencies and Sydney based Head Offices sought ideas for promotional material and bespoke manufacturing. I utilised our base products into point of sale units using simple changes. Unfortunately, our factory was constantly late on delivery, and with deadlines for advertising and promotions, irate clients left us as big advertising budgets and promotions needed point of sale NOW!

Chasing orders in the factory, I met with Managing Director, Cliff Gibson, asking how business was developing. I didn't know Cliff very well, only that he was the Managing Director. I now had the opportunity to share my problem. In his office I didn't hold back, assuming if he couldn't do anything, nobody could, and I would leave. Cliff asked what I would do if it were my business. I left nothing to chance, explaining in detail what I thought should happen. He sat back in his chair, seriously listening to every word I shared. Leaning forward across his desk he agreed with everything I said, and from that moment on I became Special Manager to the MD, responsible for interviewing everyone in the company, setting up job descriptions, implementing safety measures, and working with department heads setting up procedures designed to flow

production. I wasn't popular by any means, not until people began to understand the advantages of change. Staff gradually became less stressed because they knew what they were supposed to do. Cliff was terrific, backing me in everything I put forward.

To help employees feel they were part of a group of companies, I edited a company magazine, *Shoptalk*, introducing personal stories about individual employees, igniting a common interest throughout the whole of the Gibson Group across Australia.

Our Melbourne branch began utilising commercial dress racks as portable wardrobes for people living in flats. We adopted the idea nationally; identifying other products we registered as *'TIDEE'* as a home products division. Resellers with major department stores, and TV advertising soon swelled sales across the country, and as far as I know the system is still working today with over a million units sold.

Cliff Gibson was a fun-loving guy who saw his employees as family. There is no doubt I was offered a great job and a pleasant work experience. Work had kept me alive; I spent a lot of time working. Its creativity and relevant people skills helped me re-understand myself. I let go of trying to meet someone for the sake of it, concentrating on friends new and old and enjoying each day as it came.

Bill Marzouk, an architect at the company, invited me to dinner. Bill and his wife Greta were lots of fun, parties, and fancy dressing up, lots of slapstick! I accepted on the condition Bill wasn't setting up a blind date. He lied! A few drinks into the evening, the doorbell rang and in walked the most beautiful lady I had ever seen. I was wearing a black polo neck, black trousers and shoes, which she later told me made her think I was a priest, but then, I hadn't dressed to meet someone, especially of the opposite sex.

Helen Boecher Rafferty was a nurse. She passed her student nurse qualifications working in a Catholic hospital environment but on qualifying took an air hostess job with Trans Australia Airways. She loved the work, but when she wanted to marry had to leave, as no air hostess was allowed marriage. Helen married a German temporarily working in Australia. When their daughter Angela was born, they moved to Frankenthal, near Ludwigshafen, the industrial heartland of BASF, the worldwide German chemical company. Their marriage didn't work. After seven years, Helen returned to Australia when Angela was three, initially living with her parents at Homebush.

Helen's beauty, big, wide smile and twinkling eyes were breathtaking. The second I saw her I was hooked. The evening became one of continuous laughter. When we left that evening, I asked if I could see her again, but Helen sped away in her clapped-out Rotary Engine Mazda.

It was November 1979, thirteen months after my divorce. We agreed to a dinner date. I lived on the opposite side of the city, seeking a restaurant close to Helen's flat. A 'dine and dance' at Bexley appeared an attractive venue. On arrival, our table for two was lodged between the in and out doors of the kitchen, and the stage adjacent to the table, the least romantic place one could ever choose. Helen attracted me more because of her acceptance of the evening, laughing, eating the night away. For our next date I was determined to impress her. Delving into savings, I booked the John Cadman on Sydney Harbour. The pre-dinner drinks on deck created the magic of the harbour at night. Directed downstairs for dinner, we were placed at the top of the hull with no windows or harbour views. The repeat of an unromantic night didn't concern Helen one bit.

I was now in love. Really in love.

Our relationship grew, with Helen's daughter Angela accepting me to a point. At Christmas I had booked myself a week at O'Reilley's Guest House in Queensland. Christmas Day and Boxing Day was filled with cheer and good companionship but wondered why on earth I was up there, when I could be with the beautiful Helen. I rang to tell her I was returning to Sydney. She appeared pleased. Helen was intelligent, gorgeous looking, with the same political viewpoint, and had travelled and could speak fluent German. She was independent, and being a nurse had empathy for others.

I anticipated my increasing involvement would not be easy for Angela, nor for her to accept me. I felt for her. This man was taking her mother away, but I was prepared for her feelings. She was ten when we met and had had her mother's sole attention from the age of three. I was an intruder, a somewhat unwelcome outsider.

I always say Helen asked me to marry her, though she insists it was I who asked her.

I recall the exact place and time. Helen doesn't agree. But whoever asked, the other accepted and I was overjoyed that Helen Boecher would become Helen Hockney. The date for our marriage was set for 23 October 1980, my birthday. Brother Philip and his wife Mary had moved into their new house in Castle Hill. A sweeping drive led around a lake, offering a perfect place for our celebrant wedding. Philip had built a Rotunda in the garden overlooking the lake, amply accommodating our guests at their tables. It was fun, joyful and loving. Our honeymoon just a short two nights at The Entrance.

Neither of us felt repeating vows of life commitment should be made, though it has pleasurably turned out that way. Helen had not been given absolution from the Roman Catholic Church, and her father considered us sinful, refusing to attend our wedding.

I was conscious Angela's life was to be intruded by me. Rather

than moving into Helen's existing flat, I suggested we rent a house until we had settled. We took a house at Peakhurst nearby, a new beginning for all of us, helping us harmonise into a family unit.

Angela's high school began parenting classes, facilitated by the nuns. The course highlighted domestic situations and problem areas. I learned a lot from it. After six months renting, we decided to sell the flat and purchase a house of our own. We found a three-bedroom two storey at Penshurst. It had all we wanted but needed some decorative touches. Helen and I adored decorating, loved colour, and had similar ideas. She liked me to be a bit off-beat in my dress, another attribute to add to our list of compatibility. Even my wearing odd-coloured shoes Helen didn't bat an eyelid. The more outrageous the dress, the more she liked it.

Once settled in the house in Penshurst, I took a two-year TAFE graphics course, passing with credit. The tutor advised I should apply for Sydney College of the Arts, taking a design course. I was accepted and began in 1983. I chose a two-year option rather than three, which meant a lot more study. Helen was totally supportive.

After six months the college moved under the auspice of the University of Sydney, becoming a Postgraduate Diploma course. The end result was now a degree. I was disappointed if I didn't get a distinction, always aiming for high distinction every exam. I completed within the two years. Not only did I gain a Graduate Diploma in Design, I was asked to become a part-time lecturer. I withdrew from the position two years later when my hearing became too difficult in the lecture theatre, being asked questions I could not hear properly or answer. As students were paying for the course, I felt it unfair to continue.

Angela had finished school and a secretarial course and was working in an office in Sydney. We had considered settling in the UK. It wasn't a rushed decision, taking close to two years until we

left. Helen would be close to her sister Catherine, Angela to her father, and we could set up a bed and breakfast. Plus, I would see Mum and the rest of the family. I wrote to the Yorkshire and English tourist boards querying grant availability for a bed and breakfast. We received favourable responses, confirming the decision to leave Australia.

In 1989, we sold Peakhurst for three times what we paid for it, when loans were at seventeen and a half per cent with Paul Keating's 'recession we had to have.' Travelling to Europe via Thailand, touring in Chiang Mai, Bangkok and onto Germany, catching up with friends and family. Sailing the ferry to Hull in England from Zeebrugge, our trip had taken six weeks, and were ready for work when we arrived in the UK.

Between the time we left Australia and arrived in England, Margaret Thatcher had introduced the abortive Poll Tax. The law smashed our dreams and plans, as both the English Tourist Board and Yorkshire Tourist Board were de-registered and responsibility for tourism passed to local councils. If we wanted to set up a bed and breakfast in York, we had to install a stainless-steel kitchen, provide parking for three cars, plus annual house rates had soared.

The Poll Tax was grossly unfair, favouring the wealthy in its distribution. An elderly couple living in a one-up-one-down cottage suddenly had to pay seven hundred pounds annual rates, yet Castle Howard, on the outskirts of York, paid a thousand and fifty pounds for three people. Totally unjust, and the reason it was soon rejected. The Scots refused to pay it, as did many individuals. Prisons would have been full very quickly if the tax had not been abolished. It was the end of Thatcherism, but tourism never recovered sufficiently, at least not for us.

David offered to help us find a property. We found a house in Albemarle Road in York, overlooking the Stray. Perfect for a

bed and breakfast. Though we could not legally register with the council, we continued operating provided we didn't advertise at York Visitor Centre. Our next-door neighbours produced films, often having directors and producers as well as actors conferencing in York. It was a reciprocal advantage as quite a number of artists stayed with us and the word spread, but it was insufficient financially to make the living we had originally planned.

To be useful, Helen began working in aged care nursing, whilst I began a graphics business. To supplement a few living expenses whilst getting started, I took a part-time job at Terry's chocolate factory, less than five minutes from the house. Starting at 4 p.m. my shift finished at 9 p.m. packing Easter eggs into cartons. I had to show my fingernails when I applied. If I had bit them I couldn't get a job. The job at Terry's allowed me time to catch the 6 a.m. train to London's King's Cross, cover appointments, and return on the 2 p.m. express to clock on at Terry's on the dot of four. The work at Terry's was pure labour, though I did submit an idea to help the straight placement of labels on cartons, which they adopted. When I gave notice to quit, they offered me a job in the office. It was tempting, but long term I sought better opportunities for myself.

I was lucky to have Mike Daldry, a friend I met at Dexion in Australia. Mike had his own Dexion distributorship and installation business near St Albans. He was quoting a timeshare company for installation of an exhibition spaces at Blackpool Pleasure Beach, but Mike wasn't interested in providing the graphics. He passed me a copy of the specifications and I submitted drawings. Leisure Share Industries (LSI) accepted and planned to build a network of exhibition spaces throughout UK, as well as France, Spain and Italy.

My brother Paul, as my accountant, announced I had made twelve thousand pounds in the first year. I loved the work, had a

great network of suppliers, and moved around the country.

Unfortunately, Mrs Thatcher indirectly interfered with our business again, declaring ALL timeshare crooked business. LSI was not a shonky company; I would never have worked with them if they had been. People were offered a genuine forty-eight hours to retract any contract with full repayment. There were no gimmicky free TVs, no monetary prizes for attendance. Their business was respectable. We had helped expand their market producing travelling exhibitions, fitting out twelve caravan trailers that were taken to markets and shopping centres. The whole operation came to an abrupt halt. Finished!

Mike received an enquiry from John Deere, seeking concepts for an outdoor exhibition space to be held in the Middle East. I talked to Mike, playing with an idea for mammoth Bedouin-style tents allowing their machinery to be demonstrated under cover. I approached a company in Warrington who made tent material. They were keen to develop ideas and between us we came up with some practical, exciting design solutions. We priced the project, submitting it to John Deere who were keen to place an order with us. Unfortunately, the Archbishop of Canterbury's emissary Terry Waite was captured and held hostage in Baghdad. It was the city in which the exhibition was to be held, which was now politically unstable, we were told.

Helen earned poor wages of three pounds an hour compared to Australia– and she was in charge of a nursing home. In Sydney her pay would equate more than twelve pounds an hour. The owner went into liquidation owing back pay. We were better off financially than most of the staff, some had mortgages and kids to feed. We decided to put our house on the market, expecting it to take a year to sell, and hoped opportunities would meanwhile develop. Around us there were streets of houses for sale more than twelve

months. Some vendors owed more than the selling price for repayments as the housing market crashed. Unfortunately, in one sense, we got a buyer at the price we asked. Eleven weeks later we moved out and made our way back to Australia.

Helen's parents had both died and the family home was up for sale, requiring major work. We rented the house at Homebush in Sydney from the family, looking other suburbs, but coming back to Homebush.

Renovating the house, we settled back into work with the future bright. In October 1992 I had a bladder neck procedure in a local private hospital. A far as I knew, the procedure was conducted without any problem. In late November I began feeling unwell but continued working. By January I was having two or three changes of sheets due to night sweats. Early February I continued forcing myself to work as my local GP insisted my problem was nerves. I never agreed with him but pushed on. Knowing the illness must be serious, I called my endocrinologist. Blood cultures taken on Friday normally take a week to develop, but mine had resonded in just two days. On Monday Dr Calligeros asked me to see him immediately. I drove across the city to his rooms at Randwick. When I walked into his surgery, he asked for my car keys, and informing me I was a very, very sick boy and he couldn't understand how I was still standing.

I didn't stand any longer. I collapsed. At last somebody beside Helen had diagnosed the illness. I was rushed to intensive care with endocarditis, slowly recovering over eight weeks with a line directly into the heart valve. David flew to my bedside, staying until he knew I would recover.

My first weeks were touch and go. In a semi-conscious state, I heard some nurses conversing.

'He'll never get well unless he starts walking.'

Nobody had told me to walk. The next morning, I woke at 5 a.m., and with my heart monitor on wheels began fast walking down the outer ward. Up and down, up and down to keep the heartbeat moving fast. Every day in the morning and late evening I exercised.

I pleaded to be able to have lunch with Helen one day. I was only out for half an hour when I knew I had to go back to bed. Recuperation was slow. When I left hospital, David asked if I would convalesce in Bridlington to work on Dad's archive, which I later did.

Flight to Heaven

Nothing had prepared me for what I was about to experience. I had grown up with parents who cared for us the way they thought best. I had missed my father's funeral. It taught me a lesson to always let someone know where you are. It was six weeks later I discovered Dad had gone. His eccentricity, his love of fellow man, his passion for peace and the anti-war cause would be no more.

Now here I was on a journey to see my dying mother. I received a call from my brother Paul telling me that Mum was dying. She wasn't ill, just tired. If I wanted to see her, I'd better make arrangements immediately. I caught the fast flight to the UK with British Airways. One stop in Bangkok arrived in London at 5.30 a.m. A flight to Humberside was at 8.30, which would get me to the train from Hull to Bridlington by 11.30 a.m.

My thoughts tossed in my mind about life with Mum. We never enjoyed the best of relationships, but in later years I cared for her as much as I could. Much was due to her age: At ninety-eight she had outlived her own siblings and friends. Every time I visited Bradford, I drove her through the Yorkshire countryside, to Bolton Abbey, the place she met Dad. Driving on to the Misses Wilsons

at Morecambe, who once were neighbours and fellow Methodists, Mum loved the outings as much as they did. I heard all their stories with mutual pleasure.

It was only a year since Mum had moved from Margaret's house into Rosegarth Nursing Home close by. She had needed extra care but never liked it, never settled.

I don't think I would care to be suddenly stuck with strangers who don't share a common interest. We all have our own habits and must be difficult to change, not having your own things – own choices of programmes.

An announcement on board called for Mr Hockney to make himself known to cabin crew. A stewardess advised me there was a change of plan organised by David and Paul. I was to disembark in London and David Graves, David's assistant, would drive me to Kings Cross station to catch the 7 a.m. train to York. By nine-thirty I would be at my mother's bedside. A saving of two hours!

The curtains were partly drawn when I entered Mum's room, letting a shaft of light beam bright beside her bedside. Like a stairway to heaven? Flowers filled every table, colourful, bright and sweet-scented. As I walked in, she was propped up on pillows. David and Margaret announced I had arrived. Her eyes seemed to flutter for a moment as she looked towards me, then, closed with her head to one side. Her arms and hands arthritic and crippled rested above the blanket. Bent-over fingers rested on the sheet. David and Margaret kissed me and quietly left. Here we were, Mum and I left to ourselves. Helen assured me the last sense to go is hearing.

'If you talk to her', she said, 'She will hear every word.'

I sat gazing into her face. Picking up her hand, I held it in mine. She was cold. Her fingers seemed to move slightly. Her white, snowy hair had been groomed and fell off the side of her face. Her

cheeks sunken, and her skin had a shine. For a few minutes I said nothing, gazing at her, regretting the many times we had disagreed. To her I had been her wayward son, but now was not the time for remembering difficult times.

I began to tell her that I was never the wayward son she believed. I was OK. I had done well, and life had been good. For the next three hours I spoke about our lives, even reminding her of the time she read my diary, when she should have left it alone. Because of her act I never kept a journal or diary again, which is a pity as it would have been invaluable now, when I write the family story.

The one-sided conversation took many turns, as I remembered the fun as well as the difficulties we had confronted. Sometimes I felt her hand squeeze if there were something she might not agree with.

For me, it was the best conversation I ever had with her.

It was noon when the clock chimed, and the lunch bell rang. I was tired, needed a shower and clean-up before I continued. I kissed her forehead, telling her I wouldn't be long and would be back soon.

The walk from the nursing home to my sister's house takes exactly four minutes. As I pushed the door open, the phone rang. It was Paul, my brother to say Mum had gone. It wasn't a sad time. Mum enjoyed a full life, especially over the last thirty years. She had met film stars in the US and in her home. She had been introduced to the Queen and Duke of Edinburgh, enjoyed tea at Hutton Terrace with Vincent Price the actor. She had met Michael Caine in Hollywood and when he asked her how she liked it, her answer was:

'Nobody seems to hang their washing out, Michael.'

The first years of her life journey had been hard but the last thirty-nine provided her with wonders, travels and places she

would have only dreamed of. Pity Dad hadn't been there to share it too.

Is there light at the end of the tunnel? Is God at the gates checking our lives in a big book?

Or is there nothing? There will only be one way to find out.

I flew back to Australia, content I had an opportunity of saying goodbye.

Telling Real Stories

It was uncanny, I had never thought of retirement. I always anticipated I would be working at something, whatever that may be. I certainly had no intention of sitting on my arse watching telly. Perish the thought.

I was standing in a queue at Strathfield Library waiting for my selection of books to be stamped, when a small yellow A5 leaflet caught my attention with the word **'Storyteller'** in bold print across the top, promoting the Australian Storytelling Guild of New South Wales. I hadn't planned to pick it up, it was a bit like supermarkets displaying all the small stuff near checkouts, luring shoppers to 'add on', spending more than they need.

It advertised nothing more than where the guild met, what time and date. My mother always reminded me that I 'tell a lot of stories', though I never knew there was such a thing as a professional storyteller. The flyer was successful. I went to the next meeting at the Writers Centre in Rozelle, intrigued rather than serious, but that day changed my life forever, and I began an unknown journey.

That first visit hooked me, recognising I too could become a professional storyteller. Here were people who sat on a simple chair captivating their audience with voice, tone, depth and variance. Others used hand puppets and songs. I already had all

the necessary skills, including graphic arts. I could design props, play the guitar, and act. Plus, I was no stranger to the stage. I began to mingle with creative and outgoing people, bursting with ideas, energy and stories. No one was selfish; they shared skills willingly. The monthly meeting of members shared off-the-floor stories in the morning, with a workshop in the afternoon. An instant camaraderie was warm, welcoming and engaging. I realised I had all the relevant attributes to become a storyteller. I loved entertaining. I wasn't shy on stage, and indeed knew many stories to share. I could apply for accreditation with the guild. I eagerly awaited each month's meetings, gradually befriending those who had similar ideas to my own.

A few months later I was ready to present my two stories. I wanted to be remembered for an unforgettable performance. For my first story I designed a story tree. Two metres tall and a metre wide, the demountable tree was covered in blue felt on top and had bright red for its trunk. Visually, the tree would appeal to primary school aged kids. Stuck to face of the tree with Velcro were fifteen green apples, representing fifteen different stories. A member of the audience selected one of the apples and read the title of the story I had written on the back. People were instantly involved. I then told the story with all the enthusiasm I could muster. My second story was a song in story form, originally performed by Robin Hall and Jimmie McGregor, a folk duo appearing on Cliff Michelmore's show in UK in the late fifties. For a fun song called *When I First Came to This Land*, I made visual boards of a house, cow, donkey, hen and a wife. Each verse invited a person from the audience to hold a card. It was about participation and I'm glad to say I received my accreditation.

My heart was pumping. I had thoroughly enjoyed my presentation and so had my audience! I was on my way – but was I? I

hadn't been informed of the secondary accreditation with the Department of Education. This superior accreditation would allow me to perform at any primary school in the state. Meanwhile, I was asked by Scholastic Books to perform at schools prior to their sales ventures, for which I would be paid. They were a godsend, as I began to contact children's librarians and teachers at primary schools prior to my official accreditation.

Two attempts later I achieved state education recognition. I was back on stage again.

It had taken a lifetime of stages to arrive at this point, but here I was at last. I knew this was my true vocation. The more I involved myself with storytelling, the more I believed this was me; this was who I was, this was what I had always wanted but I didn't know. My fellow storytellers became friends, pooling ideas. I began working in schools professionally, making a living.

The Story Guild asked for three storytellers to present at an alumni dinner at a university. I, Christine Greenough and Sue Alvarez agreed to present an adult programme. After the performance, a diversional therapist asked if we shared any *reminiscing* stories for nursing homes. None of us had, but we would consider the idea. As Helen worked in aged care, she was a great help with suggestions to include in our programme. Six months later we had a show called *Days of the Week*, based on lives of housewives whose often-dreary repetitive tasks were repeated each week. Washing on Mondays, Tuesdays ironing, Wednesday's cleaning and Thursday's baking, with Friday's shopping.

Our first presentation was at a nursing home in North Sydney. I was singing the introductory song when a lady in a wheelchair was pushed to the back. No sooner had she been placed, she shouted at the top of her voice:

'Aw! Sherrup!'

Whimsical Weavers Storytelling Troupe, 2003

I was gobsmacked, but continued singing, finishing the show fifty-five minutes later.

The diversional therapist ran to us, greatly excited, telling us the lady had been at the home for two years and hadn't spoken, now she wouldn't shut up. She had been an opera singer and something in my voice jarred with her. Others had memories brought back as they talked to each other, and I realised this was our future path to pursue.

Visiting nursing homes around the country, we became educated to the variance of care. Our programme was in great demand and we travelled intra and interstate. At each performance we shook hands with every person before and after the show. The number of

stories we were told after the show triggered memories often added to our repertoire.

And in particular many did not want the touch of a hand to stop. Touch became an important tool to adding moments of comfort to those whose memories were touched.

The New South Wales Government invited me to become a Seniors Week Ambassador during Seniors Week in 2001 and each year following until 2005. The position promoted the advantage of reminiscing and stories. It began to be recognised as a useful art form for elders.

The more nursing homes we performed in, the more the elderly wanted to write their own stories but didn't know where to start.

In 2003 I was invited to the Asian Congress of Storytellers in Singapore. Not only did I facilitate workshops and give stage performances, I also spoke to a Chinese group of elders. That day took me on a path of reminiscing stories and learned the cultural differences when asking questions.

Following one of my scheduled workshops a young Thai lady, Atchara Pradit, approached me. She was Director of the Faculty of Humanities Child Literacy Programme at Srinakharinawot University in Bangkok. She asked if I could design a workshop for her students on how to access stories from elders. Culturally, elders' stories were rarely shared in Thailand as it was thought disrespectful to ask about someone's past. Atchara recognised an opportunity to change thinking, and who better to do that than young teachers?

At one workshop I told my swimming trunks story, whilst Atchara translated as I spoke. I asked the audience to share any story they wished. A young lady stood up. Atchara leaned forward, telling me the student was the funniest, liveliest girl in her class. Her story was anything but funny. Her parents split up, her mother remarried

and she, the daughter, was rejected, unwanted, living basically on the streets and just surviving until this opportunity for university arose. No one had an inkling of her tragic past. The whole audience hugged her, many in tears. After her story, I emphasised I couldn't have asked for a better person to share the power of what a story can do. No one in that room would ever have exactly the same relationship with her again. There would always be empathy.

One of the tutors shared the simple heartfelt story of her mother's death. She was at her mother's bedside, naturally upset, and began crying. Her mother took a tissue, offering it to her daughter who wiped away the tears. Then her mother died. She keeps the tissue in her handbag as the precious last gift of a mother to her daughter.

Since 2004 I have presented the programme every two years. It works, and stories are beginning to be shared.

I began writing stories by linking them to questions about life. In 2005 Tom Keneally, the noted Australian author, launched my book *Remember When: How to Unlock Your Life Story*. It was never intended as an academic book, only for those elders who wanted to write their own story. I covered thirty-two subjects, from birthdays to war, sharing my own stories but with questions alongside, prompting different answers for the elders to write their story.

The *Sydney Morning Herald* featured a half page on my Reminiscing programme and how it helps memory, bringing value to some who had felt worthless. Diversional therapists used my book as weekly therapy, with more stories being shared and new relationships explored. The *Encounter* programme on ABC Radio National broadcast an interview with me nationally one Sunday morning. The ABC Classic FM programme invited me to chat with Margaret Throsby about my own family and how reminiscing is a worthy exercise.

Every time, book sales were boosted.

I arranged to launch my book at Salts Mill in Bradford. Some old friends joined me, pleased to be part of the proceedings and adding to the frivolity. It was then I decided to begin this book. I never believed it would take as long as it has but living in Australia hasn't helped when seeking relevant information from siblings and archives.

Stories connect us all in some way or another. War, famine, refugees, success, fear, hope and courage are all part of our human nature to understand. Only through stories can we empathise with our fellow human beings. I began interviewing elders about their lives using digital recording equipment.

I joined The Oral History Association of New South Wales, empowered to interview people for oral stories. Local councils of Penrith west of Sydney, City of Sydney Council, Tumut in the Snowy Mountains and Waverley Council in Bondi have used my skills, when I became a ghost writer for a couple who had lived extensive and fulfilling lives.

I follow the path wherever it takes me, currently working with mental health and local community centres in the Blue Mountains 100km west of Sydney. My workshops, *Your Life – Your Story*, encourage everyone to share their own lives. I will never stop whilst I am able to move, listen and share the importance and power of stories. Currently I conduct a monthly book club, a life story writing group, and have designed a special writing programme for people suffering mental health issues. Titled *Life In Progress*, the programme offers participants the opportunity to understand that everyone's life is a 'life in progress' just as my siblings and mine are here in this book today. Mistakes, knowledge, joy and sadness, success and failure are all part of our lives. How we deal with issues makes the difference of life itself.

I offer a lecture about David's love of art, *Hockney talks Hockney*, which I have presented in Australia and through the British Council in Thailand.

I thank my parents, who gave us the power of choice – the opportunity to be who we wanted to be. My own path took longer, but the journey has taught me the one thing each of us have as part of our make-up. 'NEVER WORRY WHAT THE NEIGHBOURS THINK.' Be who you want to be.

I love DR Seuss's quote: *It's truer than true, there is no one alive you'er than you.*

When you think of the statement and consider all the individual experiences you have lived, it can reveal some fascinating stories.

I do not believe there is such a thing as an 'ORDINARY' person. Some have advantages over other's but no one is 'ordinary.'

For Paul, Philip, Margaret, David and myself there was another quote Mum shared that I have found just as useful as my father's: 'Don't mix with people that vex your soul.'

I am happy to still be on stage and will 'Never worry what the neighbours think!'

Paul, Philip, Margaret, David, and me, are a family of individuals. Each of us have been passionate about our achievements, passionate about our chosen careers, passionate about life. My parents Kenneth and Laura Hockney provided the grounding to have faith in ourselves, faith in what we chose. I think we have been lucky. They never stopped us leaving the nest, yet to have worked and moulded us allowing us the freedom to choose must have been at times heart wrenching, especially when we left not just home but the country. I dedicate this book to honour them as well as my siblings, for their love and insight to making us who we are:

The Hockney's – Never Worried What the Neighbours Think.

A Thank You to Bradford

Our family were not the only ones who benefited from opportunities in our home town, the City of Bradford. Education was a right for every child, rich or poor. I and my siblings all enjoyed a Grammar school education, with Paul and David winning scholarships to the Bradford Grammar School.

Had additional financial assistance from Bradford Metropolitan District Council not been provided to my parents to cover school fees, bus fares, and government-funded school dinners, our survival at times of hardship would have inevitably been more difficult.

David went on to attend Bradford Regional College of Art and the Royal College in London due to grants offered by Bradford City Council. Margaret studied Nursing at St Luke's Hospital, Philip and Paul attended Bradford Technical College, and I was at the Regional College of Art for Display.

Bradford was a mucky place, especially in the 1940s. Coal-fired smoke poured from chimneys, polluting the skies, and when winter

fogs hung in the valley creating smog, visibility could be less than a metre, and breathing difficult. Many elderly people died. Respite of clear blue skies came at Bowling Tide Week or the Bradford holiday fortnight, when mills closed down for summer holidays, and smokeless fuel eventually replaced coal.

The foresight of our forebears, investing in reservoirs high on the Pennines and the design and building of Esholt Sewerage works, provided Bradford with natural soft water in abundance. Recycling happened in Bradford long before it became the buzzword it is today. With ample soft water to wash and scour wool, Bradford developed as a world centre for processing, enticing investors to build scouring and weaving sheds in close vicinity to the city.

Bradfordians enjoyed the philanthropy of businessmen who supported live theatre, symphony and choral concerts at St Georges Hall, and the Alhambra. The Princes and Civic theatres promoted repertory theatre and amateur dramatics.

Bradford gave the world the Brontë sisters, and literature still read worldwide today. Delius composed his music and Sir Edward Appleton looked at space. Benjamin and William Jowett built cars and the famous Bradford Van. J B Priestley wrote poems, stories and plays. John Braine wrote *Room at the Top*, joining the many famous Bradfordians, as have Billie Whitelaw, and today artist David Hockney, actor Peter Firth, TV presenter Richard Whitely, actors Timothy West and Adrian Edmondson.

Thank you, Bradford.

Acknowledgements

Over the years I have many people to thank for their encouragement to continue with this book. The idea began when I interviewed my mother in 1989, but the genesis began in 2005 when I interviewed some of the people in the stories. Living in Australia away from contacts, took far longer than expected.

I need to thank:

Helen Hockney My wife who is so glad this book is finished.

Bevan and Barbara Roper For connecting me to Legend Press

Legend Press and Tom Chalmers For their acceptance to publish and their wholehearted support and guidance.

My Mother who recorded some of the early starter stories.

My Father for his wisdom to Never Worry What the Neighbours Think.

My Siblings: Paul (deceased July 1st 2018) and Jean Hockney, Philip and Mary Hockney, Margaret Hockney, David Hockney for use of pictures and drawings.

David's staff in LA: Gregory Evans, Julie Green and George Snyder.

Paul's children: Janine Hill, Simon Hockney, Lisa Knight, Nick Hockney.

Philip's children: Beverley Gunn, Michelle Paul, Melanie McCarthy.

Friends in Yorkshire: Anne and David Bottomley for initial encouragement and hospitality.

Maggie Silver, for frequent generous hospitality at Salts Mill.

Philip and Kate Naylor, hospitality and childhood friends.

Mike and Janet Powell, hospitality and childhood friends.

In Hertfordshire: Mike and Linda Daldry – for their hospitality and support.

In Australia: Ian and Anne Smith, always there to listen and help.

Marilla North and Rob for writing advice and support.

Maggie Fitzpatrick at Australind – Goulburn, for the peace and tranquillity of her property.

Murray Bailey, Alison Hill, for reading through the draft and early suggestions.

Roy West, my cousin and a great listener.

Brian Langford for assistance with images.

6/12/19.